WOODSTOCK CRAFTSMAN'S MANUAL

WOODSTOCK CRAFTSMAN'S MANUAL

provoked by Jean Young

PRAEGER PUBLISHERS

New York • Washington

BOOKS THAT MATTER

Published in the United States of America in 1972
by Praeger Publishers, Inc.
111 Fourth Avenue, New York, N. Y. 10003

Fourth printing, 1973

© 1972 by Praeger Publishers, Inc.

Library of Congress Catalog Card Number: 76-185655

Printed in the United States of America

Woodstock Roots

This book grew out of experiences I had while working in the Juggler bookstore in Woodstock. The typical craft book wasn't with it--the people who came into our shop knew this, and we would rap about crafts and craft books. The idea of a craftsman's manual evolved.

The idea was to put together a manual written by craftsmen that would give more information for less bread, be fun to read, and identify with our New World. Besides trying to give clear instructions, we wanted the book to be a liberation trip, free from patterns and designs to copy. It's you, your imagination, your interest, and your time that are the essentials.

I want to thank all the authors--with special thanks to Carol Abrams for her great positive vitality--and David Bell at Praeger, who listened and acted.

Many of the authors illustrated their own chapters. One exception was Home Recording , with illustrations by Rick and Gloria, and Michael. Carol illustrated Weaving. Albert illustrated Leather, Rick and Gloria also illustrated Silkscreen, and Peggy Farber illustrated Macrame. I also want to thank Lenny Busciglio, who took some of the photographs, and Arnie Abrams, who took most of them; Michael Green, who did the cover; my family, Jim and Michael; Fran Danowski, Diane, Jean Shaw, Bea Binger, Estelle, Bell Abrams, Jim Matteson, Dennis and Barbara, Dennis the drummer, Alfie and Susan, Cris, Emily, Betsy Bocci, and Ellyn, the editor.

Jean Young

WOODSTOCK CRAFTSMAN'S MANUAL

Candles
Duncan Syme

Chapter One of John Muir's beautiful book on fixing VWs is really direct. He says, "Now that you've spent your bread for this book--read it! Read it all the way through like a novel, skipping the detailed steps in the procedures, but scan all the comments and notes. This will give you a feel for the operational viewpoint I took when I wrote it. The intent is to give you some sort of answer for every situation you'll run into. . . ." This states his case and mine very succinctly and much better than I could have. For you people who will be bored by elliptical comments I have included cookbook-type recipes for making some candles. These recipes are self-contained and tell you all you need to know about making that particular type candle, but they tell you nothing about the art to which I hope to introduce you. Good reading and good luck.

WICKS

The main thing to get behind you first is the hassle about wicks. I could list long, boring tables and things to remember, but the best thing is to figure it out for yourself because there are many different kinds on the market and they all behave differently with the various waxes. Very quickly, the general idea is the bigger the wick the larger diameter of melted wax it will make. The main problem is that if you get too much melt it is possible the wick will drown. They make metal-cored wicks to keep them upright, which helps. The metal is very soft lead-type stuff which burns away nicely. If you're doing huge stuff cast in bowls, Chinese woks, etc., then one metal-cored number might be braided with a couple of cloth ones. No, you cannot use ordinary string just the way it comes. At least not with any real effectiveness. The wicking is so cheap that it's not worth the risk of having an unburnable candle. You might just as well buy the stuff which is made for candles.

One formula for making wicking says to take "strong string and soak overnight in 1 tablespoon salt and 2 tablespoons borax dissolved in 1 cup water. Hang the string up to dry and stiffen by dipping in melted paraffin." I assume that they mean some kind of thick cotton string, but that wasn't mentioned. The salt-and-borax treatment is to stop smoking when the candle is extinguished. This may work fine, and I would be curious to know, so no doubt someday I'll give it a try.

The metal-cored wicks start about as big as a skinny pencil lead and go up in about four sizes to a fat pencil lead. Same with the cloth ones, but they get even bigger. Some sennits are round and some are flat, but they all do the job. Usually the hobby shops will have them packaged in little plastic bags with about six feet of wicking per bag. Actually you can make quite a slew of candles with six feet of wick. Local stores have it on spools and will cut off whatever you want. Get two sizes of metal-cored and two or three sizes of cloth. What you don't need you'll soon discover, and the education is cheap.

One last thing about wicking. On a big candle sometimes a weird thing will happen. Let's say you made a really nice candle in a milk carton, and so you send it off to your sister who lives in an overdone house in Elizabeth, New Jersey. She is so overwhelmed at such a touching show of conventional emotion that it is given the place of honor in the center of grandma's damask tablecloth at Thanksgiving, and she lights it up. It goes great for a while, making a melt pool about two-and-a-half inches in diameter, but not quite in the middle. After dinner, and while waiting for dessert, they're all out throwing the main course dishes into the Kitchen Aid. When they come back into the dining room you need never worry about having to go and visit them again. The melt pool got so close to the edge that the thin dam of solid wax was softened and the hot stuff in the pool ran down onto the table, draining

the pool completely. The wick, being big, then melted some more wax, which also immediately ran out, cutting the channel a little deeper. This keeps going and you wind up with a hollow shell with a tiny slit down one side where the hot wax ran out and the wick has burned a hole through the table-cloth, the finish, and into that precious cherry wood. Of course, wax all over the place too. Once the dam breaks the whole thing happens quite quickly and inside of five minutes, you have no candle or place to crash in Elizabeth, New Jersey.

Of course, you can't predict which way the wick will bend as it burns, and this will in effect move the point of heat closer to the wall. Sometimes when the melt pool becomes quite deep, the wick will want to bend from the bottom of the pool, so it can move quite far. This can happen with all kinds of wax. A guy who was into candles on a really big scale tells me that wicks are usually braided out of three strands, and one is pulled tighter than the other two to make the wick bend on purpose. If you have excess trouble with bendy wicks maybe a home-braided number would be the answer.

WAX

The next thing is waxes. There are two kinds of things you can do here. One is to set out with the idea that you will turn out those charming little Black Forest numbers with all the Slavic peasant folk art decorations. This requires apprenticing yourself to a little old candlemaker from . . . etc., and spending the rest of your life analyzing eutectic gradients and other MIT sounding stuff. Or, secondly, you can figure out what the WAX wants to do, and let it do it. This saves enthusiasm, and you have a ball discovering what it's all about. In this light, I recommend that you start out with what-ever the local hobby shop has to offer. If you live in a rural area ask the telephone operator for the number of a hobby store. She will give yellow-page information, especially if you are rural. Once you have the name of a big city place, write and they should be helpful. You can expect to pay from 24 to 40 cents a pound for their "special" blend. Nonsense of course, but don't fight it. Let them play their money-trip game, and you put your heart into the wax. If you plan to make more than a couple of candles, get a slab of wax (from eight to twelve pounds) and a candy thermometer, or maybe it's called a deep fry thermometer. The best kind are about seven inches long, are enclosed in a test tube about an inch in diameter with a sort of pointed end. They have a metal spring clip with a wooden ball, and all this slides up and down on the test tube so that you can keep just the tip in the hot wax. They start at 100°F. and go up to 400°.

Since the rough draft was completed, I've looked around in the stores and they don't seem to make that kind anymore. It's probably a case of Owre's Law (a friend of mine has discovered that whenever a product ap-pears on the market that is too good, then it is immediately replaced by one of inferior quality and serviceability). My commercial friend told me

that he had good luck with a pasteurizing thermometer. These are the things that the milk destroyers use, and they are cheap. They have been around a buck-and-a-half or so. You get them from Agway feed-and-farm-supply stores. You city types will just have to be content with meat or candy thermometers. Don't get the type that has a wand and a dial of the kind that is tucked into the meat, for the first time they fall into the wax, they're done. What you need is a range from roughly 120°F. to 250° and something that is easily cleaned so that the scale can be read even if it becomes coated with wax.

A gas stove has better karma, but of course you use what's at hand. Start out by using a double boiler (with this rig you don't need a thermometer). It takes much longer, but until you and the wax know each other, play it safe. Remember this stuff burns and is dangerous. The flash point (the temperature at which it will burst into flame without directly applying fire) of melted wax is as low as 290°F. Should a pot of wax catch fire the easiest way to put it out is to cover it with a lid. If you have a thermometer stuck into the pot you will have to take it out first, but that can easily be done with a long knife or something along those lines. Just don't panic and tip the thing over for then you will be in real trouble. A large pot for the water champer on the bottom will work best. A Chinese wok with a ring is really good, for it is easy to add more water as it boils away. You don't want too much water, for then the wax pot will float and it gets harder to work with. You should only use just enough heat to keep the water simmering, for a violent boil will only splash water into the wax, and then the candle won't burn too well. Also, when you pour, remember to set the pot down briefly with a wiping motion on an old towel or rags so that the water on the bottom of the pot won't run off into the mold and ruin the candle. When you get the hang of the thing you'll put the wax pot directly over the flame and eliminate the double boiler. But don't expect to go and try to sue us should something go wrong, for you have been warned. Even though I've been doing this for a time I still don't heat directly over an electric stove. There's just too much localized heat, and even if you turn it off there is a lot of residual heat that takes a long time to disappear, and by that time the house may have gone

with it. Be cautious. Also don't plan to get too involved if you are being interrupted. I once forgot about what I was doing and discovered that the temperature had gone up to over 300°F. and was smoking like crazy. I was lucky.

But I didn't mean to get started on that, so let me say some more about the wax. The stuff is some kind of by-product of gasoline, I think. Maybe they make it directly from crude oil on purpose; I'm not sure. The main thing is that it exists. There also seems to be something that can be done to it to achieve different characteristics, for there is great variety among name brands. These are subtle differences, though, and you don't have to worry about anything unless you get into production.

The basic stuff has a melting temperature of around 133°F., and you will quite often find that this information is either part of, or its entire name (for example, Chevron XB-212133). Usually, at the hobby-shop level they will call it just 133 and pretend it's their special blend. There is a possibility they might have recast it with some additive, but this only adds to the price and doesn't do much. Paraffin (or canning wax) will make candles fine, but it is expensive and has a lower melting temperature. This means that it burns more quickly, and will make a melt pool that is larger. Nothing wrong with this, but just keep it in mind. I sometimes use it to lower the melting point when I'm stuck with the high-temperature stuff. It is also handy for making the color clearer. By this I mean that the flame will light up more of the candle under it. The general rule is, the lower the melting temperature of the wax, the brighter the candle will glow. The light from the flame of a candle also shines downward. If the wax is translucent, like low-melting-temperature wax is, then the candle itself will seem to glow with an inner light. This is sometimes a very nice effect and will even work with colors if they are kept relatively thin. High-temperature waxes are quite opaque. So much for paraffin.

The high-temperature stuff (also in your local hobby shop) has a melting point around 156°F. The thing about this stuff is that it will last longer. But it's tricky, and I like the 133. The big harangue I gave you about your sister in Jersey is a classic example of what this 156 will do to you. In smaller diameter candles, where the melt pool is big or bigger than the candle, it will drip and run all over the place. Of course they don't last too long, but fine for special effects. If you're going to give these away, just tell them first what to expect. Oh yeah, one thing this reminds me of is this. Burn your own. I got into the whole thing by accident (luck?) and before I knew what was happening, I was giving them away, and selling them so fast I never really had a chance to find out how they behaved. Some I was lucky on, and with others I wiped out. I kind of like to have one or more going anyway while I'm messing around. I guess what I mean is that making them is only part of the trip.

OK, so back to 156. Colors will be darker with the 156, and of course more opaque. The outside of the candle may be smoother, but not necessarily. There may be fewer bubbles, but not necessarily. It may take more scent to do the same job, but not necessarily, etc., etc. Try it, and find out what you want. You probably won't care too much about this type of thing, which is better anyway, for it means that what the candle wants to be is more apt to reach you.

BEESWAX

Man, does this stuff have soul! Getting it and getting the bread for it is the hassle. If you know any apiaries, go there. Ask the guys in the health food store where they get their organic honey and go there. Big orchards either keep bees or know who does. Sometimes it's available in New York, Boston, L. A., but following the beekeeper out to a half-falling-down barn on a beautiful spring day with the apple trees pouring out their blossoms and nectar and bees flying all around can really turn you on. After moving his hand-cultivator and a pile of burlap bags--THERE IT IS. Fantastic! He's got a whole damn barn just filled with the stuff. A beautiful, kneadable yellow that looks kind of like Little Black Sambo gold. And it is, too. From 45 to 70 cents a pound (in stores, $1 to $2). What the hell, man, blow it and get ten pounds. Get twenty, so you don't get tight with it. To become tight with a material is for the art to die. Great for technology, but you're an MIT dropout--remember? What does it do? Smell it. Take a small piece in your hand and warm it--push it with your thumb--bite it. Oh, by the way, it burns. Don't waste it on your sister in Jersey. Let the people there burn Chevron XB-212133, they've already choked on the air they ruined by making the stuff in the first place. Have you ever seen a bee in Elizabeth?

Working with it . . . Melting temperature? I don't really know--it doesn't behave at all like Chevron's stuff (by the way, I'm not knocking them. Theirs is the best on the market)--I'd guess around 140°F. or so, but it's funny. It takes a lot of heat to melt it and as it cools down it won't skim like petroleum wax, it kind of congeals in a gooey mass. I don't know what its flash point is because I've never had it over 165°. I would imagine that it would ruin it to get it too hot, but I don't really know. Try some and

16

COOKBOOK #1

Go to the grocery store and get a one-pound box of paraffin or canning wax. It is sold by both Esso and Gulf under their names, and they mention candlemaking on the box so you will know that you have the right stuff. Go to the local hobby or craft shop and get the smallest diameter candle wicking they have. If you can't do this, get some Cotton string, like kite or butcher string, and test it by setting it on fire. It should burn about like a cardboard match and if you hold it down, it will burn quite quickly and evenly. White is a must. Go home. Get out a biggish pan (two-quart) and put an inch of water in the bottom. Put a smaller pan in the water and put the burner on a medium heat so as to just boil the water. Open the box of paraffin, which will have five slabs inside, and put one in the top (dry) pot. When it has melted take out the other slabs and lay them flat on the counter. Take the pot with the melted wax out and dry the water off the bottom. Put the string or wicking into the wax, then take it out and spread it on the counter in a straight line

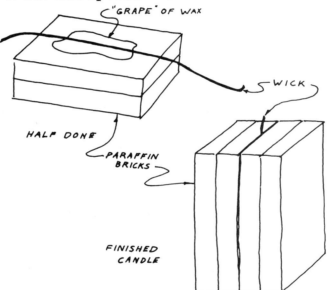

and allow to harden. Next, pour about as much wax on one lying-down slab as would be contained in a grape-sized volume and immediately put another slab on top. Be careful to align the ends reasonably. Lay the prewaxed wick on the center of the second slab the long way and pour on another grape, or grape-and-a-half. Put on another slab and align the ends. One more grape, and the last slab, and align the ends. When cool (in about five minutes) take a pair of scissors and trim the string or wick flush with one end and leave about one little finger thickness (a half-inch) sticking up from the opposite end. Stand up with this end up, strike match on appropriate surface, apply to string (hereinafter referred to, if at all, as wick). Blow out match and turn off burner under the water.

see what it will do, I'll bet some really great things. Wicks are a whole different number with this beeswax, so make sure that you burn before you give. I've found that fat wicks seem to work better, although a friend has had very good luck with regular sizes. The metal jobs help, but they have to be fat. If you have the thin metal ones, braid up some cloth wicks around them. They are hard to light because it takes a lot of heat to melt the wax in the wick, but once they're burning they will last a long time--a candle made in half a beercan will last for maybe forty hours. It will do that same weird number, so gauge the melt pool to give a fairly heavy wall thickness in a fat candle. After burning a long time the melt pool will get fairly large and anything less than a half-inch wall thickness will sag and leak. Even though the wax smells nice, the flame burns clean and there is no really noticeable aroma in the air, except while extinguishing, so don't be too disapppointed in that respect.

COLOR

Now we're making some headway. This is the most beautiful and elusive aspect of the whole thing. Before I forget the bees completely, I might as well say I've never added color to beeswax. The stuff is so wonderful just the way it is, I could never bear to frig with it. But then, the Greeks painted that fantastically beautiful Hellenic marble with what we now think of as gaudy colors, so what the hell.

Color is available at the hobby shops usually in little bricks sometimes in things like Thayer's Slippery Elm Throat Lozenges, sometimes cast into tricky plastic vacuum-molded packages like marzipan. The buttons can pretty much just be dumped in the molten wax but the bigger ones have to be sort of shaved down. Since the color is so intense, little quantities make a tremendous difference so it is practically impossible to get two batches to have the same color. This is what makes it so much fun--because you never really know what it is going to look like until it has cooled. I assume that the hobby shop junk is a super-intense dye that has been added to paraffin to cut it and make it manageable. The dye itself can be had directly, but at the beginning don't bother. Too much mess and expense. I'll give the poop on that later under turning pro.

There is an awful lot of stuff that you can use that really wasn't designed with candles in mind. One is crayons. They work pretty well, give all kinds of different colors and are cheap and readily available. They are sometimes hard to melt and don't give quite as clear a color as the real stuff. They also seem to leave some sediment in the bottom of the pan, so don't plan to dump all of the wax into a mold. Leave the crud behind in the bottom of the pot. A guy told me that he used paint. I tried Sherwin-Williams show-card enamels and they didn't work at all. I guess there is too much other junk in the pigment. Maybe right-from-the-tube artist colors

COOKBOOK #2

Take a mayonnaise or salad-dressing jar (sixteen-ounce is best) and wash out and dry leaving the label on and intact. Go to the hobby store and get at least a pound-and-a-half of their ordinary candle wax and a length of wicking. If this isn't possible, obtain materials as per Cookbook #1. Melt all of the wax in a double boiler. Tie a nut (steel, please, as in "nut-and-bolt") or small pebble or something with some weight to it to the wick and then prewax it (see Cookbook #1). Dangle the wick in the center of the jar. Shut an overhead cabinet door on the wick, or fasten it with a spring clothespin to something like a knife balanced across the top of the jar or any way you can as long as it is carefully centered (see illustration). Pour in the wax. (Another way is to drop the wick in right after pouring. Also, you can pour in one inch of wax and let it harden in cold water--put the jar in the sink--to secure the bolt at the bottom.)

Wait about one hour without messing with the thing at all unless you have to recenter the wick immediately after pouring. You will notice that the top of the wax is no longer level, but has started to dip down making a depression. Add enough extra melted wax to fill the depression. In another hour you will see that another depression, or well, has started to form. Refill again. You might have to do this three times, but two should usually take care of it. A slight well will not cause any problem. Remove the wick-suspension apparatus and trim the wick to about as long as a lima bean is wide. Congratulations, you are now the proud owner of a Mayonnaise Candle. Tee-hee-hee. If you want to get the candle out, wrap a towel around the jar and break it, or put the jar under hot water and then immediately in the freezer so it will crack.

would be OK, but I never tried it. Lipstick should work, but I don't know.
Try things and if you find something that is good, spread the word. A trick
from the kitchen might help here. Try blending some of the color with just
a small amount of wax. You can get the lumps and unevenness out here.
Then when you want to color the main bulk of the wax just add some of the
colored mixture. Children's poster color in powder form might do. If there
is a printer that you could get friendly with I'll bet his inks would be great.
Probably fairly opaque, but think of the great colors they have. If you are
even slightly versed in candlese, any guys you know who are making a bag
of candles will usually be really helpful. I ran into one exception in Colora-
do, but usually they like to swap new ideas. The world isn't so small that
it won't support one extra candlemaker. If the guy's on a money trip, forget
him. If he won't share what he knows, then he probably won't learn from
you either and the art will soon outdistance him. What is hot in stores this
year you probably won't be able to give away in five years.

One problem that is apt to occur with impure waxes or coloring agents
is the clogging of the wick. Since the wick lifts the molten wax above the
surface by capillary action, if solid matter is allowed to fill up the spaces
between the fibers then the candle will not burn. If you are having trouble
with this you can try to eliminate the impurities or, if this is not possible,
then a coarser wicking might solve the problem. The braided stuff that
you will get from the stores is apt to be fairly tightly woven. If you can
find some fairly fine stuff and braid it yourself it will help. When I suspect
a candle is giving me trouble for this reason I make a test by taking two
pure pieces of wax and sandwiching a piece of the wick between. Once it
has established a fair size melt pool I will hold a little bit of the coloring
agent over the flame and melt some into the pool. If the flame starts to
diminish immediately, then I know that the color and the wick are incompati-
ble. I try again using a different wick or color and when I'm through with
the tests I just blow the candle out and dump the still molten wax with its
impurities out and toss the sample into the pot for remelting. This tech-
nique is also good for establishing the diameter of melt pools with different
waxes and wicks. It takes a long time for the melt pool to reach its maxi-
mum size, though, so don't give up on them too quickly. At least an hour
(if not two) is required.

SCENTS

These are all phony baloney except for the beeswax, which smells like
honey, but everyone digs it so it doesn't hurt to know something about it and
try it. More about this later. I've bought scents in little bottles in a liquid
form and in translucent crystals. I'm sure that it probably comes in other
forms too (try your local hobby shop or candle shop to start with). I kind of
like the liquid because you just dump it in and that's it. Once I gave a really
beautiful candle as a wedding present and even though I put in about five tiny
bottles of the stuff, it just didn't seem to be as smelly as I wanted, so I just

COOKBOOK #3

Go to the hobby store and get some of their ordinary wax, some wicking, and some color. If they want to know any details to help in the selection of the materials tell them that you are going to make your candle in a half-gallon milk container. If there is any choice ask them for low-melting-temperature wax and a metal-cored wick. Color is color is color. Bring the stuff home. Melt enough wax and prewax the wick (see Cookbook #1). Wash out a half-gallon milk container, cut to about six inches high (two-thirds of the way up from the bottom) and dry thoroughly. Add the coloring agent to the melted wax until the tip of the bowl of a teaspoon held vertically in the molten wax is no longer visible. Just the bowl is put into the wax so, in other words, you can only see about an inch-and-a-half down into the melted wax. With yellow, two-inch visibility is good. On how to install the wick see Cookbook #2. Then fill the container with wax to one-half inch from the top. Keep topping off at hour intervals as per Cookbook #2, only this time it will take at least three refills and about six hours before the candle is really hard. When it is finally cool to the touch, and I mean <u>Cool</u>, all trace of warmth gone, you can strip off the paper container by tearing, or with a razor blade or scissors, and you have your candle. Trim the wick down to a half-inch high before lighting.

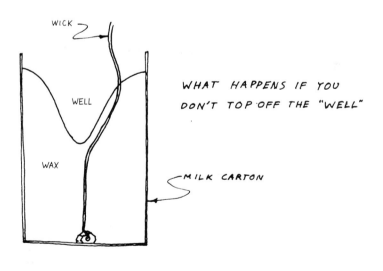

WICK

WELL

WAX

WHAT HAPPENS IF YOU
DON'T TOP OFF THE "WELL"

MILK CARTON

took a little more and rubbed it around on top with my finger. That really did it and it also made the top of the candle (which was about ten inches across) have a really nice sheen on it. Unfortunately, it kind of attracted the lint and dust so that after a couple of days, it began to look like fuzz city. Oh well. It's a good trick to remember if you want to peddle the things, though, as it will really snow the hell out of Old Mrs. Willowby, Prop., The Owl's Eye, Gifts. Here again try experimenting. Somehow the idea of putting all these hydrocarbon imitation scents in kind of turned me off and I always figured it would be nice to put in some real ones. Those little bottles of oil that they sell in the health food and head shops; are they real? I sort of figure that they are, but I'm not sure. How do you get oil out of cedar wood? Anyway they should work fine, but you'll have to do something about the price. I once tried using Dr. Bronner's Pure Castile Soap because it has such a strong mint smell, but it must be water based and there was no mixing at all. It just kind of sat there and sputtered. With all experiments, it's a good idea to try to use stuff that appears to have an oil or paraffin base, but that still won't guarantee success.

When I lived in Colorado I was making a sort of volcanic-looking number that was really great. For a while I used hydrocarbon pine scent which is the best of the batch. (The strawberry doesn't even come close and really turns your stomach.) After a while even that didn't do much for me and I picked a batch of sage brush which has a potent smell. I figured on doing a rugged-type candle with mostly natural components. Ground it in a blender and it was sort of OK, but just too many floaters. Never did get back to that, but I always thought a juicer might bring just the straight oil or I considered solvents like in Marijuana Consumer's Handbook's formulas for extracting concentrated resins from plants. I imagine that there is real room for an organically scented product if you'd like to get into that. Again, if you find out, spread the word; you don't have to work at the Max Planck Institute to add to the ocean of knowledge.

ADDITIVES

There are a bunch of these, but you don't really need them, so I won't go into it except for the main item, which is stearic acid. It comes in crystal form and goes under a variety of names such as Stearic Acid, Louisa's Magic Glow Flakes, Tuff 'n Tall, etc. Triple-pressed stearic acid is the whitest type. The idea is that it raises the melting point and slows burning. Of course, it then does all the things that I talked about under the higher-temperature waxes. It's not too bad an idea if you start off small and don't want to get involved with a lot of wax just to buy one slab of 133 and some stearic acid so you know what the higher stuff is like. It isn't quite the same, but it comes pretty close. I suppose there is some other boring information I should tell you about stearic, like keep it out of reach of children in a cool dark place, or something, but I can't think of anything. Actually, all it is is vegetable or animal fat, or both, and not dangerous.

HOW TO

This I can't tell you. The Rosicrucians can't tell you about that "split second of cosmic truth, " but they can tell you what they did to get there. This article is about what I've done and some of what others have done and some that I've wanted to do, but got all hung up in other things instead. The very first thing I tried was with some pretty nice wax that I got in Frisco. It was down under the highway as you come over from Berkeley, but I can't remember the name or the street. It doesn't matter, for I'm sure that there are places just like it all over that can get you started. Since the wax was nice, if you live there you could let your fingers do the walking and come up with the place. I bought from them a recast slab of about fifteen pounds. What they had done to it I don't know, but it wasn't just the straight refinery stuff. Anyway, after dragging the materials halfway across the country, I finally wound up living in a sort of house, but with a real stove and I got the hots to try it. I'd always kind of liked the sandcast numbers that I'd seen, with the three little legs on the bottom like a colonial cast-iron fire pot, and so I thought I'd start there. Unfortunately, two feet of snow on the ground and no sand. So I tried snow. Fantastic. Not at all like you imagined, but fantastic. The hot wax melted the snow and cut all kinds of channels through the snow which I then let melt away from wax. You wouldn't believe the incredible lacy structure that was left. Not much use as a candle in quite that form, but I could have abandoned wax candles and gone into wax and bronze-from-wax sculpture right there. If you live where there's snow, try this. Try it with loose snow, try it with packed, try it with hot wax, try it with cold; here are four different possibilities right off the bat. Mix sand with it, freeze it, shape it while soft, let it harden and reshape it with a Bernzamatic torch. Glue extra pieces on, break some off. Step on the whole thing and re-fuse it with a little heat. In getting into something, do everything that can be done, has been done, ever will be done, and can't be done. There is no reason why this idea isn't as good for music and drawing as for wax.

Getting the big sheets into smaller pieces so that you can get them into the melting pans is a sweat. I've tried all techniques and first used a knife and sort of ice-picked it to death. An ax worked pretty well, but a lot goes shooting all over the place. Putting a knife or dowel or piece of wood down on the floor and bridging the wax over it works about the best. Then you can just stand on it and it will crack nicely. Smaller pieces can be made by just hitting the piece on the floor at about a thirty-degree angle. Sharp smacks will usually break off about tennis-ball-sized chunks.

If you ever get past this to the wick stage, here are a few possibilities. I first tried putting the wick in first. A hole in the bottom of the mold (snow, paper, glass, metal) and something to hold it straight up. It'll probably leak when you pour the wax in. This can be good or bad depending on

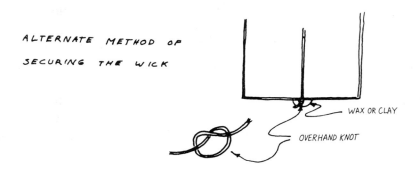

ALTERNATE METHOD OF
SECURING THE WICK

WAX OR CLAY

OVERHAND KNOT

your outlook. One way to solve the leaking problem is to put a little model-
ing clay around the wick where it comes through the hole. Since this stuff
has an oil base it will not contaminate the wick.

Next I tried a coat hanger carefully propped up and pulled out later be-
fore the wax got completely hard--then I shoved the wick down the hole (a
little hot wax kept the thing from wiggling). Fair, but the hole was pretty
small. Next, used screwdrivers. OK, but the end gets stuck if you let it
get completely hard. A smooth rod as big as a pencil and slightly tapered
would be the best; I had one of these but it still stuck and had to be pulled
out at just the right moment. Don't ask when that is, you'll find out. The
one idea that I did get out of that Colorado guy, after he'd laid his ego all
over the place about two feet deep, was to use a quarter-inch electric drill
and make the hole afterwards. One thing I can add to his idea is a bell
hanger's drill. These are drill bits that are made especially for electri-
cians going through thick walls and as I remember, the quarter-inch size
is around eight or nine inches long. They are not the easiest thing to find,
so I would recommend this really for the pros. Also there is the hassle of
the electric drill motor, and of course electricity, if you're camped out on
a deserted island in Maine or B. C.

They make little tin numbers to hold the wick in the bottom of the mold
and these are not too bad, but they don't have any real weight. If you decide
to try these, poke the wick through the hole and tie a knot in the wick to pre-
vent it from pulling out. Place the wick in the mold so that the tin jobbie is
in the center and pour in about a half inch of wax. After this has cooled you
can easily pull on the wick and straighten it out as it cannot pull out of the
wax. Actually just the knot alone will do the same thing, which is the route
that I usually went. The real metal molds sometimes come with an alligator
clip to hold the wick upright. These are fine, but I never really got into the
commercial mold thing, so on that score you'll have to experiment.

One thing I haven't mentioned yet about the wax, related to wicks is the
incredible amount of shrinkage of cooling wax (coefficient of expansion for

you MIT freaks). If you pour a candle into a beercan, without top of course, and fill it right to the top, you're in for a surprise. When it cools it will shrink and form a well. You'll wind up with a sort of funnel-like hole that is about a fifth of the volume of the candle. Now if you've got a wick in there the wax will solidify around the wick and the outside of the beercan first. As the wax cools, it will pull the wick to the side of the well, so that even though you started off with the wick in the middle, now the damn thing is halfway to one side. This is why I like the rod or drill method. If you have to put the wick in first, it's better to keep adding wax as it cools so that no well forms.

Realize that you just don't make a candle in a couple of minutes. You can do your part in about that time, but they take a while to cool. A candle cast in a half-gallon milk container will take about six hours to cool completely. Of course you will get impatient like I did and ruin the first few by trying to take them out too soon, but you'll get over that. The easiest way out is to work in the evening and then the next morning they're ready. A big candle like the half-gallon jobbie will form an enormous well so that will have to be topped off from time to time, so don't expect to just sit back and wait, otherwise you will get that pulling-over-the-wick thing.

One trick to use is to add heavily scented wax to the hole around the wick when topping off. This saves on scent and does the same thing as a heavily scented candle. There's no federal law saying how the finished item must relate to gravity so make the bottom of the mold the top of the candle if you want, or the other way around if you want. So much for wicks into candles, except for the fact that prewaxed wicks seem to work better. Use hot wax for this for better penetration into fibers--easier to light the first time and much easier to insert if you're doing wick-laters. When I say hot here, I mean around 200°F.

I've noticed that sometimes a carbon crud builds up on the wick and tends to change the size of the flame slightly, but it's no big deal. It probably means that the wax was contaminated in some way, but I don't seem to lose much sleep over it.

My next experiment was with uncolored 133 in beercans with designs poked through the aluminum with a pocket knife after the wax had cooled. The light from the flame made the entire thing glow and all the holes became illuminated. Beautiful. Keep a tiny wick on this or you'll get a leak. Then I tried different colors added on top of each other. I'd fill the can up, say, halfway with red and tip it until the level of the wax was at a crazy angle, let it cool and then top it off with yellow. Wick later on this one of course. Four or five colors are nice with this. The wax shrinks away from the mold wall when it is entirely cool, which makes it easy to get out. Also it means that if you wait too long between pours, the new color will find that space and run down and cover the first color. Also, when you add wax in stages if you

COOKBOOK #4

Now you're starting to get into it. You really had better read the whole article now, and don't say I didn't warn you if you try this and wind up with a miserable mess. At least you should read the previous recipes. You've obtained the materials as per Cookbook #3 only this time you've bought several different coloring compounds. We melt the wax just the same way and prepare and hang the wick as in previous candles, only this time we don't heat all of the wax with only one color in it. Melt enough uncolored wax in one pot to do the whole candle and set up a second double boiler outfit. When everything is ready to go, pour off about a tennis-ball volume of wax from the main pot into a secondary pot. This second one is the one that you will add the color to. You really should have a wide glass container as a mold for this one. A four-cup pyrex measuring cup would be great. With the wick all set up in the mold (the measuring cup) dump in your tennis ball of colored

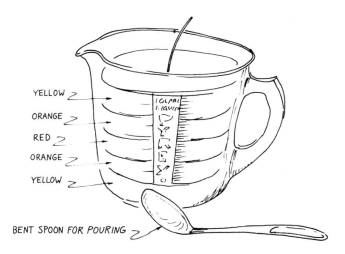

YELLOW

ORANGE

RED

ORANGE

YELLOW

BENT SPOON FOR POURING

wax. Let's say that it was yellow. Pour off a second tennis ball from the main supply and color it orange. When the yellow has formed a cloudy scum on the surface, wait five more minutes. Take a tablespoon and bend the bowl to about a forty-five degree angle to the handle. Hold the spoon just above the yellow and pour the orange into the bowl. Keep repeating this process with red, purple, then red again, orange, and yellow or until the mold is full. With the last color make about two tennis balls of colored wax, but pour only one in. The rest will be used to top off the well (see Cookbooks 2 and 3).

Great, you're coming along fine; oh yes, trim the excess wick to about as high as a hot dog split in half is above the surface of the frying pan.

let it get too cold then the layers won't stick properly which is apt to make Mrs. Willowby distraught. I found that if you've blown it and waited too long then you can actually save it by heating the next layer very hot, which will sort of remelt some of the underlayer and allow a good fuse. Of course, then you don't have a sharp separation of color, but who says that's bad. How hot you actually make it depends on the volume you add and how much volume the first layer had. Obviously if you add a quart of wax at 250°F. to a quarter-pint of cold stuff, it will completely melt the cold and mix the colors. I never did this, because at the time I wanted the layers to show. I'll bet though, that with care you might get the two to only partially mix with interesting convection swirls especially if the color agents are different types. So what if you want a red and yellow candle and wind up with an orange one, it's still going to be nice.

I like to use a thermometer all the time, as it kind of gives me a base of reference and then I know when to pour, add, etc. If you're heating a previously colored wax and can't see the bottom of the pot, you can tell when the wax is all melted by watching the thermometer. The 133 will go fairly quickly to around 140°F. or so and stay there until all the wax is melted. Then you will see an increase in temperature. Since solid wax sinks to the bottom it will be hard to tell how you're doing otherwise. This is especially true when reclaiming wax and sand chunks that you had left over from sandcasting. If the thermometer goes too deep into the wax, then it will cloud the test tube and you can't read what it says. Very hot water, from the tap, if you have it, will clean the wax off the tools and molds. Don't use abrasives, as the tiny little scratches give the wax something to grab onto and it becomes increasingly harder to clean your things. Somehow the test tube broke on my thermometer and I was able to chip the rest of the glass away until I wound up with just the core. Now I use it held in place with the spring clothespins and it works even better, so don't throw it out, should it break.

SANDCASTING

It doesn't need to be sand as I've already mentioned, but let's group all non-mold molding operations under this head. The snow I've mentioned. When I finally got some sand (from the highway department) it had clinkers mixed with it which was the way I got those volcanic looking numbers. The sand was moist with melted snow when I tried it, which turned out to be good. Of course dry sand won't hold its shape. Also if you are using coarse stuff the wax will leak all through it. The wetness seems to help cool the wax and prevent this. Maybe it just allows the sand to pack closer so as to stop the leaks; anyway, a little water helps. Once I cast a candle in a cardboard box which contained the sand and I had so many leaks that the entire box wound up being the candle.

Next--temperature. Pour at 140°F. (I'm always talking about 133° unless otherwise mentioned) and the sand won't stick at all. You'll wind up

COOKBOOK #5

Materials as per Cookbooks 3 and 4, plus some scenting agents. This time we're going to make a candle with more than one wick and so we need a fairly fat mold. A dog dish, stainless mixing bowl, or something about eight inches in diameter and smaller at the bottom than the top would be suitable. Revere Ware pots are OK, but because of the straight sides they make it more difficult to get the finished candle out. What we do this time is to heat the wax according to Cookbook #4 and create small amounts of differently colored wax as before. Only this time we need golf balls rather than tennis balls. Don't worry about the placement of the wicks yet, but do prewax them as in #1 and set them aside to harden. We will need three separate wicks. Tie the weight on the bottom prior to prewaxing and make sections about eight inches long each. Pour a golf ball of yellow melted wax into the dog dish and quickly pick up the mold and tip it first one way and then the other. Cool wax is best, and a cold mold will work easier. The object here is not to completely coat the inside of the mold but rather to have an open effect with lacelike swirls and blotches. After the yellow is completely cold, repeat the process with red. Then blue, green, or whatever colors you decide on. The idea is to wind up with the inside of the mold completely covered with about four different colors so that when you take the candle out it will have a four-color marbleized surface. The actual swishing around of these first layers will take a little practice, so don't get discouraged if the first one doesn't look quite right. With the swirled layers all in and cold, then you can proceed as in Cookbook #2 with the filling. If the scent is liquid in a small bottle, just dump it into the rest of the wax now. If it is a wax-type lump, throw it in now and allow it to melt. Just add uncolored wax for the core, as the outside is already colored and you don't need to waste the coloring agent on the center. Also the flame will light the uncolored core and cause it to glow. If the outer, colored layers are thin enough the light will glow through them creating a stained-glass effect. The core must

be poured rather cool, though, otherwise the great quantity of hot
wax in the middle will remelt your outer coating and you then have
nothing. To get the right temperature for the core-pour, take the
pot out of its water pan and let it cool until there is a skin on the top
that is thick enough to keep a lead pencil when held point down from
poking through. Arrange the wicks, poke a hole in the skin and
make the pour using only the liquid wax. Top off the well as in
Cookbook #2, trim the wicks to a pea-and-a-half high and you're
finished. Oh yeah; the wick arrangement. They should form a
triangle, with the wicks about two inches from each other and the
triangle centered in the dog dish. Of course they must hang
straight down.

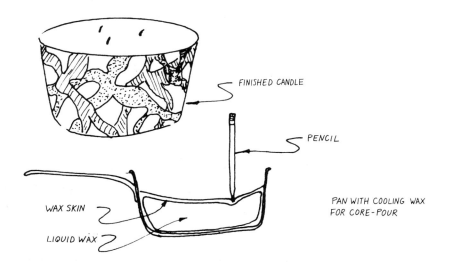

FINISHED CANDLE

PENCIL

WAX SKIN

LIQUID WAX

PAN WITH COOLING WAX
FOR CORE-POUR

with the shape of the sand and zillions of tiny air bubbles and no sand. Pour at 260O and it'll leak all over the place. I found with a damp mold 200O seems about right. Probably sand from Provincetown is quite a bit different from sand supplied by the Colorado Department of Highways, so play around. At 200O I got good adhesion and varied penetration from a half-inch to one-and-a-half inches into the sand. At first I used to clean them by brushing and brushing till most of the loose stuff was off, but they still shed. Then I discovered that by dipping the whole candle into a batch of scrap wax quickly at around 180O the outer grains were held securely and also given a gloss with the outer coating.

This is my favorite area so you'll have to bear with me as I devote most of my time to it. I thought I was doing some nice stuff with this until I saw some other guys' things. But first I have to digress a bit about the making of nothing: in other words, the hole into which you pour the wax. Anything goes. I shaped by hand at first. This should be good if you're using Provincetown- or Big-Sur-type stuff. Mine was too coarse and I needed some packing to keep the leaking down, so I got into putting a plate into the box, then a liquor bottle on top of the plate and packing the moist sand all around. Pull out the bottle and you've got it. The plate gave a smooth bottom and kept the candle from scratching beautiful tables in Elizabeth. I still like the hand forming though. Trouble is that the bottom is apt to be uneven and there isn't really much to rest it on. Easiest way to get around that is to poke your fingers down into the bottom of the mold three or four times. This gives it feet to sit on. If they're uneven, careful paring down with a knife later will fix it up.

Anyway, this other guy had done that. His candle was oval, about four by eight inches, and very shallow, maybe only two inches deep. It was a two wick job, wouldn't last too long because it was shallow, but so what. Off to one side there was a very smooth beach pebble only half imbedded in the wax and looking kind of like a Japanese sand garden. Really beautiful. Along one side, which evidently had just been laid along the inside edge of the mold before casting, was the jawbone of a deer. Sounds kind of weird, but it was just right. The bone was pure white with a slight grainy texture from weathering, and the rock was flawless. A light lemon-colored wax kind of set it all off. One night in the spring we all got stoned and burned it. Amazing.

What about sandcasting combined with other techniques? Ever seen the ones where they form separate bodies for the various wicks and then with tunnels or channels in the sand connect them all together? They don't have to be all at the same level either. There could be waterfall-type numbers. I always wanted to get some heavy, crude wrought-iron rings and bury part of them into the sand so that the iron and wax would be combined. Then leather straps maybe, but that's old-hat now. I've always dug mixed bags. In the true spirit of phony imitation in America, I faked the sandcast number in order to try to reduce the waste through leakage by putting the sand direct-ly into some wax and then applying it around the outside of a mayonnaise jar

that I had already filled and wicked. It was fine and had the advantage of being refillable. Did you ever make drip castles on the beach with wet sand? Why not try this with candles? I imagine great pagoda types soaring up and up. It's funny when you think about how important the wick is to Mrs. Willowby. How about those Santa Claus candles that people used to give your mother and she never burned? They bought them because they were candles, not because they were little statues. You can see a really nice construction a couple of feet tall made of wax, sand, shells, iron, etc. "Oh! That's lovely, what is it? Not a candle? Well thanks anyway, we're just looking." Stick a couple of bits of string here and there, call them wicks and you couldn't keep up with the volume at $50 per. And chances are, no one would ever try to burn it anyway.

So much for sand, but don't forget such things as powdered coal, Styrofoam beebees, or a box lined with leaves, and grass. (Feathers?)

RIGID MOLDS

Glass, tin, paper, plastic. All these work and others I haven't even thought of. Probably--at least with plastic and paper molds--but not necessarily, you are going to want to get the thing out. (How about my mayonnaise jar?) If the candle is to be left in the mold like the perforated beercan, no sweat, just fill it up and you're home. Luckily, because of the shrinkage of the wax you will be able to get it out of most smooth hard molds: glass and metal. Aluminum beercans, you just peel away. Paper, ditto. Milk cartons are widely used and are fine, although the sides tend to bulge in or out. If you don't like that, put the carton in the sink with water and the walls will be straight. Metal and glass molds will give a shinier and smoother wall finish if you put the mold briefly into cold water right after pouring. To help get the wax out of the metal molds, there is a silicone spray release, but I haven't found that it is really necessary. Most of the molds are quite tapered, and the shrinkage breaks them free. If you do have trouble getting a candle out of the mold and it's not one that you want to destroy for the sake of the candle then usually dipping the whole thing in boiling water for a little while will soften the wax just enough to let the candle slide out nicely. With glass, such as liquor bottles and so on, all you have to do is break them gently. If you bruise the candle while breaking, you can cover the "shattered" spot by dipping in hot water or torching briefly. Or hold over the gas stove and let the burner briefly wash the wax. Mixing bowls, dog dishes, anything goes. Clorox bottles and the other plastics are OK, but sometimes you will get a strange effect when the heat from the wax starts to make the thing melt and sag. If it looks like you're going to get into trouble, lower it into the sink to quench it.

Glass is especially nice for different colored layering because you get some idea of what you're doing. It's also very cheap, and just a little messy. I find that when making the layered ones, I like to wait until just

after the wax has skimmed over then add the next layer by pouring into a spoon held close to the surface of the underlayer. Otherwise, the new hot wax will puncture the old and you get nothing. By doing it as soon as possible you aid the adhesion too. There are plenty of things to do besides just filling the molds up. Try pouring in just a very little wax at around 160°F. and tilting the mold in all directions as you go. Then dump it out the same way. This will give lacelike tracings on the outside. Do it several times with different colors, or once with solid or layered center bodies. This is a popular item right now, but not too many are very well done. The trouble is that with the commercially available molds, you just can't see what is happening. Don't forget that once you've laid this delicate stuff down on the inside of the mold (the outside of the candle) that too hot a core-pour will wipe the whole thing out.

TRICKS

Ice from the refrigerator in a milk carton does kind of an interesting thing. The wax will fill up the spaces between the ice and of course will melt it a fair amount at first, but will still give a very lacy structure. You can then either call it quits at that or dump out the water after it has melted and the wax hardened and refill with clear or a different color. An easy way to solve the wick problem with the ice casting is to put a commercially-made taper in the middle of the mold first. Or you can put in one of your lumpy hand-dipped ones.

Dipping consists of building the candles up by repeatedly lowering them into a pot of wax at around 145°F., allowing them to cool and dry between dips. You can dip in several different colors and maybe carve into the finished item, revealing hidden layers. Or you can dip in one color enough times so as to get a reasonable thickness; then dip in another color, leaving some of the previous color exposed, etc. You can make more than one at a time by bending a strand of wick in half and dipping both ends into the wax--making two candles--or you can drape the wick over a stick, along with as many other wicks as you want and make many candles at once. Don't ask me how to get these hand-dipped numbers perfect, because I haven't the foggiest idea. Mine always came out pretty bumpy and crude, but I kind of liked them that way. There has to be a way to make them perfect, but I'll leave that up to the Black Forest experts.

Another favorite trick used to be to whip the wax as it was freezing and produce a thick air filled foam that can be kind of gopped around like a frosting. A friend of mine once made a really nice candle by casting different colored layers in a milk carton and then cutting down through the layers from top to bottom afterwards and reassembling by heating the two surfaces over the stove and resticking them together. This produces separate color cubes that look great and have no relation to the pouring process, so it's

very different. Here's another version of the same idea but even more frag-
mented. Go back to your childhood and try blocks again. Make up some
batches of different colored waxes and cast them into flatish molds like
pyrex baking dishes and bread tins so that you get wax around an inch deep.
After they have cooled and you have removed the slabs, cut them up into
blocks about an inch on a side. By stacking the different colored blocks up
you can make something really nice without having a molded look at all.
The wick on this can either be put in afterwards, or you can make the candle
in two halves and lay the wick between and stick the pieces together sand-
wiching the wick in the middle.

Glued together types have a tendency to look a little poor around the
joints so it is a good idea to torch them. Gently wash the bad areas with
the Bernzamatic torch, and with a little care you can fix it right up. The
wax that the torch melts will run, of course, so you have to keep the piece
moving to prevent drips.

Another idea for things to do with the torch is the partial destruction of
the candle after it has been removed from the mold. For instance, you
could make a layered one that alternated high- and low-temperature waxes.
Then by torching carefully you could melt out some of the softer wax which
would run and cause nice drips. This would give the finished product a nice
eroded look.

Should you want to improve the gloss of any candle that has become dull,
either by torching or because of a poor mold surface, there is an easy out.
Heat the entire surface of the candle to around the melting point or just be-
low, either by washing the candle with the torch or by dipping in hot water.
Before the wax has a chance to cool and cloud, dip it in cold water and
SHAZAM! Super Glowcoat Johnson's shine.

This just leaves a tip or two about colors and scents. If you wait until
all of the wax has melted before you add the color, it's easier to see how the
melt is coming. I generally just keep basic colors and mix my own non-pri-
mary colors like paints. This is easier on inventory, but you can just buy
the different colors or crayons. Keep separate pots going for different
colors and it will give you more variety and chance of unusual expression at
the time of pouring. If you want the candle body to glow from the light of the
flame, then you will have to go easy on the color. A transparent effect is
needed here, and too much dye will prevent the light from coming through.
With scents, add them at the very end, so that the aroma will not be cooked
off.

If you want a glue to fasten things onto the wax, shellac seems to be the
best. All my big candles used to go out with a felt bottom on them with a
woodcut inked design on the bottom giving the whole product a slightly more
finished quality. This hides any uglies you might have on the bottom too,

COOKBOOK #6

This candle will not be substantially different from Cookbook #3, but will look quite different. For a mold this time we are going to use damp sand. You can get a bucketful from the beach, local golf course, or highway department. Construction firms that handle cement will have it too. Obtain the same materials that are required for #3 and use a scent, too, as in #5. Let's use only one wick and keep the candle the size of a grapefruit so that there are no undue problems. Melt down in the double boiler a substantial amount of extra wax, say, two grapefruits and add color and scent. Of course, you have already prewaxed and prepared the wick. Make sure the sand is damp--not wet, and not dry, just damp--so that when you make your grapefruit-sized, round-bottomed hole the sides will stay in place. Take your finger and poke it into the bottom of the hole three times about an inch deep in the sand forming a triangle, so that the finger holes are about two inches apart. Now you must heat the wax to 200°F. Use a deep-fat or candy thermometer to check this. Plus or minus five degrees won't hurt. Arrange and support the wicks in the center and, when the wax is ready, pour it in. Keep topping off the well as in previous candles and then give at least six hours to cool. Dig out the candle and brush off the excess sand. Get a pot of boiling water and dip the whole candle in (holding by the wick) and hold for about three or four seconds then dip into a pot of cold water. Trim the feet so that the upper surface is parallel to the table and trim the wick half a paper match high (a half inch, naturally).

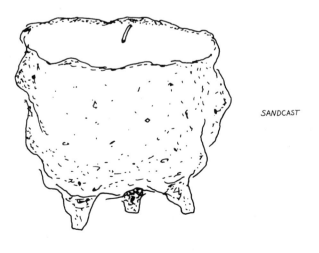

SANDCAST

like trouble with the wick. At first I stuck them on by just using the iron and having the heat melt a bit of the wax so that the wax grabbed the upper fuzziness of the felt. Too much heat would just have the molten wax saturate the felt which looked awful. Trouble was that the felt would come off pretty easily, until a friend put me onto the shellac bit. Elmer's glue etc., just won't work at all because it won't stick to the wax. Decoupage and all sorts of stuff become possible knowing this trick, but just remember that this is not wax work, but after-the-fact cosmetic stuff, which really doesn't have much to do with candles.

ON TURNING PRO

If you get into the wax at all, it is very likely to happen without your having very much to do with it. By the time you've given away all of the first slab, there'll be someone who wants to pay green. By the end of the second or third slab you'll have discovered the kind of stuff that appeals to you and the direction you want to go. Can you make a real thing of it? If your stuff is good, and I don't mean just professional and slick looking, it will no doubt sell--providing you have nice scents. All shopkeepers want scented candles, so don't waste your time taking them around if they're not scented.

But selling in the quantity that you need to do in order to quit driving cabs and stocking at the Radio Shack, that's a whole 'nother number. There's consignment and outright sales. Consignment means that you only get the bread if they sell, nothing if they just sit there, and most likely this is the way you will begin if you live in a smallish community. The price break for commission is two to three. If the shop buys outright you get 50 per cent. It's tough to wholesale after you've sold to a few friends at retail prices, but don't sweat it. Chances are you've been selling too cheap anyway and you'll get more than you think. Besides, the material investment is so low that you're not being squeezed. Bigger and more established shops in the suburbs will buy outright if they are interested at all. Don't be discouraged if they won't talk to you. Remember, they're into a pretty heavy money scene with mortgages, insurance, predicted first-quarter sales volume, and all that jazz.

Another thing is to go to the gift shows where the buyers come, or find an agent. This means a little less bread but in many cases it's worth it to eliminate the hassle of sales. You can then put your mind to making the stuff and actually produce more and make more. Breaking in is the tough thing. Once inside the magic circle, no sweat. You'll find out the type of thing that's moving and who is selling it and how much. I know a guy that was doing OK stuff in Aspen, but it wasn't really moving at three bucks. Just for kicks, the shop guy moved the price up to $5.50. They started to go. Weird things happen! Don't knock it if it pays the taxes on the farm, the tractor repairs, and the fencing for the goats.

As for producing in greater volume, the first thing is to get a better source of raw materials. First, apply to the State House for a tax-exempt sales number. This puts you formally in business and allows you to buy direct from the places that say "wholesale and trade only." Suddenly the wax is down to 15 cents a pound and the scents and colors drop accordingly. Maybe you'll want to get your accessories directly from a chemical supply outlet. A good one is McKesson Chemical, 5353 Jillson St., L. A. They have an office in New York too. The only problem here is that they have minimum orders in the neighborhood of $50. Most wholesalers have this policy. McKesson will sell scents in big bottles and powdered uncut dyes that are fantastic. As much powder as you would put sugar in your tea (none I hope, but some of the honey when you pick up the beeswax) will literally cover the entire inside of a good-sized room. Wicks you'll get by the spool and the whole thing will fall together. With larger volume, you'll have to set up a studio out in the old carriage shed. Don't use the barn, 'cause it's not fair for the animals with their better noses to have to hack the scents and wax smell. Get a hood over the stove if you can afford it. I don't know what paraffin vapors do the lungs, but I'm sure it doesn't help them any. Buy a $15 thirty-six-inch gas range with at least four burners. If you're lucky, you can find one with six or eight. Put a shut off valve on the main gas supply line that can _easily_ be reached and get a couple of heavy-duty fire extinguishers.

I got an old gas hot-water heater from which I cut the top with the welding torch. This thing is beautiful, for it has a thermostat on it and it's impossible to overheat the wax. The other thing is that you don't have to frig with the sheets. Just put them in as they come from the carton. A thirty-gallon hot-water heater cut down so that the inside is about twenty inches deep will be perfect. This will melt 150 pounds of wax and keep it at whatever temperature you set it at. Generally the range of the thermostat is from 140°F. to 180°. _Do Not_ try this with electricity. First of all, it is bad ecology, as it takes four times as much world heat reserves to do the same job as gas. Also, wax shrinks when it cools, remember? Therefore it expands when heated again. If you have a full heater of cold wax, the electric element, which is in the middle of the tank, will not give the molten wax any channel to expand into. In other words, an explosion of hot wax, which is not too cool a thing to experience. Gas heaters have a chimney coming up through the middle which gets hot and melts the wax surrounding it. This provides an expansion channel from the bottom. Thirdly, if the level of the wax should get below one of the electrical elements, it would just burn up and probably ignite the whole mess in the process.

You'll have to put a couple of bricks or something in the bottom of the heater, because the temperature-sensing element for the thermostat is a thin tube that is raised off the bottom. Should you drop in a full sheet and have it hit this relatively delicate item, you'd be in trouble. Just build up some bricks on either side of it to protect it. When you want to make a

COOKBOOK #7

This candle will not be cast, but will be constructed. Gather the standard materials and pour some scented wax into ice trays with the dividers in. These should be metal, with metal dividers, and each tray should be a different color. After the trays have completely cooled remove the wax by lowering the tray right side up into a pan of hot water for about fifteen seconds. Remove the individual cubes from the divider by dipping the whole thing in the boiling water for about five seconds and then carefully wiggling the metal and teasing the wax free. Try again as it may take more heat, but be careful that the wax cubes don't just fall off and go floating around in the hot water. Next put a little melted wax into a shallow pan double boiler. This is your glue. Begin assembling by taking a cube and dipping the surface into the glue that you want to stick to another cube. Push together and hold for a few seconds. The thing should have about the same width as a quart milk carton when finished, so the bottom should have four or six cubes in it. Use your imagination and mix the colors and don't try to keep the sides flat, let the different cubes stick out different amounts. Also, don't worry about gaps, because as the flame melts the wax, it will run down and clog up the holes. When it is all assembled, heat a number eight knitting needle directly on the burner and push it straight down the middle of the candle as far as it will go. Take it out, wipe off the melted wax, heat again and push in again. Keep doing this until you get the hole all the way to the bottom. Insert your stiffened wick, add a little new melted wax around the hole with a spoon, and trim the wick. If you managed to pull this off you can do anything mentioned in the text, and I'm sure some others besides.

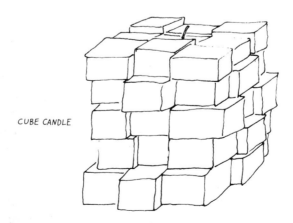

CUBE CANDLE

candle, all you have to do is just draw off some wax, add color, scents and you're home. I like to keep just unadulterated wax in the heater and add my stuff later. This way I can control colors and temperatures on a manageable scale on top of the stove.

My only other gimmick is a sandcasting table. This is, roughly, a table with the bottom twenty-four inches off the floor, sides that are fifteen inches high, and about twelve feet long. The whole mess is about three feet deep from front to back and is divided into three different sections for different types of sand.

EQUIPMENT

This is one of the beauties of wax. All you really need is something to pour it into and something to melt it in. The thermometer that I talked about before will help a lot too, but even that is not really a must (but be careful!). Pots and pans can be just the regular kitchen ones to start. Since the wax can easily be cleaned out, it really doesn't hurt anything. Just use plenty of hot water and some soap. If you get into it very deeply, you'll need a separate set of junk because you'll want to leave the pots half full, ready for the next session sometime. It's kind of a messy deal if you get to doing wild things and so I recommend newspapers on the floor. The Berkeley Barb works fine. For pots and pans, the local thrift store or Salvation Army or Goodwill store is the place. Anywhere from a nickel to a quarter for pans. I like three- and four-quart saucepans. One bigger one is good for the larger stuff. If you're pouring much, it is nice to have coffeepots because of the spout. Aluminum water pitchers work well too, although I paid a whole nickel for one only to find it had a leak where the handle was fastened on. In any case, don't use the coffeepots with a strainer type spout. If they have that, just take a pair of metal shears and cut that part out including the rim and that point in a V. If you are pouring cool wax it will freeze in the strainer and then you have no more spout. A big campfire-type enamel coffeepot is great, but they are getting rather scarce. So much for melting gear. For pouring into, you need molds. These are dealt with under the how-to heading and so I won't go into them here. If you really feel the need for commercial molds, and I can't talk you out of them, the local hobby supplier will be able to help you out. They come in all sorts of ugly shapes and sizes. Could you really dig a sixteen-inch, tapered, star-shaped mold?

I'm sure you'll come up with some neat inventions, but don't get too gimmicky. I know potters who have great studios, but don't make any pots. Remember, the craft is subservient to the art. Technique never produced any great art.

Crochet
Shelagh Young

"A propensity for crochet work has kept many
ladies from the streets and the river. . . ."
 Aleister Crowley

Crocheting always seemed a great mystery to me. I wanted to learn a long time before I actually did. I would sneak furtive looks into newsstand magazines and instruction books, only to find sentences like: "2 ch 1 tr 3 ch 2 tr into 3 ch sp at corner, 3 ch 1 dc sp. . . ." This mystical language would make my palms sweat, and I would slip quietly back to the sidewalk. One of the things that I've found out since is that anyone can crochet.

This is the craft whose versatility knows no bounds. With almost any material, using different combinations of a few simple stitches, one can go on to make practically everything. Crocheting provides the quiet pleasure, under the guise of concentration, of being alone with oneself. And, of course, there are so many pockets of time in a normal day--little spaces that can be spent productively: waiting for a turn in the outhouse, coffee breaks, waiting for the phone to ring, the bread to rise, the snow to melt, or the ambulance to come, not to even mention the time riding on buses, cars, and trains. Crocheting can be an aid in giving up smoking. It is totally portable. One hook, a supply of yarn, and the work in progress can always be tucked somewhere into one's trappings.

Crocheting in public always arouses friendly curiosity in all kinds of strangers. All this, for an initial investment of less than one dollar!

The basic requirements are the following:

1. Two willing hands. (These instructions are aimed at right-handed people. All others will have to be more resourceful. Hold the book to a mirror, or something.)

2. One hook, fairly large to begin with. About a size G would be good.

3. Some yarn, or other suitable material. (Two- or three-ply wool worsted, or soft string would do nicely.) It is best to begin with some substantially thick string or yarn, strong enough to bear the beginner's inevitable pullings-out. It will be faster and easier to work with, and you won't feel as if you're fussing with knots of microscopic importance. This preliminary yarn should also be of a uniform thickness, without exaggerated lumps or bumps. Later on, uneven textures become easier to handle.

And while on the subject of yarns: Department stores generally have nasty, uninspiring yarns. There is usually a poor selection of baby-bland or aggressive colors, and they are often expensive. Sometimes shops have bins of odd balls. It is wise never to pass one of these by without exploration, because often something unusual, some weird yarn that nobody else would buy is tossed in there at a reduced rate. But the absolutely best

sources of yarns are the companies that do mail-order sales to weavers. They will send out samples charts and prices. You buy yarn by the pound, which is much cheaper. These companies come and go, but the most solid ones I know are:

The Village Weaver
8 Cumberland Street
Toronto, Ontario, Canada.

The Lily Mills Company
Handweaving Department
Shelby, North Carolina, 28150

Ayotte's Designery
Centre Sandwich, New Hampshire, 03227.

Yarns are cheerful friends. They are never wasted. Every project that is, for some reason, abandoned, can be undone and reused. Even a hopelessly tangled mess is good for wiping up spills.

Plenty of people tell me they have no trouble with patterns. I can't say. I can't remember using one myself. These instructions will equip anyone to follow a pattern, though if you can devise for yourself, so much the better.

A journey of a thousand miles begins with a single step.

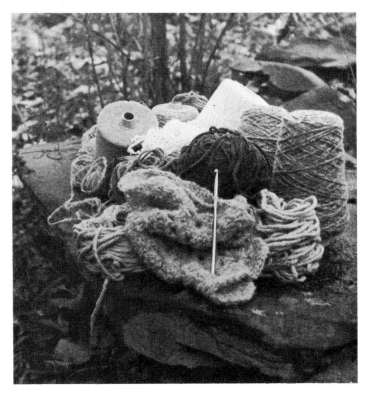

Hands

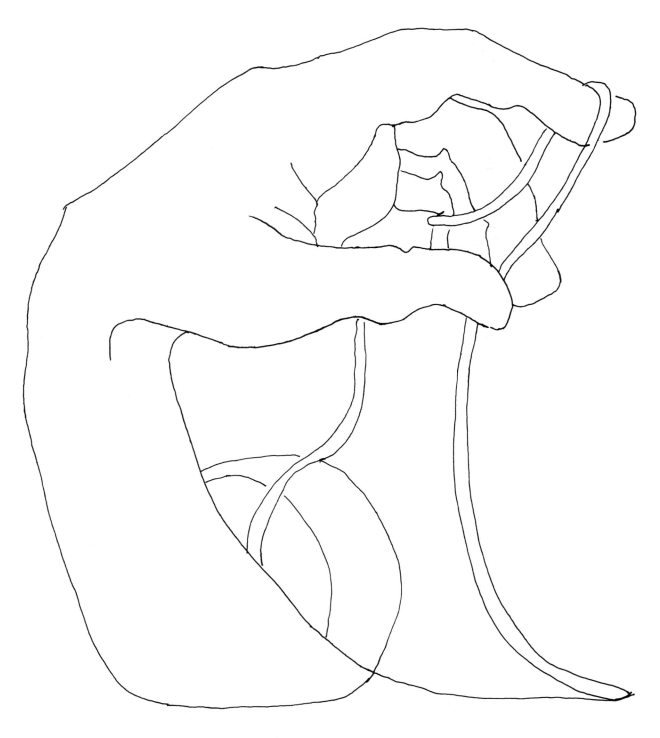

Working

Working

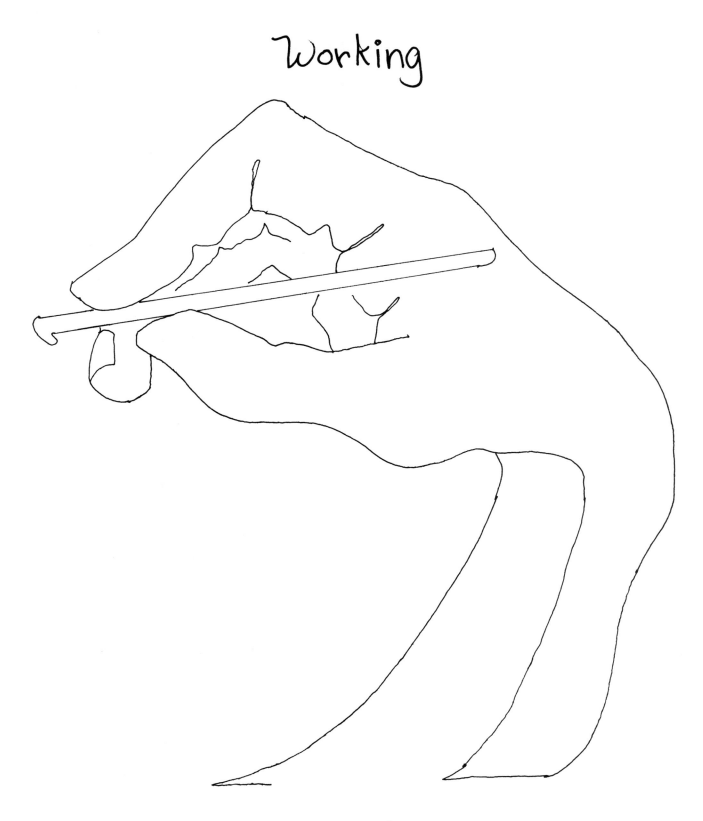

Hands

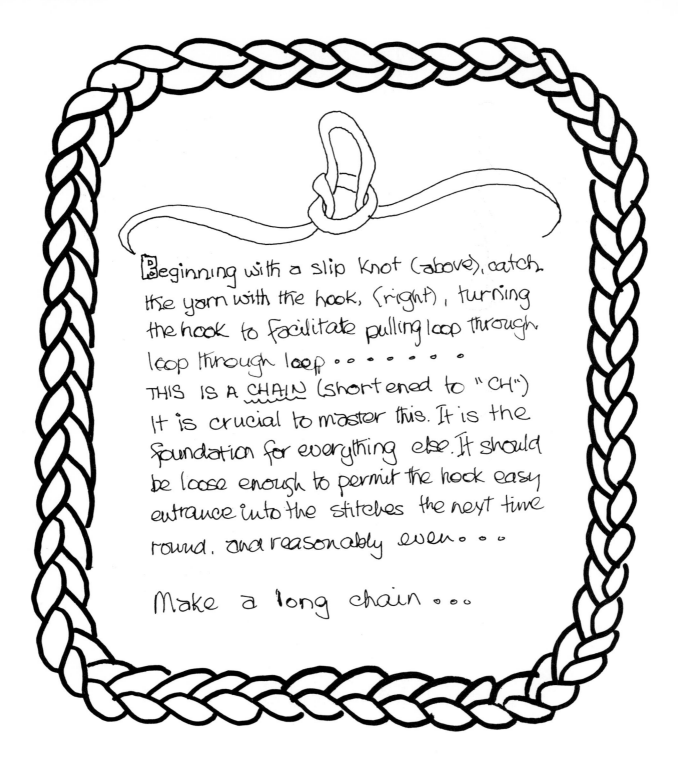

Beginning with a slip knot (above), catch the yarn with the hook, (right), turning the hook to facilitate pulling loop through loop through loop ○ ○ ○ ○ ○ ○ ○ ○
THIS IS A CHAIN (shortened to "CH")
It is crucial to master this. It is the foundation for everything else. It should be loose enough to permit the hook easy entrance into the stitches the next time round, and reasonably even ○ ○ ○

Make a long chain ○ ○ ○

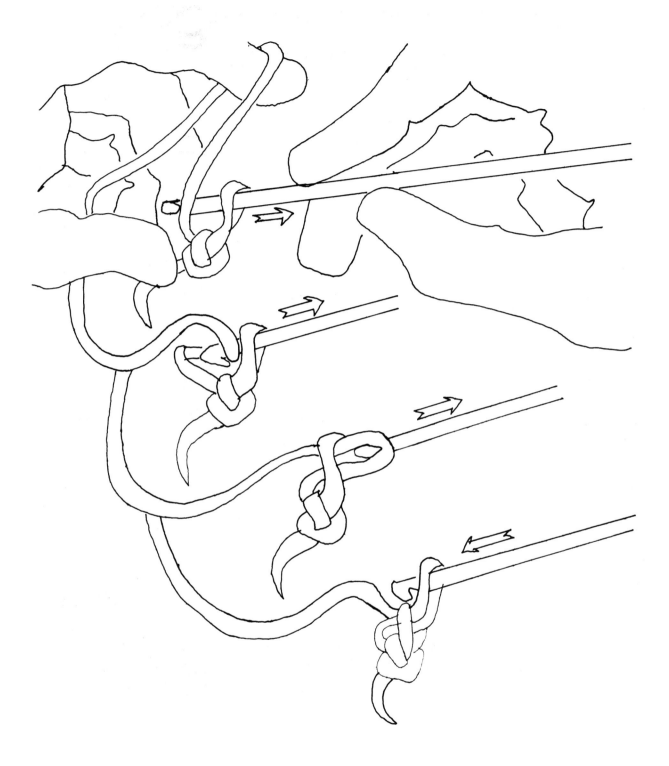

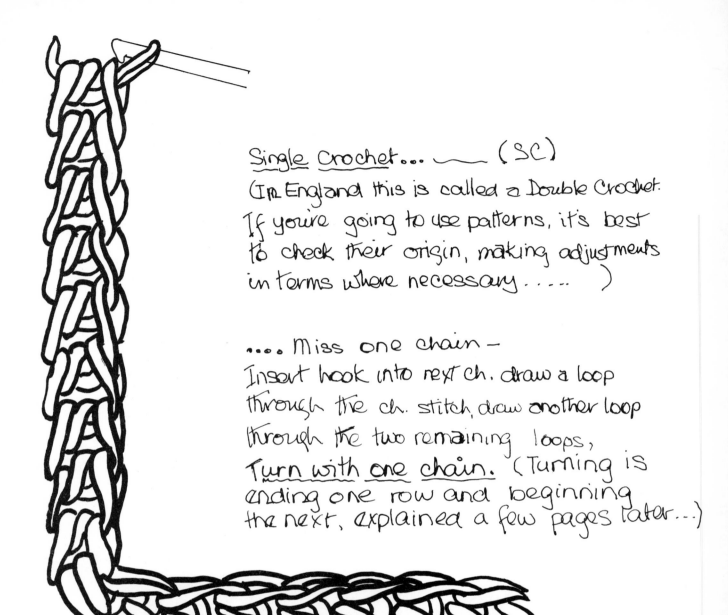

Single Crochet... ___ (SC)
(In England this is called a Double Crochet.
If you're going to use patterns, it's best
to check their origin, making adjustments
in terms where necessary.....)

.... Miss one chain —
Insert hook into next ch. draw a loop
through the ch. stitch, draw another loop
through the two remaining loops,
Turn with one chain. (Turning is
ending one row and beginning
the next, explained a few pages later...)

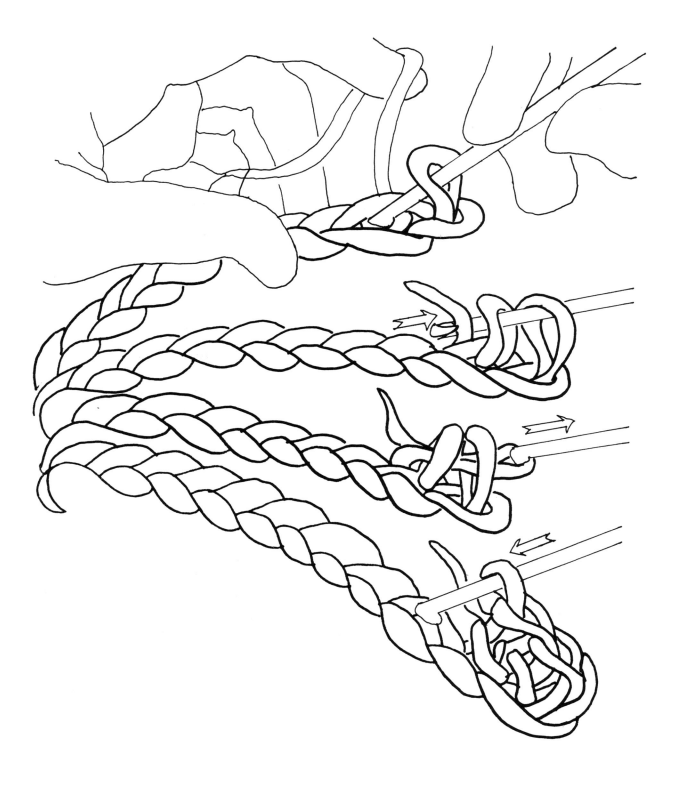

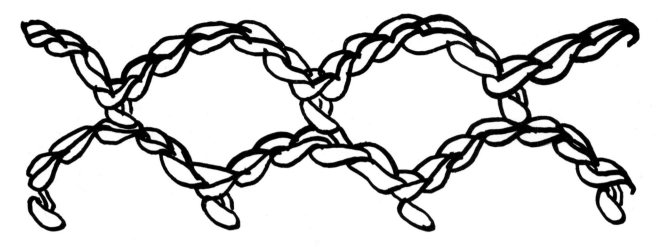

fish-net Stitch...

Make a long chain.

Single crochet (sc) into the third ch from the hook.
Chain 5.

Miss 3 chains. sc in the next,

At the end of the row, chain 5, turn.

I sc into the centre stitch of the 5 ch loop, chain 5,

I sc into the centre of the next 5 ch loop. etc...

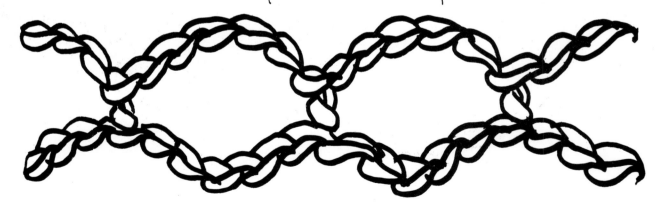

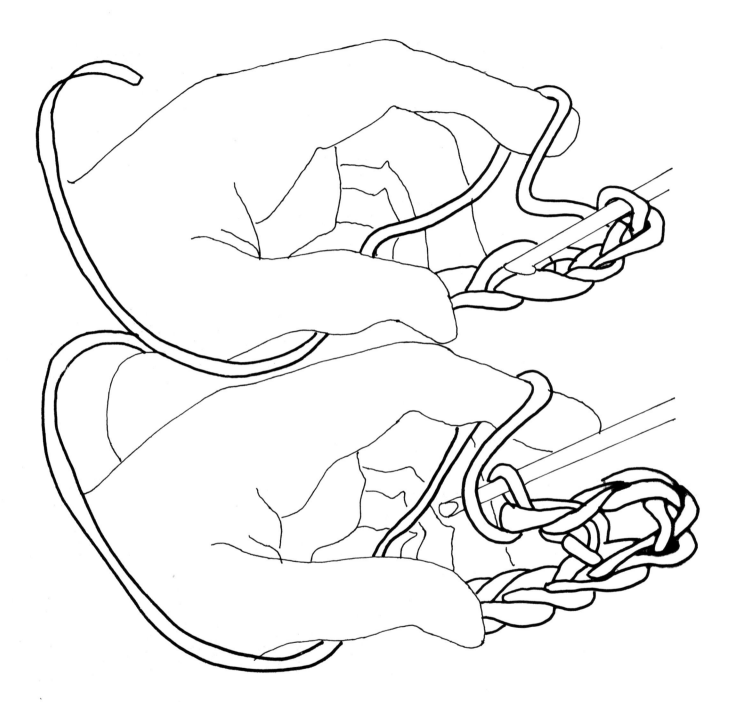

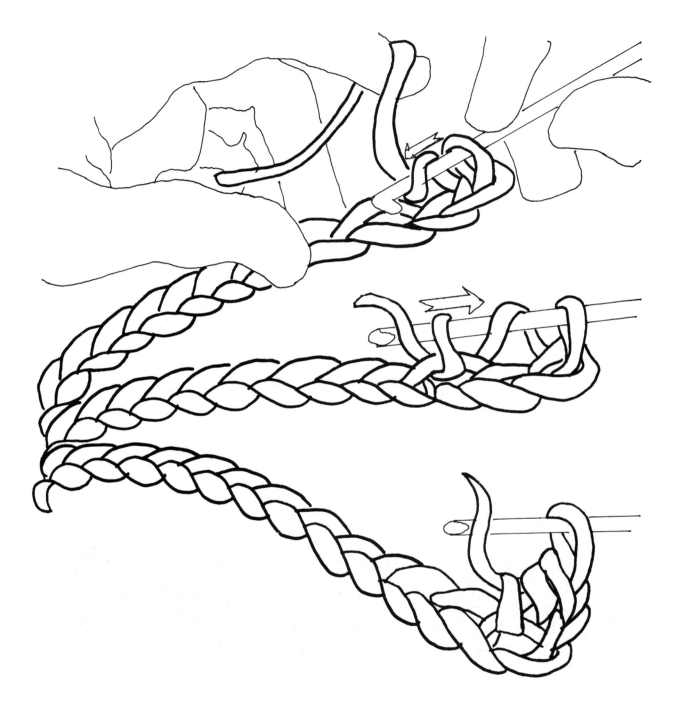

Half Double Crochet (HDC)
(English Half Treble Crochet.)

Miss 2 chains.

Draw a loop through the next chain stitch.

Draw another loop through the three loops

on the hook.

At the end of the row, chain 2, to turn...

(This is explained further next page...)

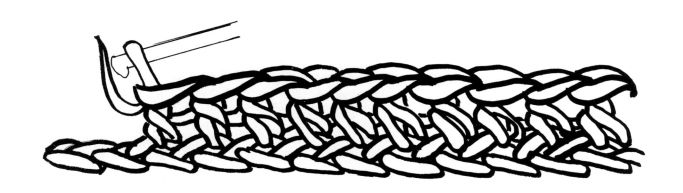

TURNING

At the end of the row, chain two.

(For a row of single crochet, you would chain one.)

The idea is to bring the beginning of the row up to the
level of the row. These two chains form the first
"stitch" of the second row.

Turn the work.

Now a regular stitch is made into the top of the previous
row, one into each stitch

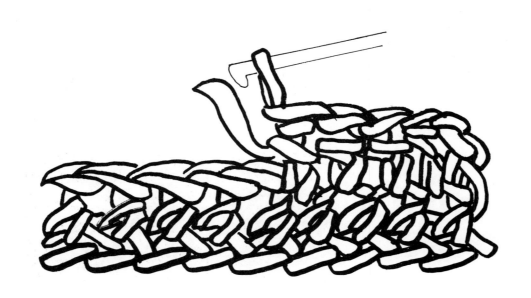

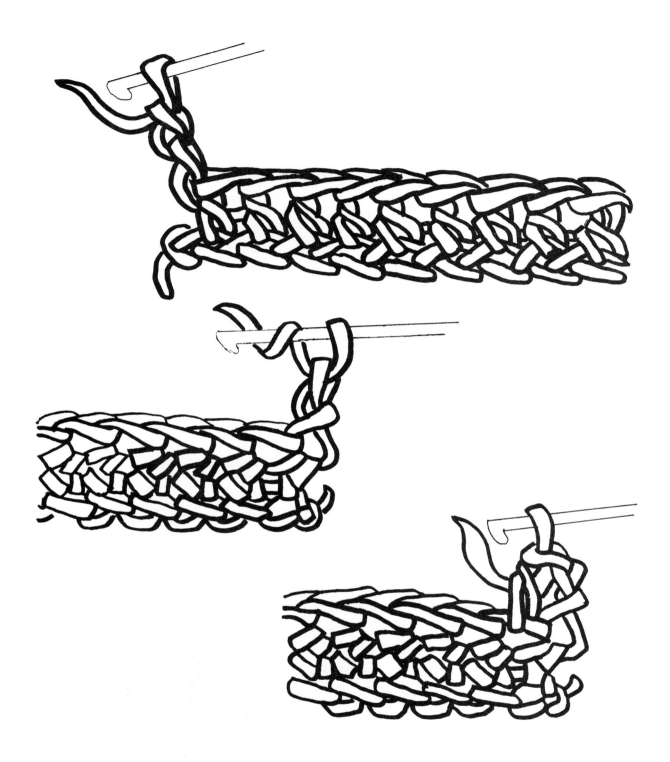

Double Crochet (DC)
(English Treble Crochet)

Miss two chains.
Draw a loop through the next chain,
another loop through two loops,
and another loop through the last two.
Chain 2 at the row end, turn.

This stitch is invaluable.
In infinite combinations and groupings,
literally everything
can be made with it...

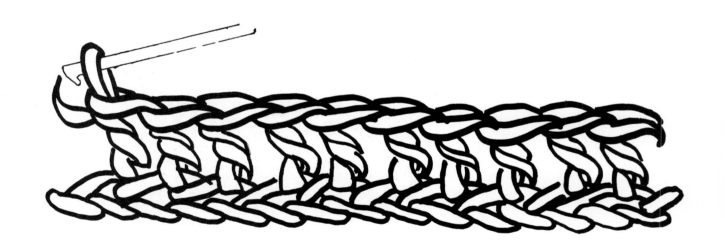

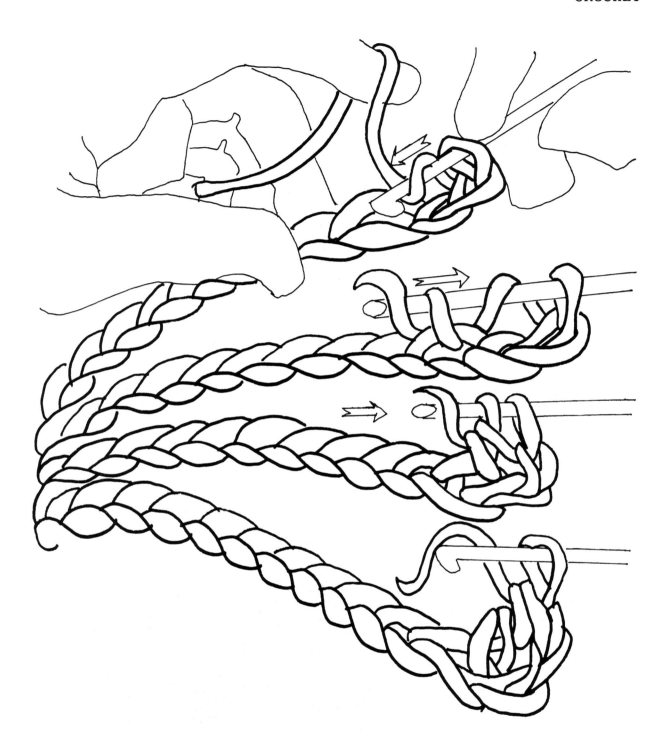

Clusters.

Miss two chains.
Do two double crochets into the next ch. stitch.
Miss two chains.
Do one sc into the next ch. st.
Miss two chains.
Do three dc into the next ch. miss2, one dc, miss 2, 3 dc.
into the next ch, etc....
Chain 2, turn, Make 2 dc in the first st, join with a sc into
the centre dc of the previous row, 3 dc on the sc, etc...

Finding this basic pattern was like Discovering a Great Truth.
I went about applying it everywhere, making everything with it.
It wore well.
It is still one of the pillars of my repertoire.

There are infinite variations on this.
Experiment with some, 2 TR. 1 ch, 2 TR 1 ch, etc.

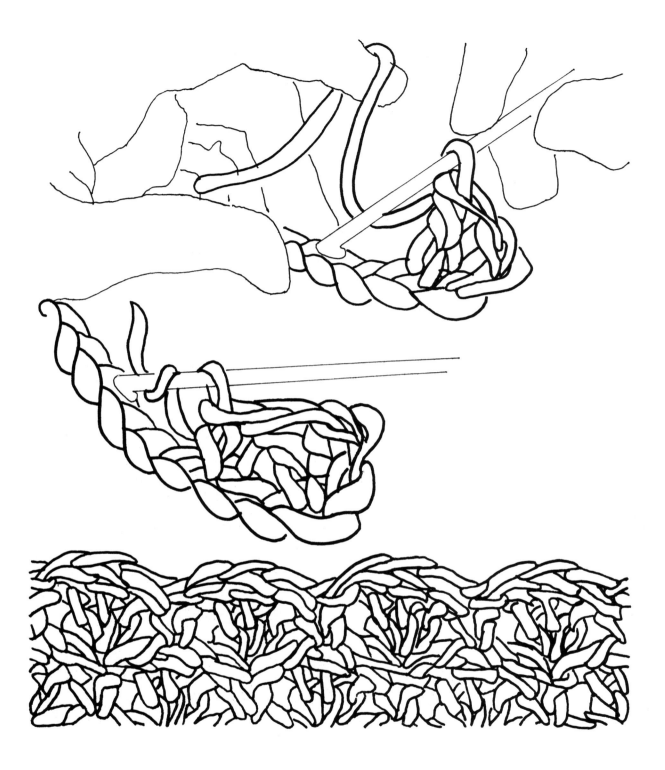

Treble Crochet. (TR.)
(English Double Treble.)

Miss 3 chains.
Wind the wool around the hook twice.
Insert the hook into the next chain,
Draw a loop through.
Draw another loop through 2 loops.
And another loop through two loops.
Then another through the last two.

At the end of the row, chain three to turn.

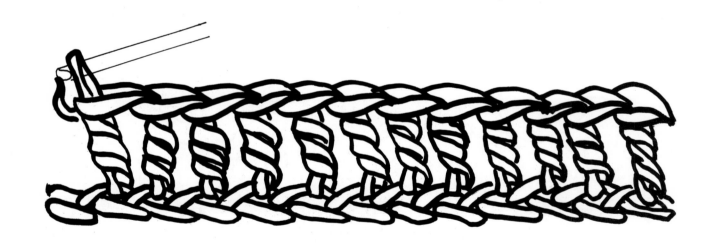

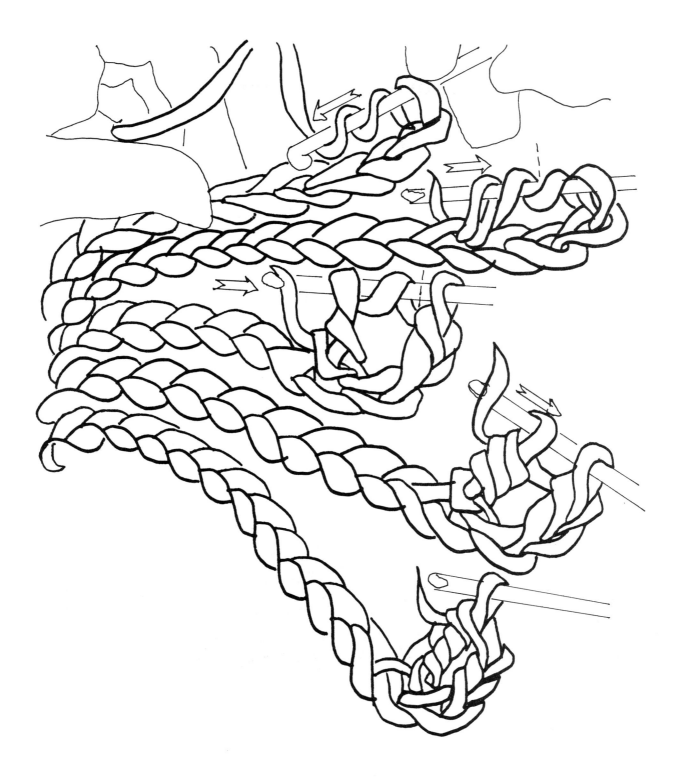

Flowers.

Chain 5. Join the ends of this chain together with a stitch to form a ring. Chain two, make 15 double crochets into the ring, joining the last double crochet to the top of the chain "stitch" with a loop pulled through.
Chain 6. Skip two chains, double crochet into each one back to the centre, skip one stitch, join this "petal" to the centre with a loop pulled through. Chain 6 again, continue all the way around —

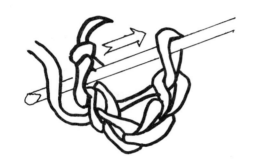

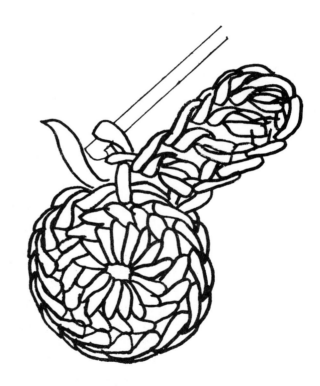

circles

Begin as for a flower, making a small chain ring.

To make a fishnet circle:

Chain three, join to next stitch, chain three, join to next, all the way around once.

This can be done in a spiral, rather than in rows...

chain three, join to the centre stitch of the previous loop.

When the circle starts becoming a cone, increase the number of stitches per row by spacing the joins closer together, (chain three, skip one, chain three, etc...)

This can be the beginning of hats, circular shawls, and doilies.

For hats, stop increasing when the crown is large enough, and it will begin to turn down.

For shawls or whathave you, keep increasing...

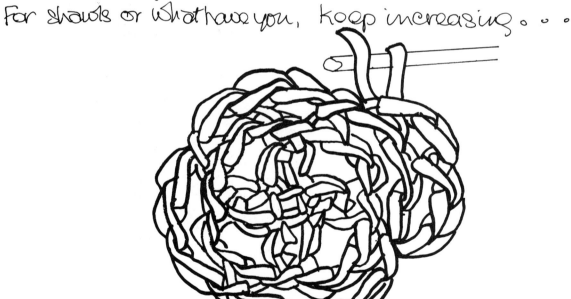

Squares.

Chain 6, join into a ring as before,
Chain 2, 2 double crochet into the ring, chain 3,
make three doubles into the ring, repeat this twice more.
Join with a loop pulled through to the first 2 chains.
Next row: Do 2 single crochets to reach the 3 chains of the
previous row. Chain 2, make 2 doubles into the 3 chains
space, chain 3, 3 doubles into the space,
Chain one, make three doubles into the next space, and so on —
Go around four times, making corners with 3 chains between
two trebles ○ ○ ○ ○

These can be sewn together for afghans,
different stitches and groupings can be used for
different effects ——

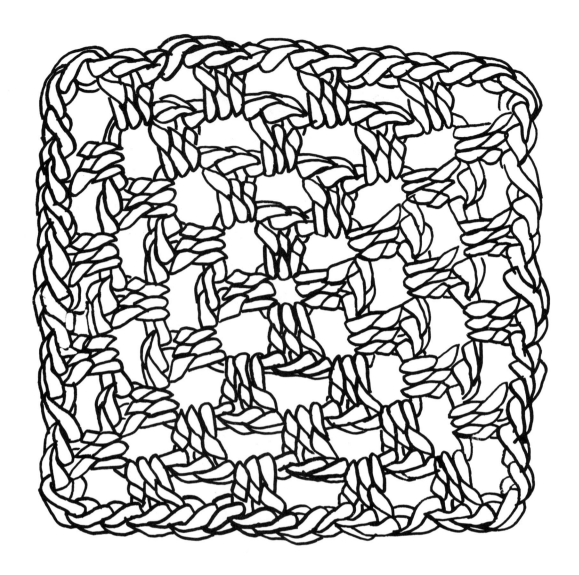

Organic Leather
Phil Havey

Working with leather is . . . Ever since man began to wear clothing, he has worn leather. But during the mechanization of the twentieth century, especially in the U.S., the craft of skilled leatherworking has slowly disappeared. Efficiency through mass production became the criterion of clothing manufacturers. But with the coming of the New Age, with its emphasis on hand work, fun, and beauty, the craft of leatherworking has sprung to new life with a naïveté of its own which is worth mentioning. Today we no longer have trades and skills passed down to us from our forebears, so whatever "specialized" skill we decide to master, we turn our hand to it unaided and unhindered by our past. This is especially true for leatherworking. With traces of Puritanism still in us, it's hard for us to accept the fact that anything goes. Don't be afraid of leather. Have respect for its specific limitations as a material (it stretches, it is thicker than cotton, and doesn't take very well to darts or gathers) and its particular beauty. But reverence does not mean fear. It is fear that keeps us from everything, including the fun we can have from working with leather.

It is most helpful, when beginning to experiment with a new medium, to know a few tricks of the trade. This can make the difference between enjoyment and discouragement. On the other hand, too much instruction inhibits the imagination. In the following pages, then, I hope to describe to you some of the tools which make leatherworking easy, without limiting you to the particular style which I have evolved.

THE WORK TABLE

You can have a good solid table constructed for you by a carpenter out of unfinished lumber. The surface can be left unfinished because you never work on the naked wooden surface itself. Don't get stuck paying a large labor fee because, if you can't work a labor exchange deal, it is much cheaper to go to a secondhand furniture store and buy one of those massive dropleaf dining room tables that no longer fit in small modern houses. They are a glut on the market. The last two that I picked up ran me $8 and $10. They are usually the right height and width for the work you are going to do.

THE CUTTING BOARD

Although other craftsmen use durable and long-lasting types of composi-

tion board, such as pressed sawdust, I have great respect for my fingers and use simple and less resistant upson board until it begins to show signs of wear. Then I cut it up into smaller panels and use it for punching. Usually the standard 4-by-8-foot piece cut in half covers the work table surface that I have described. Upson board can be purchased at lumber- and building-supply outlets. It comes in varying thicknesses. I use a board three-eighths of an inch thick, which costs about $2 a sheet.

1 Supplies

I keep separate fringing boards of the same material so that no one spot on the cutting board is overworked. This may seem like a lot of precaution, but feeling your way along with a knife, alert for the bad spots where you have to work carefully, is a drag on both time and energy. I don't forget what I am doing, but can still work with the confidence that there are no flaky disaster areas lurking under the skins that I am cutting.

A smaller, rubber "pounding board" (as small as 12 by 12 inches and a quarter-inch thick) is even better for punching than upson board if you plan to pound a hard punch with a mallet. The reason for this is that rubber won't splinter or flake at all, and will muffle the noise of your hammering. If you can't find a solid sheet of rubber to use, a craft shop should be able to sell you a pounding board for a dollar or so.

LEATHER

Most of the sources on the subject of leather rightly assume that the reader is a beginner, so they send him to a high-priced retail outlet. If you want to work on anything of size or quality, you will have to deal with whole-

salers. Even for small hobby-type work you are still better off if you go to leather wholesalers and buy their assorted scraps, rather than approaching retail stores or hobby shops. You can always pool your resources with another leatherworker so that it is worthwhile for the wholesaler to deal with you. In any coffee shop in the large cities, you will find half-a-dozen people seriously working with leather without doing anything like the type of thing that you are into. The medium is extremely flexible and personal (in fact, it becomes very hard to make a person that you hire reproduce exactly what you want him to do: leave him on his own for one week and you'll hardly recognize your original design). Make sure you are the one who makes the trip to the tannery.

Rarely have I been located where a tannery or wholesaler was not less than a three-hour drive from my shop. You only have to go once a month, so that is no great hardship, and you can always resell good leather at a price that makes up for its cost and the time you have spent picking out. But you can also have them ship your leather to you.

Information about wholesalers is hard to find. In New York I would suggest Gloversville, where there are at least two good tanneries that will wholesale (Cayadutta Tanning and Eton Leathers). Once you realize how tightly the big leather shops sit on the names of their wholesalers, you'll know that this little bit of information alone is worth the price of admission to this book. To many people in the trade, this problem is like the New York Times's Defense Department issue. The people in the big leather shops will give you a lot of technical aid, but when it comes to explaining an overall design that is exclusively theirs, or a materials source, just don't bother to ask.

When you get to the tannery, you'll find graded stacks of skins. With enough time on my hands, I have found skins in the 45-cents-per-square-foot stacks that were either misgraded or so close to the 55- and 65-cent skins that they downgraded them to avoid a hassle with some finicky buyer. The price differential is principally based on faults and scarring. If you have a fairly well-organized way of laying out your patterns, you can see right away which skins will work for you. This personal inspection of the skins will enable you to see all the new colors and textures being produced by the tanners. Even when there are no new colors, there is a wide diversity in dye lots, and the same standard colors can vary widely. I've seen colors like the dark blues that I don't normally like in leather come out of some dye lots so electric that they demand to be worked with. This variation in dye lots is one of the reasons that I always cut my laces from the skin that I am working with, rather than use prepared laces.

There are a lot of technical terms about skins--slunk, kip, belly cut, and so forth. These are more meaningful to the tanner than to the craftsman; however, there are one or two to know just so that you'll understand

the possibilities of what exists.

Cowhide is the sandalmaker's stock-in-trade. It's good for tooled work and durability. On the retail market it runs from 70 cents to $1 per foot. I never work in it and have no idea of wholesale arrangements. It is not uniformly thick, for it thins out the farther you get from the animal's backbone.

Suede is leather with a nap. It runs up to almost $2 per foot in calfskin, but people expect to pay well for anything in good suede. You can, however, use the reverse side of glove-tanned cowhide (see below) for the same suede effect at far less cost.

Shorthaired calf or cow is hide with the hair still on it. The American Indians are always running around in it in those bad movies that take place in the southwestern United States. It makes arresting vests and beautiful handbags and belts.

Splits are skins with a suede surface on both sides.

Glove-tanned cowhide is very flexible leather more suitable for garments than its stiffer, less processed cousin that I mentioned first. One side is smooth, the other sueded. Most of my work is done in this leather. It runs from 45 cents to 52 cents, depending on how often the steer brushed up against a barbed-wire fence in his lifetime or had a case of bovine acne.

DESIGN AND PATTERNS

Forget the brown-wrapping-paper approach that most books speak about

2 Tracing a pattern on the leather

and use poster board. It won't fold up on you or require a lot of pinning.
Just lay it down on the skin, holding it fast with one hand, and run right
along the edges with a slightly greasy colored pencil or chalk. You can
transfer your basic pattern to posterboard by pinning it down on the board
and cutting around it. If you don't already know a little about patterns either,
buy some standard shirt and jacket patterns at the sewing store or care-
fully take apart some old clothes. Remember to pick simple patterns that
do not require gathers or many darts. Bantam has a little pamphlet on pat-
terns for 50 cents. Minor adaptations will be made in your work as you
progress beyond the more conventional ways of doing things.

CUTTING

Use a matting knife or an Exacto-cutter and just face the fact that
you're going to have to change an awful lot of blades, especially if you do
fine fringe work. (These tools can be purchased at a hardware store. A
mat knife costs about $1.50. Exacto-knives can be purchased for 70 cents.)
Some people use a whetstone or some other sharpening device to rework
their blades. The same time could have been used at their work table and
they would have come out way ahead. I've often worked a deal with friends
who are house painters, for my used blades are just right for scraping spots
off windows. Friendship made the difference, otherwise that too would have
been a bother. You'll probably find that a good, sharp scissors will work
just as well on the thinner leathers. I cut a number of pieces at one time,
following the old Zen adage "Do what you are doing." Be as social as you
want while tracing and lacing, but cutting calls for concentration. There is
a declining scale of catastrophes that runs like this: 1) cutting--you can
make an irreversible mistake on the leather or on your own fingers; 2) punch-
ing--you can make a usually salvageable mistake on the leather; 3) tracing
and lacing--you can rework anything as long as your blood pressure holds
steady.

FRINGING

3 Cutting fringe

Fringing is a special kind of cutting that can make or break a jacket.
I've seen some pretty slipshod work zipped right off the counter because the
fringe was so well executed: I don't want to encourage a shoddy way of going

about the work, but I do wish to doubly stress the care that should be taken with fringe. I cut fringe on separate panels from the main cutting board so that I can change them frequently. Fringe can be repaired by skiving the cut pieces so they can be glued. This consists of paring down some of the thickness of the leather so that there can be an overlap without a lump. You should glue these mended areas with an especially strong epoxy resin. A metal ruler or straight-edge can be purchased in the hardware store. Be very careful when fringing that the knife does not slip up onto the ruler and fringe your thumb.

GLUING

The reason for gluing edges under is purely aesthetic. If you are using thick leather, forget about it. Assuming that you will be doing a bit of gluing, I want to explain a little trick about the glue pot. You can buy a glue pot with a brush fixed through the center of the lid in any engineering or blue-print-supply shop. It is worth the little extra effort, for you don't have to worry where you are going to set down the brush every three minutes or the lid every ten minutes. Neither the brush nor the glue in the pot cake with the rapidity that happens otherwise. Take a square of scrap leather somewhat larger than the mouth of the glue pot and cut a hole in it about three-quarters the size of the opening. After stretching this over the mouth of the pot, fix it with a thick rubber band. This protects the threads around the neck of the jar from being smeared with glue. If you think this is much ado about nothing, you've never been around a leather shop on a Monday morning when the sloppy pots have had all weekend to harden. You can buy gallon cans of glue for as little as $5. For small projects, the rubber-cement glue sold at hardware and stationery stores will do quite nicely.

For a half-inch turn-under, paint the under edge of the leather an inch wide with glue, wait five minutes, or until the glue is crackly-tacky, fold

4 Cutting corner off after gluing down edge

the leather back a half-inch, and hammer with a regular carpenter's hammer. Make sure the hammer strokes overlap slightly. There will be a

small piece of leather at the corners that has to be trimmed off (Fig. 4). Large sheets of simple brown wrapping paper can be used over and over again to protect the upson board while you work.

PUNCHING

I suggest a standard hole punch with a rolled rawhide mallet as the best means of making holes. You can get a nice rhythm going for you once you are into it and work out a whole array of tensions. I've never understood

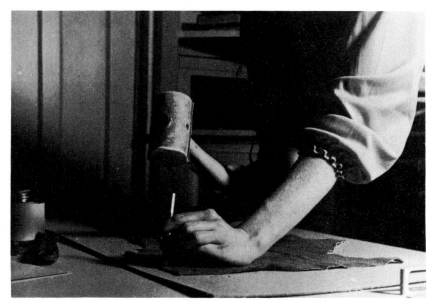

5 Punching

the physics of it, but using a metal hammer instead of the mallet makes you feel like you are working on soggy blotting paper. Old pieces of cutting board or rubber board serve much better than the wooden blocks that some books recommend. Avoid a spring punch and its big brother the rotary punch (the kind you scrunch with your two hands) unless you have hands like John Henry or are intending to enter the international grasp and squeeze contest. If you are caught in one of those situations where you can't make a sound or your Aunt Tilly will blow a gasket, you have to use a spring punch and a small roller to press together glued leather. A rawhide mallet can be found at most hardware stores for about $5. The hole punches come in various sizes. Hobby stores like Tandy Craft on Fourteenth Street in N.Y.C. carry them for about 85 cents apiece.

LACING AND SEWING

There are a number of possible ways of putting the pieces of your pattern together. The most obvious method is with a sewing machine, but the standard machine will only work on the thinnest leather. With the better model machines, where you have a strong power source, you can use a

71

heavy-duty needle and fifteen- or thirty-weight thread on any soft leather garment. You can also sew by hand. If you don't care for machines and you like more roughhewn stuff, you can also lace the pieces of the pattern togeth-

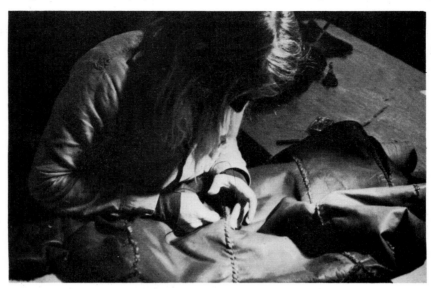

6 Stitching by hand

er with leather strips. This is also decorative and can be done in as leisurely a fashion as knitting. The lacing for a shoulder seam is shown in Figure 7. Just remember that the upper sleeve sets into the armpit hole and then the sleeve and body seams are laced together. To avoid lacing shoulder seam right on top of the shoulder, choose a pattern with a yoke (a shaped

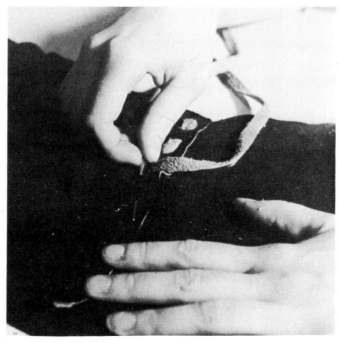

7 Lacing

piece) to add over the shoulder and back of the neck. Lacing is something that I'm tempted to touch on very lightly, for I've seen people who knew very little about leather invent fantastic new methods for lack of prepared instructions. Some things stay vaguely stable because they are so broad in principle.

I have found that a single knot at the end of a lace usually pulls through a lacing hole with wear. I use a knot that takes one extra turn around before going through the loop. Rather than knotting laces together when they have to be extended, I have found a rather nice way of lacing one through another

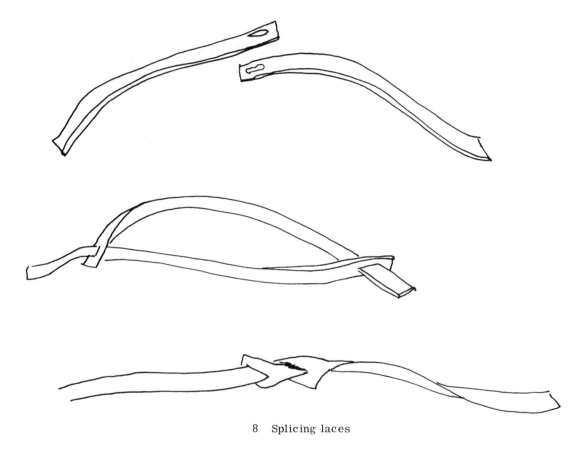

8 Splicing laces

(Fig. 8). Needless to say, the trick is done on the inside of the piece. Another basic is that front panels, pieces, and so forth overlap the back pieces.

It is often easier to draw the laces through the holes with a large needle, as in sewing. I always just slice the lace thin for about four inches and run it through the eye like a thread (Fig. 9). The needle itself should be mentioned in passing, for if you don't know that the ruggers needle comes in plastic, you'll end up inside on those nice spring days because of the way the sun flashes off a metal needle. I usually lace on a board the size of a portable draftsman's drawing board so I don't have to rearrange things if I have to set the work aside.

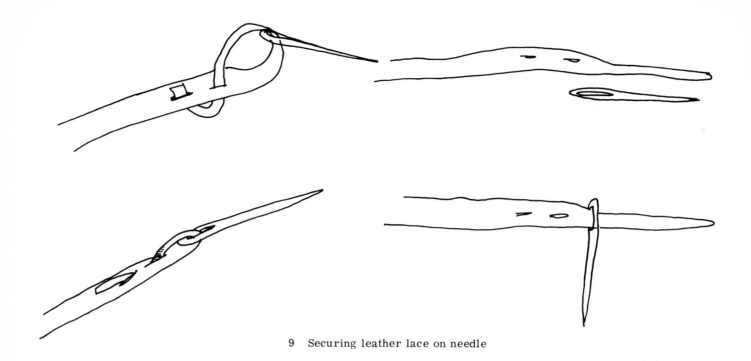

9 Securing leather lace on needle

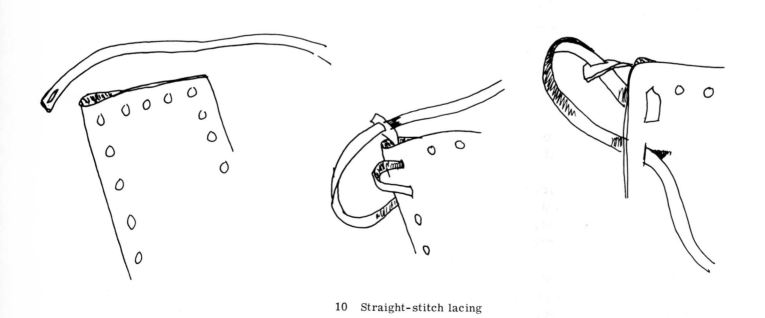

10 Straight-stitch lacing

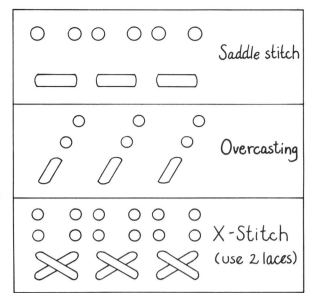

11 Other lacing techniques

MOSAIC AND PATCHWORK

Most patchwork garments aren't commercially profitable. That's why one that is well done is such an eye-catcher. Unless you really like to do patchwork the way some of our grandmothers enjoyed quilting, your return will be marginal if you sell your work.

The Eskimos and the natives of Liberia have done some excellent work by setting scraps of uniform thickness against a cloth background. As the glue is drying, the pieces of leather can be stretched slightly to make up any small gaps between them. These pieces can also be stitched together if more than normal wear is expected, but most of my designs were too expensive to work in and not cut for heavy winter sports; however, even in some of the high-fashion pieces, I did take the precaution of tacking down the panel corners.

When you want to fit pieces into each other with fancy curved lines, simply overlap the pieces and cut any kind of line that you want through both pieces. They'll knit right into each other.

To get a very primitive effect, take strips of leather about an inch and a half wide and run a line of glue three-quarters of an inch wide down the center. Pinch the strips together down the middle and you'll have a little leather ridge with wings flaring out on either side. Sew squares of scraps to these pieces that flare outward. This gives the same effect that leading does in stained-glass work. Remember, because leather cannot be eased (that is, led into curves without crinkling), it is better to keep to square designs. The corners are a small problem. Stick to sewing and lacing the

squares together. You can also skive, or pare down the thickness of a piece of leather with a knife until you have a strip along both edges of the patches to be joined that is half the original thickness of the leather. This means that there will be no bulging seam where they join. I've heard of garments that have been skived and glued holding up well without lacing, especially if they have been glued with the new epoxies.

DECORATION

There are many ways of decorating leather. Besides using an interesting lacing technique and fringes, you can add beads (see Melinda's note on page 78), paint beautiful designs (best done with good-quality acrylics) or try actually embroidering on the leather. As far as what or how goes, it would be best for you to experiment and discover for yourself. You should have plenty of scraps of leather left over to experiment on. As with picking or designing a pattern, if you don't know too much about what you can or can't, should or shouldn't do, anything is possible, and whatever develops will at least be your own creation.

Dennis in a beaded jacket by Melinda

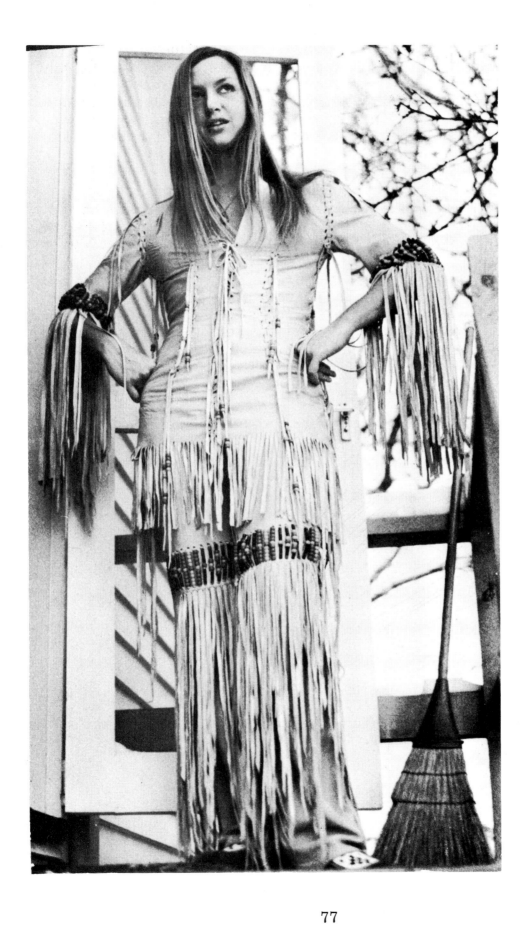

LEATHER BEADING

Beading on leather requires, first of all, great patience. There are several ways of applying beading, such as first beading whole parts on a loom, then sewing them onto the leather. For people, like myself, who simply sew, sewing directly on leather can produce textural and color effects that are just as satisfying.

Start by turning the piece to be beaded right side down and, on the back side, draw your design as it will be when it is finished. Using a number seven crewel embroidery needle (the smallest eye possible), thread it with Tandys heavy-duty, fine-weight thread, double, and knot. Cut the thread about a quarter-inch below the knot to ensure its holding. From the back, pierce the starting point of the design with the needle, draw the thread through to the front, pick up four beads on the needle, making sure the last two have large holes. Lay the beads on the right side of the leather and go down through the skin with the needle on the line of the design. Measure half way back down the line of the design you've already beaded and come up and pick up those last two beads. Pass the needle and thread through them

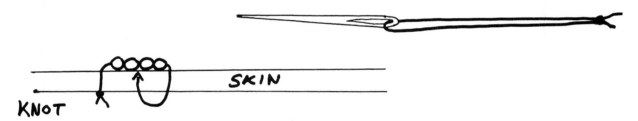

Start over, picking up four more beads, being sure the last two have large holes . . . , and so forth. The picking up of the last two beads ensures strength of hold and unity of line.

Love,
Melinda

In and Out the Hoops: Embroidery
Carol W. Abrams

Imaginative needlework design died with Mary, Queen of Scots and it seems no one has had the impetus to do anything about it. It's about time the "old lady in gingham and shawl" syndrome was phased out of the contemporary scene. I'm not saying those sweet little scroll-and-flower motifs are useless--just you-less. I think that what you make should say what you are. Individual expression in embroidery as well as in any other media, makes it vital.

We are a product of the kit-generation. Designing your own personal piece of embroidery can be as easy or as difficult as you want to make it. Start with joy and with simplicity; however, if you are absolutely desperate and completely without experience in anything aesthetically inspiring-- meaning trees, water, rocks, grass, machinery, the alphabet--then use a kit. Sigh. But if you've ever experienced a moonscape, or examined the surface of a rock, or wished the Easter egg in your head really was, then you sure as hell don't need a kit! And if you're saying right now that you can't draw straight lines—use your name, or trace shapes you find around you--ashtrays, cups, feet, cookie-cutters--anything with a strong outline. Check out those pre-European American Indian embroideries and those marvelous early American samplers, and some of those contemporary East Indian designs, and then say you can't design your own piece!

Embroidery is a phenomenal medium; I can say that although, naturally, I'm prejudiced. You have available to you colors ranging from antique yellows to electrifying magentas and nearly an infinite number of textures: wools, cottons, silks, blends, synthetics, metallics, and on, and on, and on. Being mainly a linear medium, almost any two-dimensional design adapts well to fabric and threads, yielding a fairly substantial product. I get a real sense of well-being with embroidery; it's warm--warm with wools, and cloth, and wooden hoops, holding an aura of peace that only fireplaces and home-made bread have.

Anyone with eyesight, a steady hand, and a bit of patience can do it. And you don't have to do chair covers or adorable little owls either. The equipment is fairly simple and can be very cheap. All you need to start is a hoop, a length of fabric, some threads, scissors, and a needle.

A HOOP IS A HOOP IS A HOOP

Beware: there are all sorts of fascinating hoops and frames with nuts, bolts, rivets, carving, holes, stands, gorgeous wood finishes, springs, and gadgets. Unless you are an <u>experienced</u> needleworker, these things are a waste of cash. Also those metal frames and hoops will bend, rust, lose their tightness, stain fabric and generally fall apart. Even if they are cheap, avoid, avoid, avoid. Most needlework shops, five-and-dimes,

Different-sized hoops

and department stores carry hoops. I prefer a ten-inch-diameter, lap-standing, wooden hoop now, but until I became more proficient with stitching and fully convinced that I liked embroidery, I found a three- or four-inch-diameter wooden screw hoop the greatest. It's small enough to hold in your hand and manipulate with ease. Anyway, if I hadn't liked embroidery I wouldn't have felt as guilty for putting aside a fifty-cent hoop as I would a twelve-dollar investment. Your hand-size hoop may seem a little puny when you bring it home, but once you work with it a while you might want it bronzed.

FINDING A SURFACE: A TWO DIMENSIONAL FEELING

Now you have to have a piece of stuff to work on. A good linen is your best beginning, though any hefty, closely woven fabric is fine. It's senseless to start with a sleazy fabric that's uncomfortable to handle and won't take to lots of throwing around. For all you know, you'll like your completed piece and regret the fact the fabric stinks. Homespuns, Belgian and Irish linens, and smooth-finished upholstery materials are all good bases. Select the fabric as you might select drawing paper or canvas--so that its color and texture coordinate well with your design. I prefer linen because it's solid stuff with a good substantial feel, takes a lot of handling, has a neutral color and a variety of textures that are pleasant, and lets the embroidery do its thing. By the way, linen does not need to cost nine dollars a yard--go somewhere else if it does. It shouldn't run any more than a decent dressmaker's fabric.

LET IT SHRINK

Buy six inches more of the stuff than you need to allow for shrinking and straightening. Wash the goods to soften the texture and to pull up that beautiful grain. Let it shrink now, before stitching. If you prefer a stiffer positive feeling between you and your medium, then add a little starch to the rinse.

WARPS AND WOOFS

If the salesman cut your fabric as straight as I've had mine cut, you'll have no choice but to straighten it. If you don't, your finished piece will disappoint you by coming out lopsided and distorted after blocking and finishing. You will probably find the edges that were cut were not cut along one single thread of the fabric, but rather many threads were severed in a seemingly straight line. You must, therefore, pull out the first thread or so, that runs <u>completely</u> from one selvage to the other. The selvages are the finished edges that don't unravel when picked at. Find these threads by following a single thread from one selvage across to the other, and seeing if it runs a complete course from edge to edge. To do this, clip it at the ends, carefully, and gently pull it until it is completely removed from the fabric. On some pieces of fabric there may be only one selvage or no selvages at all. In that case start with the single selvaged side and repeat the process on all the cut sides, or pick any side and use the same process on all four sides. The goal here is to have a piece of goods with four right-angled corners. Once the threads are pulled, cut away the excess fabric following the pulled thread line <u>carefully</u>. It's a real drag and takes up time, but if you do it to music it's not so hard to take. Just think, if Da Vinci had been a little more concerned with his

Pulling the thread to straighten the fabric

surfaces, maybe then his immortal paintings would not have proven to be so painfully mortal.

After all this thread pulling is over you will notice that the fabric's threads are running at right angles to one another, more or less. Find or draw a true, old fashioned ninety-degree right angle and lay a corner of the goods on it—if it doesn't line up perfectly then pull the opposite corners and edges diagonally, gently and firmly, humming a pleasant tune. Keep stretching the fabric in this manner until the fabric's corners and edges are at true right angle in keeping with the one you've drawn. Be careful not to unravel the edges that you've just so lovingly and pain-fully straightened, unless you like to work on postage stamps. Hem, whip or machine-stitch down folded narrow margins on all unselvaged edges. This prevents fraying. Would you believe, your fabric is ready for the application of your design! Whew!

DESIGN YOUR OWN THING

If you are still dry for sources of design, then open your eyes, baby, it's all right in front of you--in your knuckles, the grain of wood in a table top, the shape and shadows of that coke bottle in front of you, ice-coated trees in moonlight, a cross-section study of a molar, a camera lens, your signature, random patterns--embroider! Don't get graphic, that pansy need not come out looking like the real thing--it's a pattern, a source, a taking-off point, that's what really matters. You are celebrating forms, rejoicing in color, feeling the warmth, the textures of threads and cloth. Touch, enjoy, let your needle wander, be rhythmic, be free! If you feel

like rearranging an established pattern then, by God, do it! Beg, steal, borrow, copy, but always, always make it your own. Most of all--enjoy-- never settle for someone else's joy.

It seems the only thing offered to a prospective needleworker is kits. A kit is great if you really don't care if you are the technician at the end of a long line of people--the designer, manufacturer, merchant, etc.-- along with those fifty thousand other people that are doing the same kit. If that's your bag, love, then do it.

LAYING IT ON

Getting your design out of your head and onto the linen can be simple. There are many techniques. I've taken watercolor not too unlike the color of the fabric and drawn it on with a fine brush in freehand. Block out only the basic shapes--leave the detailing to the embroidery. Always keep in mind that you might want to change it, and too many unwanted painted lines are tough to get rid of.

Another technique I like, that doesn't mar the surface in any way, is to use regular sewing cotton and in basting stitches, using your needle as a pen, sew the design to the surface. Again it's best if the thread you use is also a similar color to the fabric so that if there are any threads left showing after embroidering they are unnoticeable or easily removed. This way, too, if you decide to eliminate or modify large sections you can just pull the threads out.

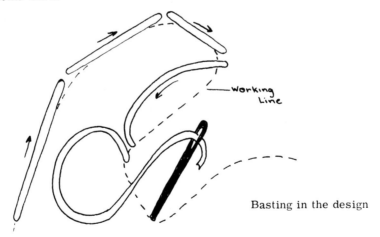

Basting in the design

Let's say you have a complicated design, one that you just don't want to change at all during the transfer onto the fabric, then this same basting technique can be used with modification. Draw or trace your pattern on tracing paper, gauze, chiffon, or any other sheer, fine material with a felt tip marker, watercolor, fountain pen or whatever suits you best. With basting stitches or even masking tape, tack this pattern on the back-side of your fabric. This way it will come out the right side up on the front

of your fabric. Logical? Using basting stitches sew through the paper or material pattern and the fabric beneath, following the design carefully. Use small stitches in the more complicated areas so that when you are finished the pattern isn't lost in a myriad of stitches that mean nothing.

Basting in the design through paper

Changing the color of your threads may make it easier to distinguish the pattern later. Remember, though, that some of these threads will remain behind after you embroider over them, even when you've pulled out all the excess you can after completion. That's the reason for keeping the threads in shades of the base fabric or linen.

It's still best not to get too involved with the pattern's detail in the transfer--small changes are inevitable, and the transfer is only a guide for your needle's freedom. Keep the drawing or whatever else your pattern came from next to you always, so you can refer to that for the real details.

FUSSY

(This is necessary for those who feel it's necessary, and sometimes it is)

Another technique for pattern transfer is the Holy (as in hole) paper-and-charcoal method. Tack thy fabric down on a board with thumbtacks or carpet nails, being sure all the corners are at right angles. Then lay a paper pattern made of wrapping paper from the butcher or heavy drawing paper on the fabric. Center it. Tape or thumbtack the paper pattern down. Better yet, use some books or bricks so that it will be easier to lift the paper up and see the progress on the fabric. Prick holes along the pattern's lines carefully, using a needle mounted in a cork or pencil eraser, or a small awl (which is like an ice pick).

Once the pattern is pricked, rub powdered charcoal in firm circular movements over the entire pattern with a blackboard eraser, a piece of wadded-up cotton, or a few layers of felt. Peek under the pattern every now and then to see if the charcoal is falling through the holes, adjusting the amount of charcoal or the size of the holes if necessary. The rubbing must be done in firm movements and with care--the charcoal shouldn't be too heavy or it will smudge.

I used to crush my own charcoal in the belfry at mid-night on Bedlam Boulevard where I once lived, but you can buy powdered charcoal, or "pounce," in a pharmacy.

Be sure the pattern is complete on the fabric before removing the paper pattern. Imagine the job you'd have to realign the pattern if the transfer didn't work. Lift the pattern carefully. With watercolor and a brush follow the dots (remember the game "dot-to-dot" in comic books?--same technique), being careful not to smudge the charcoal with your hands. Air the fabric out on a nice breezy day or throw it in a dryer on the 'air cycle' for a few minutes. This should flap out all the loose charcoal. Thus ends the Holy Order of the holey-paper-and-charcoal method.

This whole thing, as far as I'm concerned, is too messy and too much trouble, and it places you in the irreversible position of not being able to change your pattern without a great deal of difficulty. But, if there's something that you really revere and it has to be exact, then this is a good way to do it. I say, though, freedoms all the way, and this is not one of them. Thus spake Carol, daughter of John and Ginny. Rest in Peace.

THE OTHERS

You can also use dressmaker's carbon found in a notions department, or wherever sewing supplies are sold. Follow the directions on the

packet, using a blunt-pointed instrument instead of a dressmaker's wheel, which might be suggested on the packet. They are not worth the investment. There's also a thing called a transfer pencil. I understand that you draw with it on tracing paper, turn the drawing over onto the fabric and press with an iron. It's not supposed to give a very fine line, though, so it's best for larger, simple patterns than for very complicated, tiny patterns.

With all transfer techniques, be sure to leave an excess of at least a half-inch of fabric as a border all around the area your pattern covers, so you will have some room to work with when you mount it.

Don't--believe me-- use pencil to draw your pattern on the fabric. It smudges the cloth and the yarns, giving a gray murky cast to everything. You'll have to redraw the pattern many times, as the lines tend to dust off with handling. Also, avoid typing carbon--that can be disastrous! Felt-tip markers are not advisable either, the lines being too broad, and, unless they are positively waterproof they will run when you wet the fabric for blocking later. All of these methods are not worth the convenience they offer.

So now that you've got a good piece of straightened and hemmed cloth and a pattern transferred onto it, you are ready for the joyous part--the threads and the stitches.

STRINGS

You're in for a fantastic trip when you find your threads! The colors! The textures are indescribable--smooth shiny silks, nubbly synthetics, metallics, cotton flosses, yarns in wools and blends in a good variety of weights, tapestry wools, crewels in earthy shades. Touch them, smell them, rub them against your face, lay them next to one another. Revel in their presence, their substance. Any and all threads should come under your scrutiny. There's nothing more delightful than placing the polished brilliance of silk against the rich deep pile of wool. Imagine, play with, the threads, carefully choosing the ones you really like. A mountain of threads can be very frustrating, though, as can too many colors, so try restricting yourself in quantity at least. A little discipline is good for the soul. The stitches add dimension and, by combining threads, you can add to your spectrum of colors and textures. If you dig purple, then for Pete's sake, use purple!

I found the best threads to start with--and you may too if you are a raw beginner--were the very inexpensive cotton embroidery thread and crewel wools, a wool used specifically for embroidery.

Embroidery cotton (cotton floss) comes in six-strand skeins and in bulk quantities. The skeins are easiest to get, usually in dime stores and almost

every other sewing department. Each thread in the skeins is made of six strands, and you usually work only with three of those strands at a time. Experiment by using all the threads or fewer--depending on the effect that you need.

Crewel wool is wool made for embroidery. The best is from England and comes in shanks of one color or plaited in a flat braid in shades of one color. The texture is fine and strong by comparison to standard knitting wools and the colors are usually in heathers, antique tones, and soft muted shades. The manufacturers are slowly realizing that there is a demand for more modern colors like the ecstatic reds and purples and cool, vibrating greens and blues that are so contemporary. Unfortunately, dyeing the threads with commercial dyes can be disappointing, though very tempting. They are usually not colorfast, which can be disastrous when you block. I have no experience, as of now, with the natural dyes that are becoming popular, and don't know if any or all of them are colorfast. I would assume they must be to some extent, as the colonial women used natural dyes almost exclusively.

Threading the needle

Many places don't carry loose crewel wool, except that in kits, ugh. Root around in yarn shops and craft places, asking about them. If they don't or won't carry these wools for some reason, maybe the people can tell you where to get it. Friends of mine order their own.

When using crewel wool, use only one strand to start, doubled through the needle. Thread the needle as illustrated above. Doubling the thread over gives a richer effect and adds strength to the stitches. This, like everything else is no cardinal rule . . . follow your own head.

Tapestry wools are easily gotten because needlepoint is so "in" today. You'll usually find it in places that deal in yarns and rug-hooking equipment.

These wools have a heavy texture and are very strong by comparison to knitting wools. They also come in a fairly limited range of colors similar to the crewel wools--heathers, antique shades, and a greater selection of more contemporary shades than the crewels, but even so, not as many as I would like to see. You'll have to use a blunted tapestry needle or an embroidery needle with a very large eye, as this thread is tough to sew with otherwise. I find using single thread easiest to handle (rather than doubling it through the needle). Because it is difficult to handle at times, I prefer using it for surface stitches such as couching and the raised stitches. It's also easily split down into two or more strands (as in floss) that can be used very successfully.

Knitting wools and rug yarns have a more exciting range of colors and textures than either tapestry or crewel wools, and are much more available in most areas than either of these. The only real problem is that you can seldom buy less than one-ounce skeins (a skein is a quantity of thread usually measured out by length or by weight). One ounce is usually an awful lot of wool for usual embroidery needs. The stuff shreds easily and should be used in shorter lengths than other threads. It's very easy to work with and adapts well to almost all embroidery stitches.

I have found in some really complete knitting shops, something called mending yarn, used by knitters to make argyle socks, mend knitted goods, and embroider on sweaters and stuff. The texture is very fine and soft, not as hairy as crewel wool and the colors are usually soft and classic. The great thing about this thread is that it comes in lengths of only a few yards and it adapts beautifully to embroidery on fabric.

Silk thread is the queen of all embroidery threads, and is probably the most temperamental. I have found an almost unlimited range of colors. I've been told that you must rub beeswax on the ends of the threads but find this unnecessary if I work slowly and rhythmically, using threads no longer than the distance from my wrist to my elbow, doubled. Silk comes in threads of multiple strands like embroidery cotton and can be split in whatever configuration you want. It snags on any rough skin on your fingers and hands and it really doesn't hold up well on pieces that will be handled a great deal, but as far as I am concerned, it's worth all the trouble. I'm really hooked on silk.

All the silk I have has been imported and is relatively expensive compared to the other threads, so I make a point of not using stitches that leave a lot of thread on the wrong side of the fabric. I'm cheap.

DOODLE CLOTH AND OTHER STUFF

You'll need a good set of embroidery needles that have smooth long eyes and sharp points. Get them in assorted sizes if you are using a variety of

different weight threads. A set of different size tapestry needles with blunt points is good to have if you are using heavier wools. If you are having difficulty pulling the thread through the fabric then the needle eye is too small. If there are obvious holes left around the stitch then the needle is too large. Having a set of needles in assorted sizes makes it easier to adjust them when you need to. Right?

If you don't already have a pair on hand, a good sharp pair of manicure or embroidery scissors, or any small, sharp-pointed scissors is absolutely essential. Large paper shears and such are clumsy though not entirely impossible to use. If you have to buy a pair of scissors this will probably be your most expensive piece of equipment for the whole project.

Along with everything else I also keep a notebook or journal with a fairly substantial binding so I can lug it around with me easily. In it I draw diagrams and notes on new stitches that I find in all those expensive stitch dictionaries. That way it's free. It's also great to have around to jot down ideas and sketches for projects, addresses of equipment and yarn shops, titles of relevant books and articles and anything else relative to my work. When I think I'm dry for ideas or have forgotten a stitch that I need right away, then I just consult my little old notebook.

A foot-square scrap of cloth of similar weight and texture to your fabric's is handy to have to doodle around on with new stitches. This way you also have a record of the stitches that you've learned and see what they can do with the threads you are using. It gives you a chance to mess around with the stitches, playing with them to find different effects and deciding which ones you want to use or not on your piece. It's terrible to anticipate covering any area, spending time and energy with a stitch you don't like. Don't settle for anything. Time is not relevant unless you are doing something you don't like.

TWO RINGS AND A SCREW: NOT BY TOLKIEN

To mount the fabric in the hoop, remove the inner ring from the outer ring and lay the area of the fabric you are to work on over the inner ring. Adjust the outer ring's screw so that it will fit firmly over the fabric and the other ring. You shouldn't have to adjust the screw again until you change the area you're working on. Press the outer ring down onto the fabric and inner ring, working with your palms and fingers all around the rings until the fabric is taut. I like to have the threads of the fabric in the ring running at reasonable right angles to one another, adjusting them visually. It's not that important. Pull the excess fabric evenly all around the rings until the fabric is drum tight. Remember, you will not be sewing as you would a seam, but punching your needle up and down through the fabric. A few stitches, like large areas of satin stitching and some knots, crush and dent

under the hoop's edge as you move about from area to area. My suggestion here is to do these stitches last if you can.

The hoop and fabric are now prepared for the application of the stitches. Hooray!

ANATOMY OF A STITCH

Use the stitches, distort them as it suits you. Try them as linear stitches and fillers, next to one another, over each other, isolate them--do what you feel like doing.

I'm only including in the following section the stitches that I enjoy the most and find the most versatile. They are easy to modify if you just think of the possibilities--try weaving a thread in and out a running stitch or placing a raised stitch over a trellis. Experiment, enjoy.

Follow the diagrams slowly and carefully, working it out in your head first. Take up your doodle cloth and get into the rhythm of the stitch and watch it grow. Touch it, inspect it closely--really look at it from all possible angles. Think of all the possibilities the stitch has to offer you. Even though you may have decided not to use it on your piece, note it anyway in your notebook. It might be just perfect for something later, and memory is not reliable.

To thread the needle, first loop the thread over the needle and pull the needle away from you and the thread toward you. This flattens the thread so that it will easily pass through the needle. Pinch the thread, grasping it tightly and slip the needle out. Push the needle eye against the pinched thread. It usually takes a few tries to get the thread through at first.

KNOTTING OFF: Knot the end or ends (depending upon whether you are doubling or leaving the thread as a single strand) of the thread and punch the needle down through the top of the fabric a bit off to the side of the working line. Follow the diagram (next page) carefully. After completing the area of stitches, cut off the original surface knot (A on the diagram). That way there are no bunchy knots on back of the piece and all the stitching is done on the front of the piece. Theoretically you shouldn't ever have to turn the hoop over during the whole process of embroidering, which is a good goal to work for if you like games.

FINISHING OFF: It's the same process as starting off. Tuck the two little stitches used for knotting off under the last set of stitches completed, pulling F off to the side of the work. Cut the thread close to the fabric surface at F.

KNOTTING OFF/ FINISHING OFF

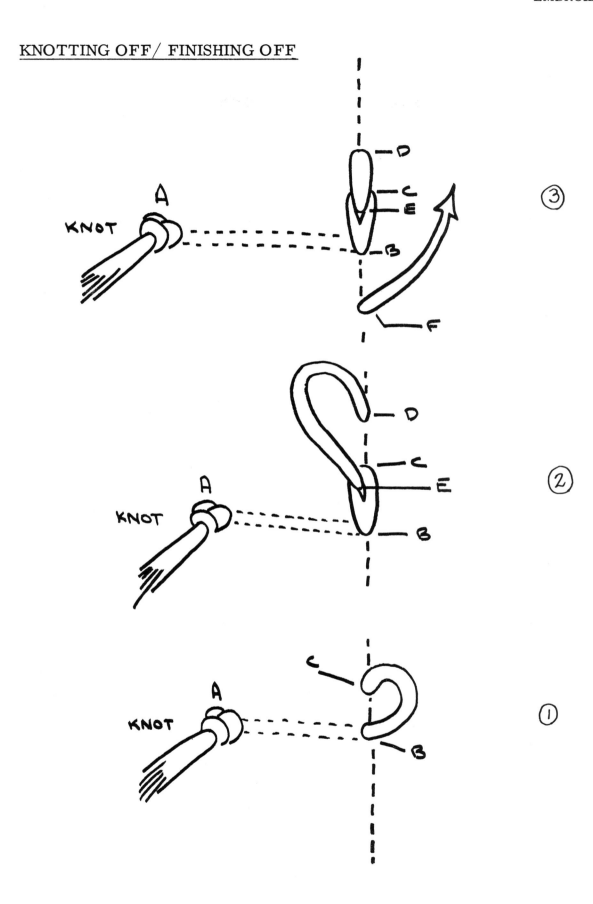

RUNNING STITCH: This is probably the simplest stitch in the whole con-
glomerate of stitches. It can be used readily for a linear stitch and can be
modified for filling in an area.

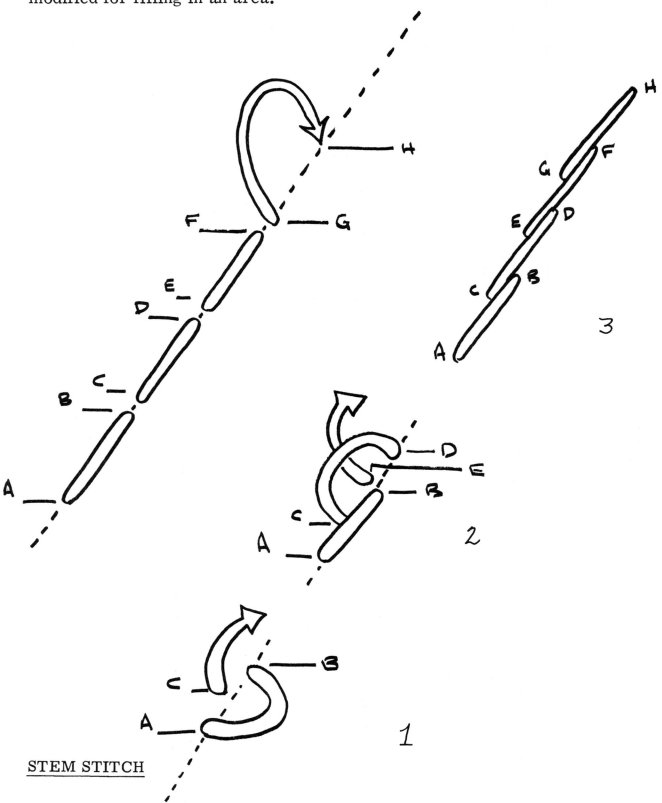

STEM STITCH

COUCHING: This is a great way to show off beautiful threads without much loss on the underside of the fabric. It's also an effective linear stitch.

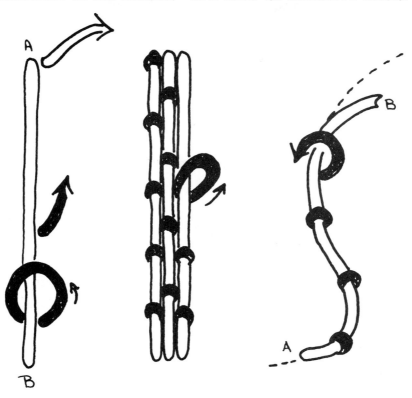

BOKHARA COUCHING: This is used mainly as a filler in classical embroidery. Because it uses only one thread, I have found it difficult to use as a linear stitch. That's a challenge.

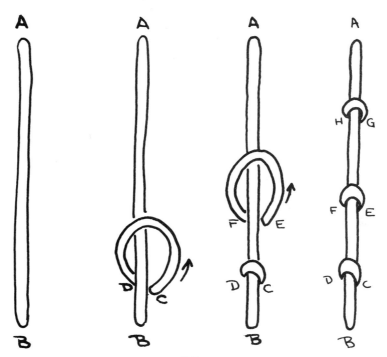

CHAIN STITCH

TWISTED CHAIN STITCH

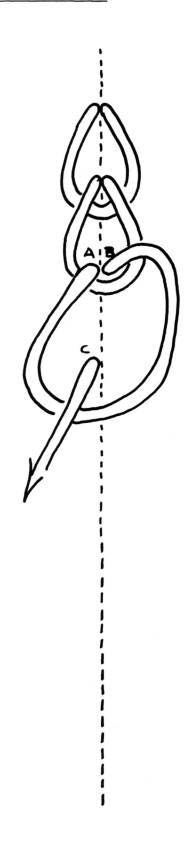

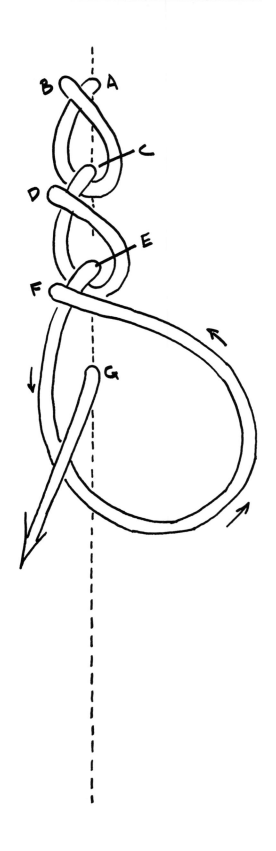

BUTTONHOLE STITCH

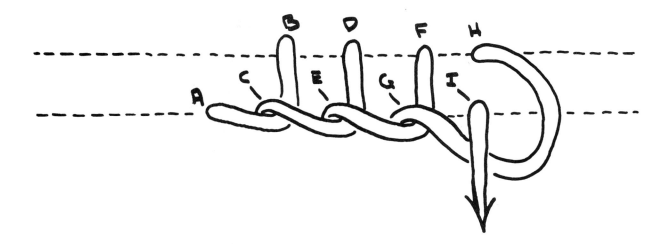

FRENCH KNOT: If you pull up on <u>B</u> it will be a lot easier to complete.

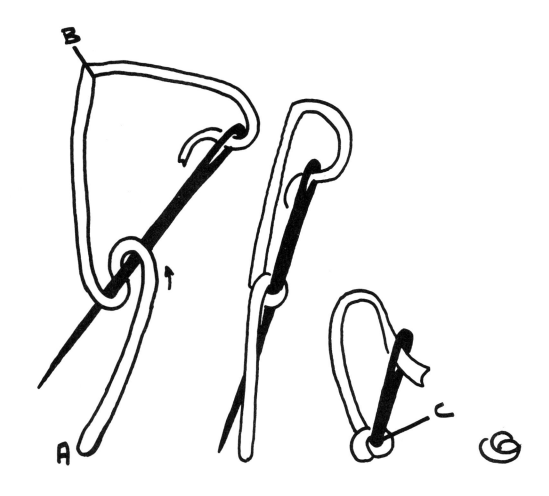

CORAL KNOT: Hold your thumb down on <u>D</u>.

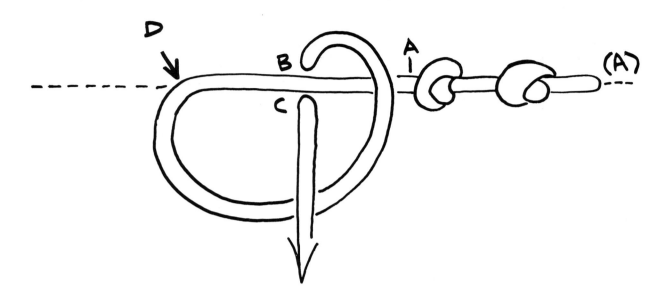

SCROLL

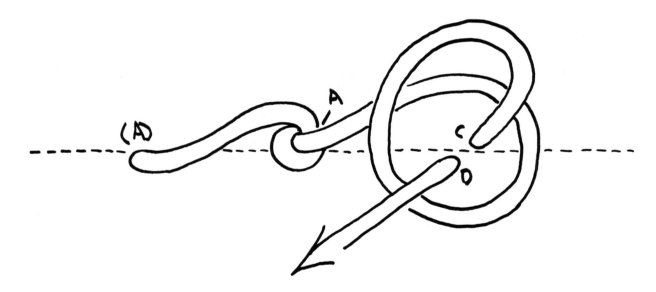

DOUBLE KNOT: This is my favorite stitch and is especially effective when the knots are spaced a short distance away from one another. Use D as if it were A to make the next knot, and repeat.

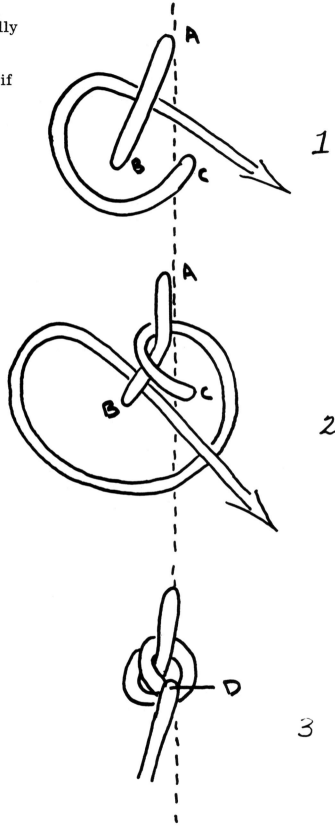

<u>**CLOSED FLY STITCH:**</u> With a name like this it has to be a good stitch, right? I've shown you the classical method of using this stitch, as it's easy to draw this way. If you think about it, the closed fly can be very versatile--in embroidery, that is.

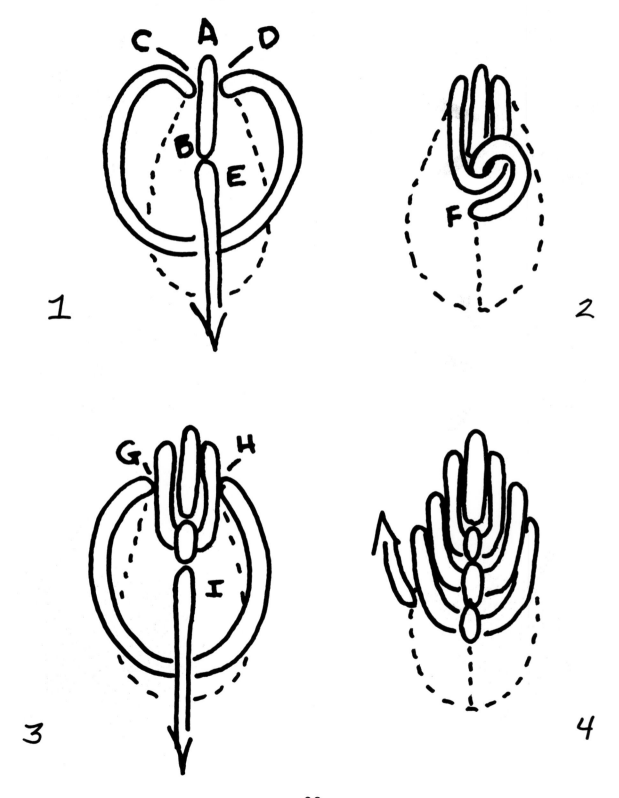

SPIDER'S WEBS: Always use an odd number of spokes, five minimally. This spoke-like structure is used for both the whipped (right) and the woven (left) types of webs.

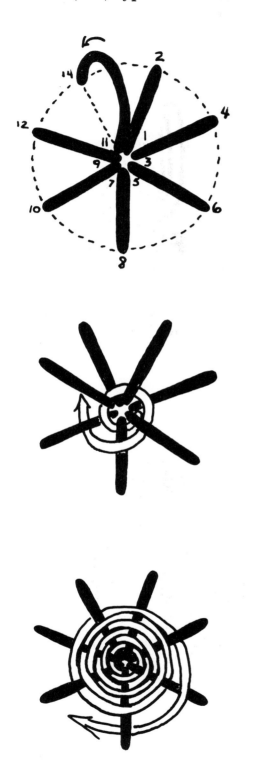

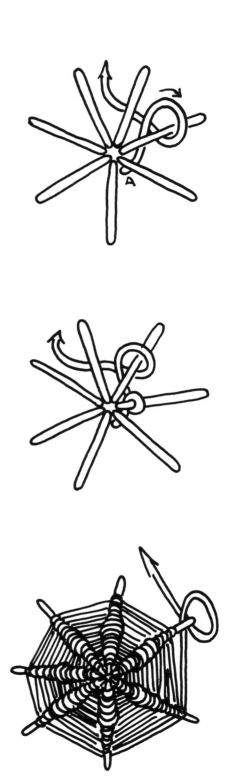

99

TRELLIS FILLING: Parallel lines and perpendicular corners are the usual order. The corners of the squares produced should be tacked down as shown, or in any way you can think of. The trellis lends itself very well to filling with other stitches. When filling an odd shape with the trellis, use the method illustrated at the right.

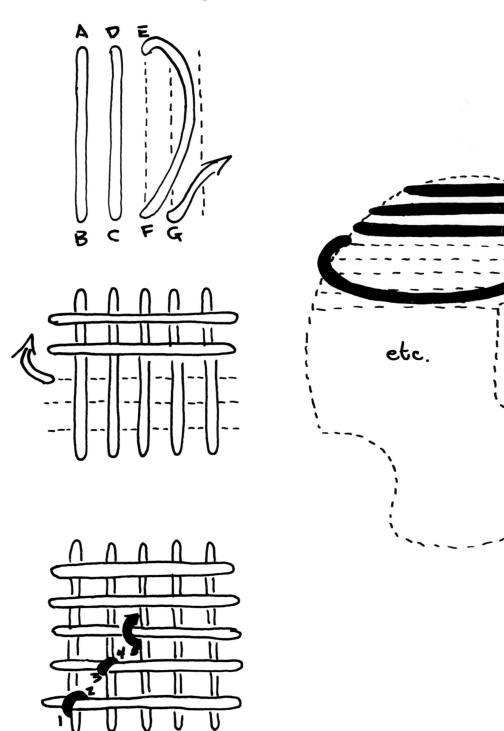

RAISED BUTTONHOLE STITCH: This, like all the raised stitches, can be used as a filling, or for a linear stitch if the parallel stitches used for a base are made one raised buttonhole stitch wide.

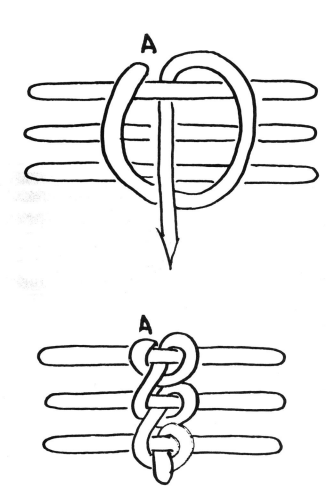

RAISED ZIGZAG STITCH: This stitch is a variation on the raised buttonhole and gives an intriguing knitted effect when used as a filling.

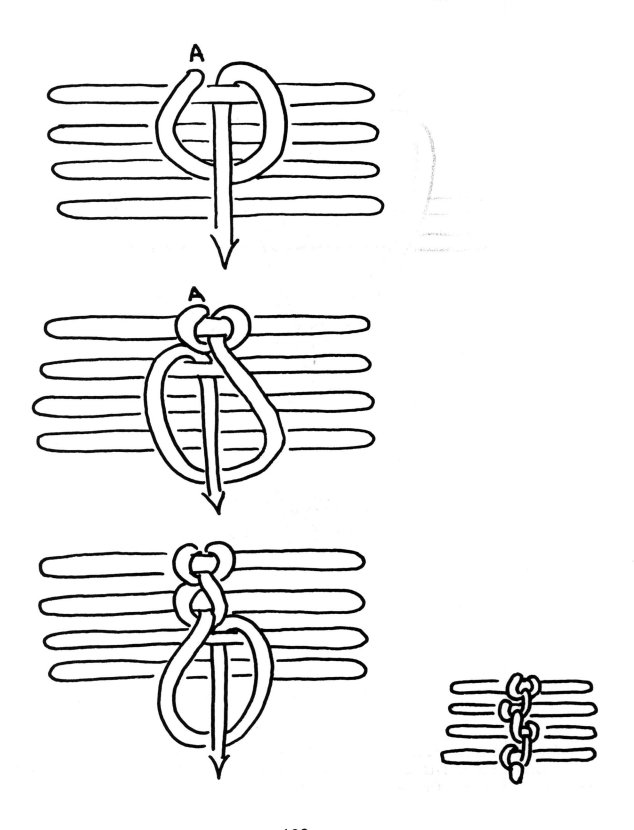

RAISED CHAIN STITCH: Pull up firmly at the arrow in order to get an even, symmetrical stitch.

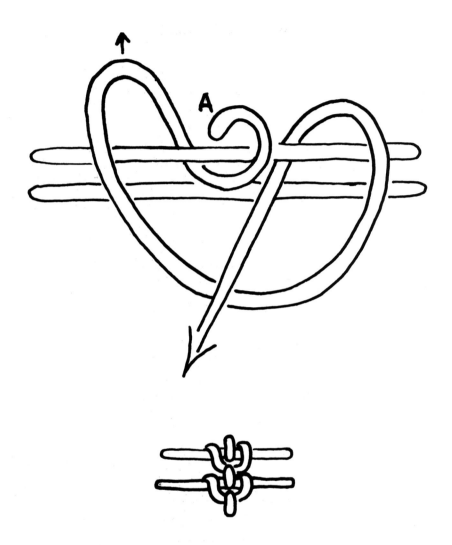

To use all the raised stitches as filling stitches in odd shapes, use the same principle of filling in the parallel lines as in the trellis stitch, eliminating, of course, the perpendicular lines.

SATIN STITCH: Outline the shape to be filled with a very fine chain stitch or stem stitch and fill with long running stitches. Keep the satin stitches close together and at even tensions to one another. The back looks fairly much like the front.

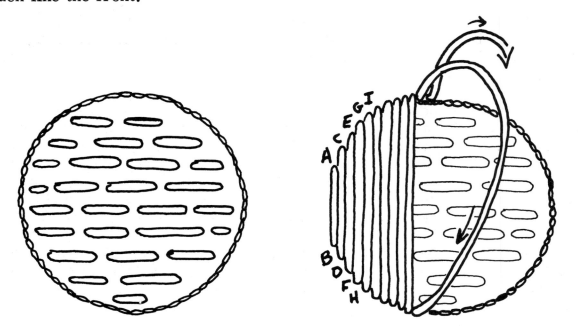

FALSE SATIN STITCH: There is very little difference, as far as I'm concerned, between the net result of this and the "real" satin stitch. The "real" satin stitch has more thread covering the back of the fabric. Some people say the false satin stitch looks flatter. It's up to you. I use it because there is very little thread waste on the back. As I have already said, I'm cheap. Use the same method of outlining the shape first and filling in with running stitches.

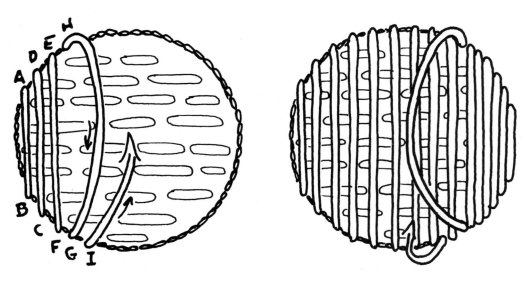

WRINKLED, HUH?

After completing your piece, you'll lay it out and it will probably be all wrinkled and hoop marked--not at all like the smooth finished thing you pictured. That's why you block it. You could press it, placing it between two or three damp towels and using a hot iron. The only drawback to the pressing bit is that it is difficult to prevent the fabric from becoming lopsided. It's fine for small items but becomes tougher to handle on larger pieces.

The best method is blocking the completed piece. You can have this done by a professional (who is usually someone with more guts than his client). Find a reputable needlework shop, and attempt to see the caliber of work they do. Be fussy--after all this is the last bend in the long road to completion and now is no time for disaster. Most professional mistakes, though very few, are usually due to lack of concern. Don't be discouraged about doing the blocking yourself, you've done everything else so far.

You'll need cold water, a box of carpet tacks, a hammer, an old piece of cotton cloth or sheet (that's larger than your piece), and a wooden surface such as an old table or board that you can staple or hammer nails into (also larger than your piece). A pair of blunt-nosed pliers or, better yet, canvas-stretcher pliers.

Lay the sheet over the wood surface. Dunk your embroidery in cold water until it is soaked and spread it out, dripping, on the sheet. You did use colorfast threads and fabric, right? I like facing the embroidery up so that the stitches on the finished work will reveal their full textures. Facing it down flattens the stitches, which is good if you want a smooth, flat effect.

Smooth your piece out and measure the distance between each top to bottom and diagonal corner in order to make sure that the distance top to bottom on one side of the piece is the same as top to bottom distance on the other side of the piece and that the lengths measured across the piece to diagonal corners are the same. A carpenter's right-angle or a protractor would be handy to be sure the corners form right angles. <u>This is most important.</u>

Pull the fabric really tight, starting from the centers, using the pliers. Tack at even intervals working from the centers of the sides out, until there is about a one-half to one-quarter inch interval between tacks. Check the measured distances between diagonal corners and be sure the corners form true right angles. Let the fabric dry completely. (I hope you are not using your kitchen table.) If you don't plan to mount it right away after it's dry, then roll it up in tissue paper around a cardboard tube, rolling so the embroidery faces out. This prevents creasing of the fabric and crunching of the stitches.

PUTTING IT ALL TOGETHER: MOUNTING

There are several ways of mounting the completed piece. The most convenient for me is using canvas-stretcher strips which can be bought in almost any decent art-supply shop. They should be smaller in length and width than the dimensions of your fabric. As you can see, allowing for excess around the area of your fabric is a very bright idea. Canvas pliers or large blunt-nosed pliers, a staple gun (or hammer), staples (or carpet tacks), and time are the rest of the equipment you need. If you are using a hammer and tacks you had better have someone help you, as I understand most people don't have three hands yet.

Assemble the strips, being sure the corners are at solid right angles. Lay one side of the fabric along one stretcher strip, leaving enough cloth to fold over the strip along the back. Follow a thread running from one corner to the other, much the same way you did when you straightened the fabric. Lay this thread along the front top edge of the stretcher strip. This will help in keeping the threads running at right angles during the whole process. Start from the center tacking down the fabric on the top of the stretcher strip. Work your way out to the sides being sure that thread you've chosen as your guide is running on the top edge of the stretcher strip. On the opposite side pull the fabric tight, starting also from the

Mounting with tacks or staples

center using the pliers for better grip, and tacking as you did the top. You will probably find staples easier to use, pulling the fabric with one hand and stapling with the other, unless, as I mentioned, you have someone willing to work with you. Try having the threads of the fabric running as parallel as you can to the edges of the stretcher strips, throughout this whole procedure. If the blocking came out well, there should be little trouble with this. This avoids possible distortion of the whole piece when finished. Repeat the process on the remaining sides; find a thread, run it along the front outer edge of the stretcher strip, staple the fabric down working from the centers out. All along be sure the fabric is very taut and smooth on the front surface. Check the thread angles at the corners

of the stretcher strips and get them as close to right angles as possible. It should resemble a fine stretched canvas when complete. There should be no puckering or odd pulling. The corners of the fabric on the back should be manipulated so that they lie as flat as you can get them. Staple them down.

Certain fabrics such as linen twill are nearly impossible to line up perfectly, so in a case like this, stretch the fabric so that it is smooth and the embroidery looks good. That's the whole point behind mounting, anyway.

The classic method for mounting is to whip the fabric onto a frame of thin board or stretcher strips with linen thread. I don't care to use this method, but someone might want to try. The board or the stretcher strips should be cut smaller than the fabric, as in the previous method. A thin piece of masonite or plywood is good. Heavy cardboard can be used for small items. It warps too easily to be used on larger pieces.

Use linen thread, which, unfortunately, is difficult to find. Try shoe repair shops or upholstery shops. Maybe a place dealing with weaving supplies will have it. Also the thread used for sewing braided rugs together might be good. Buttonhole twist or the other heavy cotton sewing threads at the sewing counters in department stores are not strong enough, and one broken thread can ruin the whole thing. What you want is a thread that's super-strong.

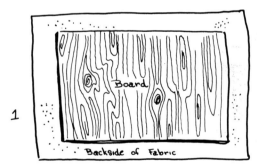
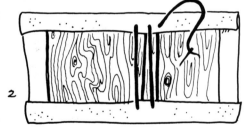
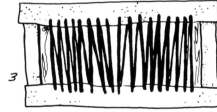

Mounting by whipstitching

Lay the fabric face down on a table, lay the board (or stretcher strips) over the fabric, centering it. There should be enough fabric in excess to fold over on all sides in a minimum of one and a half inches. With a doubled length of linen thread and a heavy tapestry needle, starting from the center in the same manner prescribed in the previous section, catch up about a half-inch of the fabric. Also find a thread running from one side to the other and have it run along the top of the board, so that there is a much easier time getting the threads to run at right angles to one another later.

Fold up the excess fabric on the bottom of the board. Bring the threads

down to the edge of the fabric you just folded up and catch another half-inch. Pull the thread tight. By whipping the fabric this way, the front is pulled tight and relatively smooth. Keep checking the thread you chose to run along the edge of the board to see that it stays in place. Repeat this process on the other two sides. The spaces between the stitches vary, depending on the weight and substance of the fabric, but on the average they should probably be about one-half to one-quarter of an inch apart.

Check the threads on the front surface to see if they are running at right angles and that the fabric is smooth and tight. There should be no puckers or pulling on the front at all.

Now, using either method you can frame your pieces as you please.

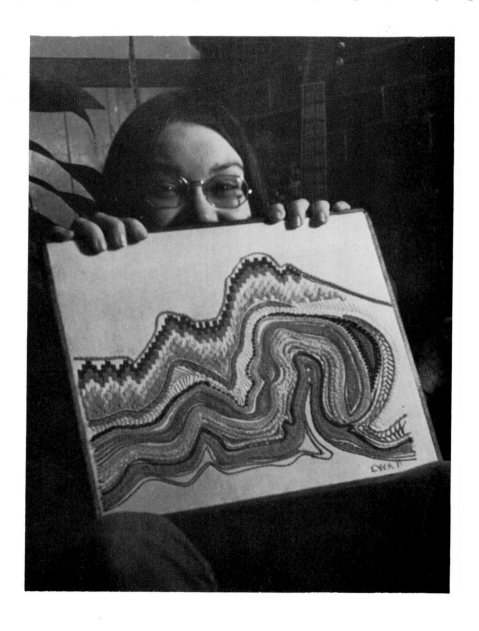

"LET ME MAKE THIS PERFECTLY CLEAR..."

I have restricted myself to embroidery "picture-making" just for the lack of space. The possibilities of this craft are vast if you just put your mind to it. As with life, it can be all encompassing or just a passing gig. As a crusader for self-expression and total individuality in media, I believe that embroidery is not only an expressive craft, but a completely contemporary means of personal communication. Anyone can take this craft as far as he wants to go. There are those who paint old mailboxes in order to enliven their environment, and then there is Picasso. The range between is infinite. Infinity is awesome in its possibilities. Embroidery, as with any other means of self-expression, is what you make it and can go as far as you want to carry it.

Hopefully, I have outlined a basic "vocabulary" of stitches and techniques that will get you started in new directions. Maybe I've introduced you to possibilities you've never considered. The point is not whether you've chosen embroidery as your means of expression, as your thing. Being a media snob is not my style. What is vital is that you express yourself, however it suits you. Do it with joy, with life!

Being is celebration.

PEACE

Carol

Getting Into Pottery
[NOTES FROM THE UNDERGROUND]
Jean Young

Just remembering the cool, smooth, and sensuous feeling of bare feet in mud should get your head moving in the pottery energy field. That was really a feeling for the material, as they say; yes--however elemental it sounds. It'll be the same when you begin rolling a piece of wet clay around in your hands. Remember doing that with mud? There are other feelings to groove with when you think about doing pottery. Like a feel for form. A feel for design and color. The whole point is to get it all together into some kind of unity that your finished piece will reflect.

Start out by making something you really dig. Something you need. Then you'll be closer to expressing yourself.

A few people have been lucky enough to find clay ready to use in their own gardens. Some tools can be found or made at home. A knife and a sponge might be all you need. But whatever you feel you need can be found at the ceramic-supply shops. The best tools are your hands.

SUPERIOR CHEAP TOOLS, SOME HANDMADE

WIRE: Anything will do--an electric-guitar string, or even a nylon one. Tie each end to anything that you can easily grasp.

WIRE LOOP TOOLS: These have wooden handles and a wire loop at one or both ends. Several different sizes are needed. They cost from around 60 cents to $1.75, depending on size.

WOODEN MODELING TOOLS: These are all wood. There are any number of sizes and shapes. Choose a selection. They run from around 30 cents up, depending on size.

PIN TOOL: This is a pointed tool for scratching in designs and for trimming. A needle with the eye end pressed into a bottle cork will work for some things.

SPONGES: A sponge shaped like an elephant's ear is best. It's flat and thin with plenty of surface area.

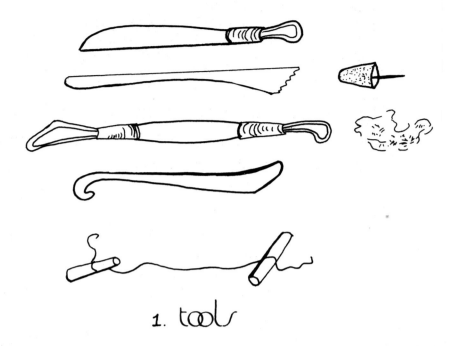

1. tools

PLASTER BATS: These are usually pie-shaped pieces of dried plaster. They support the objects you are working on, and they are used for moving your piece around without having to touch it (clay won't stick to plaster). Bats are only 70 cents to $2.00, but if you have a number of pots going at once the cost does add up. To save bread some people like to make their own bats. Buy some plaster of paris at the lumber yard. Enough for making four or five bats and a wedging table should cost under $3. Mix it up using directions on the package. Use paper pie-plates, aluminum pie-plates, or, for a square, you can pour it into any cardboard box. Coat pans with soap or vaseline to facilitate removal when dry. Just make sure that the form you're pouring into is on a level surface. A good, easy-to-use bat measures 6 by 6 inches across and 1 inch thick. Be sure to tape the corners of the cardboard box so the plaster won't run out. It'll take about twenty minutes for the plaster to harden.

WEDGING TABLE: This is a plaster slab used for throwing down moist clay to force out any air bubbles trapped inside. If you don't plan on going into pottery in a big way, at least right in the beginning, you really don't need a wedging table. Instead, you can tack down a piece of canvas to a sturdy table or floor (clay will stick to most everything not plaster or canvas). A wooden box 30 inches long, 20 inches wide, and 4 inches deep will make a wedging slab for every need. Perhaps you have one that size or smaller around the house. But if you have to make one, use the least expensive quarter-inch plywood and one-by-fours. Then mix up the plaster and pour it into the box or form. (Remember, the box should be on a level surface.) Scrape the surface of the wet plaster with the edge of a yardstick or straight board until smooth. When the plaster is dry, break away the box and move the slab to your working table.

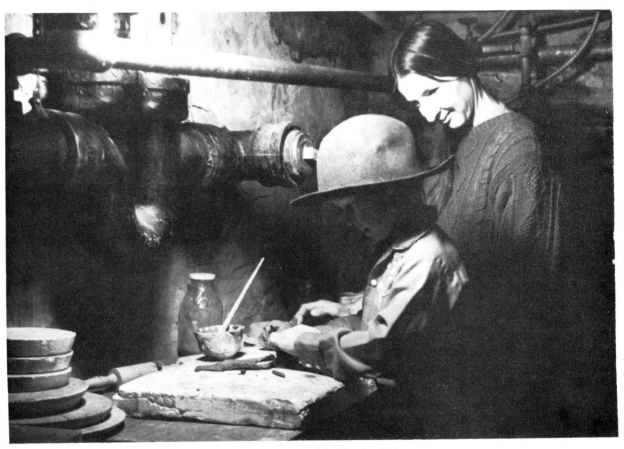

2 Working on a big plaster bat

If you don't have a working table you can stack some cement blocks (also available at the lumber yard) against a wall which will hold the wedging slab and keep it from slipping. The holes in cement blocks make good places to store equipment.

A BIT ABOUT COOKING POTS

I have to rap about this now even though it is one of the last things you do in the pottery process. Reason is--so you'll know what I'm talking about when we come back to it again.

All clay is fired (baked) in a kiln (oven) for permanence so it won't leak or crack. These kilns are ovens made to reach very high temperatures, a minimum of 2000° F. Different clays are fired at different degrees of heat, sometimes referred to as "cone temperatures." That's because in order to check the oven temperature you place small cone-shaped pieces of glaze and clay (dime a dozen in the craft shop) inside the kiln in a pat of clay. Usually, cones are used in sets of three or four, and they are made to melt at a definite temperature. Most kilns have a peephole on the side through which the cones can be watched. This chart shows you how the cone numbers increase

as the Fahrenheit temperature increases.

$$06\text{--}1859^{\circ}$$
$$05\text{--}1905^{\circ}$$
$$04\text{--}1940^{\circ}$$
$$03\text{--}2039^{\circ}$$
$$02\text{--}2057^{\circ}$$
$$01\text{--}2120^{\circ}$$
$$1\text{--}2120^{\circ}$$
$$2\text{--}2129^{\circ}$$
$$3\text{--}2133^{\circ}$$
$$4\text{--}2174^{\circ}$$
$$5\text{--}2201^{\circ}$$
$$6\text{--}2246^{\circ}$$

3. cones

Ceramic wares are classified as earthenware, stoneware, china, and porcelain. The two types most made are earthenware and stoneware. Earthenware is fired at low temperatures, around 1700°F. to 1900°F. (or cones 09 to 05). When fired, it is porous and will not hold liquids unless it is glazed. The clay color is red or buff after firing. Stoneware is harder and more vitreous (glasslike) than low-fired clays. It holds water even when not glazed. It won't scratch or break as easily as low-fired clays. It fires at cones 5 to 11.

There are many types of kilns: electric, gas, oil, wood, etc. (The Indians put their ware into a pit and burned firewood over it. The earth itself was the insulation.) Before you choose a clay you should locate someone in your area who has a kiln and will fire your things for you. This may not be easy. The YMCA and YWCA usually have kilns. Public schools and craft shops may have kilns or they may be able to turn you on to individuals who will fire your stuff. There is always a charge for this because kilns use a lot of gas or electricity. Daniel Rhodes's book Kilns costs $10, but if you are thinking of getting a kiln for yourself it would be worth the reading. The Golden Press book on pottery shows how to make a kiln for raku (used only for pottery that is glazed in ten minutes) that is relatively simple. However, their description on how to light it is rather vague, and I was told by someone who had gone through a course

on how to make this kind of kiln that lighting it should be approached with caution. Craft shops and art stores will show you their catalogues of kilns, and they can order for you.

4 Opening an electric kiln for loading

THE GOOD EARTH

Almost everywhere there are spots where you can find clay for the digging. It's usually red clay. What you find might need a lot of cleaning because natural clay will have rocks in it or other stuff. Sift the clay through a screen to get out this unwanted material. It also might be too sticky or too sandy, and when this happens other clays can be obtained to add to it to make it a good working clay. For instance, a "ball" clay is too sticky to use by itself, but it may be what you need to hold together what you've found. If the clay you've dug up is too sticky then a "fire" clay which has tooth and texture can be added.

Workable clay (called "clay body") usually contains a combination of different clays. The good clay body should be plastic enough to be rolled into a coil without showing lots of cracks. It should have enough coarser clays or it will shrink too much when it's fired.

Clay also comes ready-mixed, with fine or medium grog (grog is a clay that has been fired and ground down. It gives texture and tooth to the clay). These ready-mixed clays come wet in quantities as small as a five-pound box for $1.25. I suggest you buy a twenty-five-pound quantity for around $3.75 to give yourself enough to work with. Five pounds isn't as much as you think. Clay weighs a ton. A fifty-pound tin which holds two separate twenty-five-pound batches in plastic bags costs around $6.50.

Gray clay is called different names by different companies. It's anywhere from pink to buff after it has been fired. Red clay is also called by different names such as Terra Cotta, Red Mexiclay, etc. The gray ready-mixed, though, has a wide firing range (cones 06 to 9). Red clay has a firing range of cones 08 to 9. These are the cheapest kinds to buy. Because of its weight, I suggest picking bought clay up in a car to save shipping costs, which are almost double the price of the clay.

Sometime you might want to mix your own clay bodies. This is much, much cheaper. Combinations of dry clay are mixed. Decide on the amount of dry clay you want to mix up. Weigh it (use a bathroom scale). Then measure out 35 per cent of the dry clay's weight in water. Put water in a plastic or galvanized garbage can. Then add the dry clay to the water. This you have to let cure for at least a week. (The older the clay the better. The Chinese used clay a hundred years old. One generation stored it for the next generation. They in turn stored it for future generations to be used many, many years later. That's old clay!) Then knead the clay like bread. Some people step on it like making wine from grapes.

CLAY CATHARSIS: WEDGING

This is a good way to use your action muscles and/or take out aggressions. The purpose of wedging is to remove all air bubbles and holes which might cause a piece to explode in firing. It <u>has</u> to be done before starting to make your piece. Cut the clay in half and throw one half onto the plaster wedging table. Then slap the other half on top of it. Keep this up until you can cut the clay in half and don't see any holes. If you haven't gotten down to making the plaster wedging slab, tack the under side of oil cloth or canvas on a firm sturdy surface. This way, the clay won't stick. Also, if the piece of clay is small enough, wedging can be done by pressing the clay through your fingers. The larger the piece of clay the more it needs wedging.

MOTHER, MOTHER EARTH

Take care of your clay. It should be kept in tightly closed, heavy plastic bags or containers with tight-fitting covers. Clay can be worked over and over again until it is fired. To get it back to the original plastic state, just add water. While you are not actually working on your piece, keep a damp cloth covering it, and wet the plaster bat it is sitting on.

SOUP TO DUST

Different steps in the drying of clay:

Leap 1: GREEN CLAY. Clay in the wet, pliable stage. Also clay that hasn't been fired.

Leap 2: LEATHER-HARD CLAY. Clay which is no longer pliable because its moisture has evaporated somewhat. It has not yet changed color. In this stage it can be carved, decorated, etc.; handles, etc., can be added.

Leap 3: BONE-DRY CLAY. Most of the water has evaporated and the clay feels warm to the touch. All clay should dry slowly so it won't warp or crack. When it feels dry you can put it near some artificial heat to let it dry more. When it is really bone dry it can be put in the kiln.

Leap 4: BISQUE OR BISCUIT. Clay that has been fired. For all kinds of clay this firing is at a low temperature--about 1800°F. It makes a pot easy to handle for glazing. It is still porous.

CLAY ON CLAY

"Englobes" and "slips" are used interchangeably in ceramic books. They sound as if they could be used interchangeably in comic books too! Slip is simply liquid clay--about as runny as heavy cream. "Englobe" means to cover; that is, with any material; however, slip is usually used.

Slip is applied to a wet or leather-hard unfired piece to color and decorate it. Always make your slip from the same clay you're using for your piece. Just add water and appropriate color until it is the thickness of heavy cream--or heavier. The reason for this is that various clays shrink at different rates and your slip is apt to peel off the pot if you don't use the same clay that you used to make the pot.

Problem is, if you want to put a white englobe on a red clay pot you have to use different clay. Try buff clay slips on test pieces of red clay to see

how it goes. Usually ceramic shops have a white commercially mixed en-
globe that suits all kinds of clay. Slips come in colors and cost as little as
85 cents a box. If you plan to use white englobe in a big way you can mix
your own. Daniel Rhodes's book Clay and Glazes has a chart for finding
ingredients for different firing temperatures. Ceramic stores can put it
together for you too. Usually six different ingredients are needed (cost,
about 35 cents a pound). Colors can be added that cost anywhere from 35 to
85 cents a quarter-pound each, depending on the color.

 All color is made from oxides. If cobalt oxide is added to your slip,
you get a light to dark blue, depending on how much you use. Usually that
will be anywhere from 1 to 5 parts per 100 parts of slip. Chrome oxide
gives a green, uranium oxide gives a yellow. To get a jet black, which
looks good on red clay, you need to mix 10 per cent each of these three
oxides: chrome oxide, iron oxide, antimony oxide. Slip looks dull after
firing. You can rub some soft wax on the outside of a fired slip piece to
protect it and give it some shine. A transparent glaze over the englobe
protects it from eventually looking dusty. I'll talk about this further in the
Glaze Menagerie section. Slip fires at the same temperature as your clay,
but since it is a clay, it must be bone dry before it is ready to be fired.

 HOW TO APPLY SLIP (this is not a put-on): Pouring on is the best bet,
usually while your piece is still wet. This is so slip and pot body will shrink
together. Two or more applications should be applied on top of each other
rather than using one heavy coat. It is best to do the second pouring soon
after you do the first. If the first coat is too dry it might fall off when you
pour a second one.

 To fashion an area with forms and design, paint wax on your pot over
the area you don't want the slip to cover. The wax will burn out in the firing
and leave the original clay surface. Candle-melt will do, but better yet, get
some wax emulsion at the craft shop (about 75 cents a half-pint) because it
remains in the liquid state. Melted candle was will have to be kept warm to
be liquid and clogs the brushes. Wax can be painted on in a precise manner
--sponged on for a lacy pattern, or spattered on, etc., etc.

 SLIP INLAY: Slip inlay is a groove. Really! Groove out horizontal,
vertical lines (or shapes) with a pin tool, saw blade or anything else at hand.
Utilize this technique when pot is in a leather-hard stage, or just before.
Larger incising can be made with a corner of a wire loop tool. Pour on the
slip while the clay is still leather-hard. When the pot dries the surface is
scraped, leaving alternate patterns of slip and clay body. In most cases,
use a clay with less grog because it makes the piece easier to scrape.

 TRAILING: Another fulfilling way to decorate pots is trailing. Fill a
plastic bag with slip. Then cut a smallish hole in the corner so you can

squeeze out lines or dabs onto your pot like a baker uses in decorating a cake. Another little number is to squeeze out line designs on wet newspaper. Pick up the paper with the slip pattern and press it against the side of a leather-hard piece. This is called slip trailed transfer.

SGRAFITTO: This is a good technique. It means "to scratch." You can scratch through englobes or opaque glaze, or directly onto leather-hard clay. The lines expose the clay body underneath an englobe. Wait until the piece is leather-hard before you englobe, and don't wait until the englobe is over-dry before you scratch through, otherwise it might flake off as you scratch. Pencil marks will fire out, so you can draw a design on the englobe first before using the sgrafitto technique. You can carve out whole shapes and forms with a wire tool where you want the clay under the englobe to show through.

POT COOKERY, CONTINUED

I have to go into two different kinds of firing so you'll dig what happens when I get into glazes. Firing is done at a temperature that depends on what clay and glaze you use. There are two stages in firing: 1. maturing, or bisque firing, 2. fusing, or glaze firing. (Stage three: If the glaze overfires, it flows off the pot) I already mentioned bisque firing when I talked about clay. It is low-temperature firing of bone-dry clay. The result is clay that's easy to handle for glazing. The pot, or whatever, is still sufficiently porous to absorb glaze. In order to hold water the bisque pot must be refired at a high temperature, either with or without a coat of glaze. One potter I know reverses the usual maturing-fusing stages of the firing process. For the first firing she fires high so the pot becomes vitrified and can hold liquids. Her second firing is low so that the glaze she applies over the fired pot can be either a low or high fire glaze, and she has no problems with this. There are no hard and fast rules.

THE GLAZE MENAGERIE

A glaze when it has fused is glass. There are so many different glazes that I want to tell you about some--so you'll know what's happening when you make selections at the craft shop. I'd advise purchasing ready-mixed glazes rather than mixing up your own formulas, etc. For one thing, most books on glazes seem to be written for the MIT student. My first pottery teacher was working on her Ph.D. in ceramics at Southern Cal when she was offed by all the weird chemicals.

Time was when there was a mystique about mixing your own glaze. It was secret knowledge, with everyone holding on to his private (he thought) little discovery. But the word is out, and has been for some time: commercial glazes can give you consistently a better glaze than you can obtain

through random experimentation. Many potters with years of work behind them do not mix their glazes. I don't really put down getting into mixing your own recipes. It takes know-how, and eventually you may want to do it. I'm just happy that ready-made glazes are no longer referred to as the means and ways of little old ladies in hobby shops. There is plenty to do in concentrating on the essence of the item you're making, its form, color, size and whether you want a design or not and if so, what kind.

To give you an idea of what's involved if you were eager to start mixing your own glazes, you'd have to start with the knowledge that all glazes are composed of THREE BASIC INGREDIENTS: 1. Flux: any chemical which makes the glaze flow at a certain temperature; 2. hardener: used to stabilize the flux so it won't flow beyond a certain temperature; 3. fixative or adhesive, which will make the glazes stick.

These combinations form a transparent, non-colored glaze. Add color and you get a colored transparent glaze. Add an opacifier (such as tin oxide), plus the base glaze makes a white opaque (chalky) glaze. Clay, plus a colored transparent glaze makes a dull or mat glaze. Course, there's lots more to it than that. You'd also need a gram scale for measuring out dry glaze.

TYPES OF GLAZE: Basically there are three types of glaze (they're ready mixed at ceramic shops): 1. shiny; 2. semishiny; 3. dull. Shiny glaze can be transparent or colored-transparent, which allows the whole body of your piece to show through. It should be the consistency of milk, should you have to mix it with water. Glossy is also shiny but allows only slight traces of the body to show through. It should be heavier than milk. Semishiny glaze, such as enamel, is less shiny than the above. It's applied in a heavy-cream state. It is a bit more opaque (chalky) and hides the item. A thin coat however, will act like gloss. Dull glaze has a mat surface and is always opaque. Antique glazes are dull but have the habit of changing continuously and sometimes leave shiny spots. Mat is applied thicker than heavy cream. The ceramic shops will probably have preglazed tiles to look at to help you select a glaze. Ready-to-use liquid glaze is most expensive. Powdered forms have to be mixed with water (about 50 to 65 per cent), and sometimes the directions on the package tell you to add a mixing solution and screen the wet glaze through a 80- to 100-mesh screen (also in your local ceramic shop). The mix may have to stand twenty-four hours before using. But, powdered glaze is the least expensive way to buy and, should you buy a colorless base glaze, you can add your own colorant and water.

No single glaze will always react the same way. There are too many variables such as temperatures, different kinds of clay, etc. One glaze can be put over another for different effects. If you have your own kiln it is easier than having to take your pots somewhere else if you want to put them

through many firings. Each slightly higher temperature changes the look of the glaze.

WAYS TO GLAZE: There are four methods of glazing: pouring, dipping, brushing, spraying. There's not much to it. You'll probably pour if you don't have a big supply of glaze to dip into. Brushing should be done with a large soft-hair brush. Dab, don't stroke. Brushing is all right for small pieces, but for large ones it might come out unevenly. If you have to spray, do it outside with the breeze going away from you. Otherwise you get into protective masks, ventilation booths, and all that jazz. Everyone's hip that nothing is healthy to breathe but clean, fresh air--when you can get it.

Bottoms of pots shouldn't have any glaze. If they do, they stick to the kiln shelf. Paint some wax on the bottoms of pots so the glaze won't stick there (I talked about wax in the section on how to apply slip).

To glaze the inside of pots, pour glaze (it could be thinned here a bit) inside with a cup. Swish it around to the top edge. Pour out excess. All pots should be glazed on the inside if not on the outside. It makes for easy cleaning. To pour on the outside, place the pot on some chickenwire, a couple of boards, or the cooking rack of an oven over a pan. Pour evenly. You may have to adjust the thinness or thickness of the glaze. See what you can do with it to get what you want.

GLAZE DERMATOLOGY: Since doing pottery is complicated, there are many variations to what happens. You're always experimenting. Don't let any puritan pieties get in your way. A farmer once told me that if you like a plant, then it's a plant; if not, it's a weed. So if you like the way your pot comes out of the kiln, then it's not a defect. If you don't like it, then you can call it a defect. One of my first pots is still a favorite to me even though what happened in the glazing would theoretically be called a defect. It is a red clay pot with blue and white opaque glazes sort of running down from the lip. But the white part bubbled in the kiln like lace and the blue stayed put. What an accident for me--I thought I was favored by the gods!

Here are some things your glazes could do. Crawling: the glaze pulls away from the body in small areas and exposes the clay body. Sometimes firing at a higher temperature will make it flow back. Flowing: dig this; if the glaze is fired beyond the right temperature it may flow right off the pot! Crazing: if the glaze contracts more than the clay while cooling, it will have small cracks throughout. This isn't the best result if your piece was meant for food items. But sometimes you might want this effect on the outside of the pot. Crackle glazes are sold ready-made for this purpose. Potters in China used to color the cracks and then refire the new color into them. They really had it down to something like the space control. Cracks

can be heightened by rubbing in shoe polish, ink, or acrylic colors. Peeling: Slip might have been applied to a pot that was too dry, or it could have been put on too thick. Peeling can also happen to a glaze when it is not right for the clay used. Test beforehand when you are unsure, if you want to see if you like the look of some "accident" firing. Commercial glazes are reliable and you shouldn't have any problems.

STACKING AND FIRING A KILN

If you don't buy or build a kiln of your own right off, it would still be a good idea to know a little about the firing process.

There are two ways of stacking a kiln: bisque and glaze. Bisque is easy because the pieces are really stacked. You don't need shelves. You can put one pot inside the other with the heaviest on the bottom. An evenly stacked kiln heats the best. About 1750°F. or cone 07 is high enough.

Stacking glazed pieces is more difficult, for the pots should not touch or the glazes will fuse together. Place at least an eighth-inch apart. Glaze firing takes more time.

The larger the kiln, the longer it takes to heat. The kiln is heated slowly with vent holes open to let out moisture and vapors. Whoever is watching the kiln is given a warning that the kiln has reached the right temperature when the first cone bends over. A half hour later the next one starts to melt. Then it's time to turn off the kiln.

If it takes eight hours to reach your cone number, it will take twice that time to cool. The door should be cool enough for bare hands before it's opened.

A LITTLE EARNEST PREACHING [PLEASE FORGIVE]

A misquote from somewhere goes: "The fashioning of shapeless matter, like clay, shows man's drive to impress himself upon the external world."

Remember, you are free to choose your way to do a piece of pottery. For the past thirty years pottery has gone away from decoration--shape and glaze and texture have been everything. Also, muted colors have been preferred because they are believed to be more natural to the clay itself. Pottery books imply this is the "modern" way! Another taste dominating this modern trend is for the crude look. But don't be intimidated or you won't be awake to all the possibilities of contrast or even to the current changes in the pottery world itself. Thinking in terms of opposites helps.

Picasso did drawing on pottery and he is a painter. Some potters think

drawing should be seen on paper only, never on pots. If that's true, then why is there so much elaborately drawn-on pottery in the Egyptian, Greek, and Oriental rooms of the Metropolitan Museum in New York, not to mention the Museum of the American Indian?

Currently, a few potters are breaking away and doing pottery with clear geometric designs and pure color. The designs suit the shape and size of the pots. These potters feel that scale, shape, and color are amplified by their choice of decorated patterns. All modes, thank Allah, are open to you unless you're working a production-line number and don't have time to get deeper into your own thing.

WAYS TO MAKE THINGS-OR-HOW TO WORK YOUR WORK

SLAB-HAPPY: Making slabs is a method of building a piece. First, wedge the clay you're going to use, then roll out with a rolling pin. To get an even thickness, use two pieces of wood as thick as you want the clay slab (three-eighths of an inch thick is good) as in Figure 5. Cut shapes out with a knife (these will be joined to make a complete object later on).

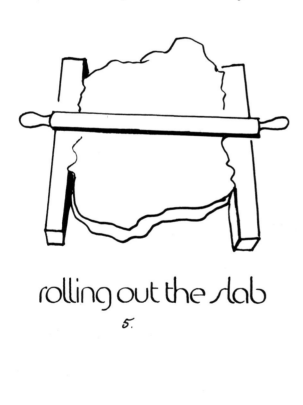

rolling out the slab
5.

cutting out the slab
6.

Decoration? Anything can be pressed on a slab of clay to make impressions. Use the end of a ruler or the side of a piece of wood or a glass to stamp out circles. Anything goes. For textural effects, slab work is a natural.

Put the cut out parts (say, of a box) on a plaster bat to stiffen. Weight them down with bats or the parts will warp. No air gets underneath, so turn them over once in a while. This will take from twenty minutes to two hours. In the leather-hard state they can be lifted in the hands without bending.

7. scoring two slabs

Joining pieces is done by scratching grooves into the clay with a fork (scoring). Loose runny clay (slip) is put on over the scored joints. Then the joints are fitted together by working both pieces with your fingers. Reinforcement is done by pressing a smoothed coil, not leather-hard, into the joint.

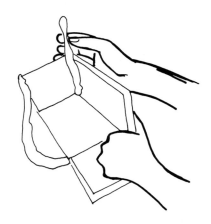

8. reinforcing corner

A simple lid for a box can be made by using a slab of the same size as the one on the bottom. Add slab strips to the underside of the slab top. Make sure they are indented in enough from the edge to fit inside the box lip.

Rather than have just the flat piece for the bottom (called "foot"), you might want it raised a bit. Strips cut at right angles and put on flat by welding is one way. Welding is done by putting some water on each part to be joined. Then rub that area until the surface loses its shine and becomes tacky. All you have to do is press them together and they stick. Beautiful!

The example of making a box (Fig. 8) is only here to show you the method of using slabs. It can be varied greatly. It can be combined with the coil method I'm getting to. Figure out what you want to make with slabs and build your own construction.

COIL (A LONG AND WINDING ROAD): Start with the amount of wedged clay you think you'll be using. Coils can be any thickness or length. The smaller the piece the thinner the coils, generally. Twist and roll a piece of clay in your hands until it becomes a coil the size you want. Then finish it off by rolling it with your fingers on a wet piece of canvas, a bat, or wedging table. Cover coils with a wet cloth so they won't dry out until you use them.

Coils can be joined any combination of ways. Welding is especially good if your clay is starting to dry a bit. You can also pinch the inside wall of the coil to each previous coil.

A base can be either coil or a piece of slab. If it is a coil, just wind the coil flat on the table until it reaches the size you want. Then add the first coil on top of it. To make the shape slope in, put coils slightly towards the inside edge of the previous coil. To make the form curve out, or become wider, add the next coil to the outside edge of the previous coil.

Coil work can be completely smoothed over both inside and out. The American Indians did pots that were so smoothed over that they almost look like wheel-thrown pots. Sometimes they simply left them unworked for a decorative effect. Scratching a design, with vertical and horizontal strokes on the horizontal unworked coils, produces interesting effects.

To make open coilwork pieces such as hanging lamps (so light can shine through) or a fruit bowl (so air will reach the underside of fruit), just wind coils into circles and undulations.

If you happen to like the shape of anything you have around--glass, tin can, a cottage cheese carton, or a museum piece you found in a rummage sale, you can use it as a form for open coil work. Turn it upside down.

First cover it with wet newspapers and then cover it with a lace design of balls and open circles laid out flat and joined together on the form. The top can be of one coil. Leave this until firm, but remove it from the form as soon as you can before any real shrinkage begins, which will cause it to crack.

rolling out the coil

9.

ring of coil on base

10.

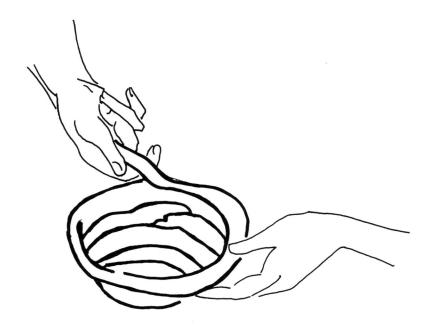

11. building the shape with
the coil

12. coils stacked

13. smoothing out coils

smoothing out coils

14.

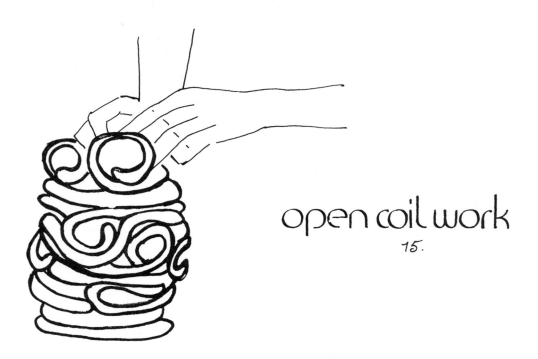

open coil work

15.

REVOLUTION AT THE WHEEL

One has to have a wheel in order to do a wheel-thrown pot. When you feel the urge to start you can always find wheels in ceramic workshops. High schools usually have adult education classes that cost little--and they have the precious items necessary like wheels and kilns. There may be a private work shop going on where you can do wheel work, or maybe you have a friend who will let you use his.

There are many kinds of wheels you can make or buy. In almost any area there is usually someone who makes wheels. Individuals who make wheels advertise in craft magazines as well as the commercial factories.

Someone told me about the most ingenious self-made wheel. His friend had found a front car wheel in a junk yard with all the brakes and springs and junk attached. He dug a hole in the ground and filled it with cement. It was deep enough to push all the stuff in back of the wheel in the cement. The wheel was then in a raised horizontal position. He also took off the tire and filled it with cement for the kick wheel. After it hardened he put the wheel back on. Next he removed the hubcap and carefully filled the center part of the tire with plaster so it was level. He uses this in much the same way primitively built wheels are used: He kicks the cement wheel and gets it going the speed he wants and uses the center plaster part to throw his clay on. It is low, so one advantage is that he can stand up over it and work on very tall cylinders.

Buying a wheel involves a lot of decisions: whether you have the room for one, cost considerations, and what type you want. Assuming you have access to a wheel, I'm going to describe how to throw.

CENTERING: This is the first phase. Throw down a wedged piece of clay about the size of an orange or grapefruit. The wheelhead must be dry. Clay won't stick to wet metal. To work on a plaster bat, pour runny clay on the wheelhead, wet the bat and stick it on the wheelhead. Clay will stick better to a damp bat. The bat can later be removed from the wheel-head with the pot still on top and left to dry, which is an advantage. The orange-sized ball of clay must be thrown with enough force to make it stick. This is why working at the potter's wheel is called "throwing." Pat and push the clay to get it more on center. If the throw was way off, do it again. A small bowl of water, plus sponge, plus modeling tools should be near you. Wet your hands so there won't be any friction between your hands and the clay. Now get the wheel going at maximum speed. Brace your elbows against your body and press on the side of the lump with right hand while the left hand presses down on top. Another method of centering is to put your hands around both sides of the clay, forcing it up into a cone shape. Then press it down--up and down until you feel it is centered. No one way

is the "right" way. Whatever feels "right" for you is the way to do it. Clay is tested to see if it's centered by supporting your arm in a stable position and holding a pencil toward the spinning clay. Your hand and arm are rigid. When the pencil lightly touches the spinning clay wall, watch to see if the pencil jumps on the edge. If so, the clay is not on center.

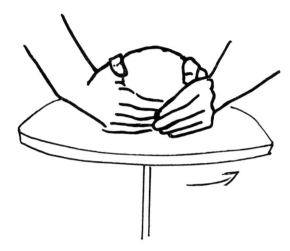

centering the clay on the wheel

16.

OPENING AND RAISING: The speed of the wheel is slightly slower than in centering. Both thumbs are pressed straight down in the center of the clay lump. Don't press all the way through the bottom. You need clay there when you build the foot.

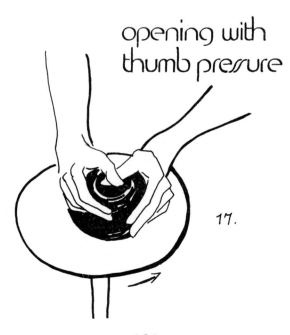

opening with
thumb pressure

17.

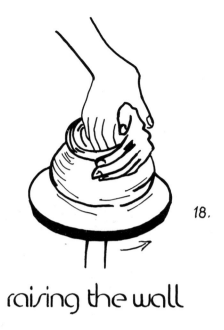

raising the wall

Thumbs move toward the fingers which are on the outside. Place your left knuckle or fingers outside the pot. Push in and up. With the inside fingers of your right hand press outward and up the wall opposite your outside fingers. Try to make the walls thin but not so thin they will collapse. Also, try for straightness. You will discover the whole thing is pressure and sensitivity to what is happening. If the wall goes out too much, choke in, use both hands on the outside to force it in. A bottle is made this way.

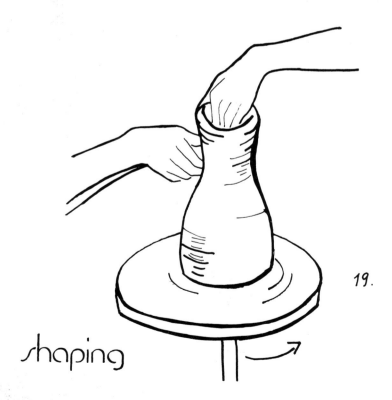

shaping

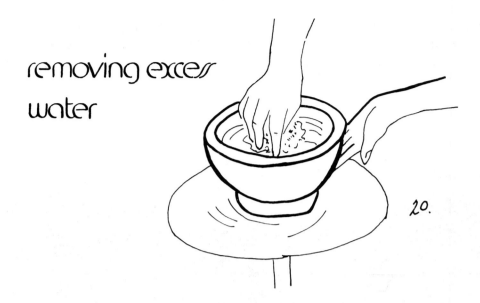

removing excess water

20.

A bowl is made by more pressure on the inside. Sponge off excess water.
Use a sponge attached to a stick for inside cylinders (the wheel is kept going
when you do this no matter how slowly). Too much water weakens the clay.

If the top is uneven, don't worry. This is common. With the wheel
going slowly, cut it off using a pointed tool. Finish with a piece of paper
towel or sponge. The walls can be smoothed with a sponge instead of
fingers.

While the wheel is still turning, trim off excess clay from around the
bottom of the pot with a wooden tool.

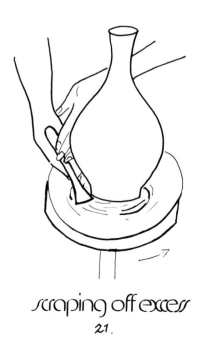

scraping off excess
21.

Remove the piece from the wheelhead by running a wire between the pot and wheelhead. If you use a bat, simply remove both bat and pot at the same time. Put it away to get leather-hard. Then you can begin to finish the bottom--or foot.

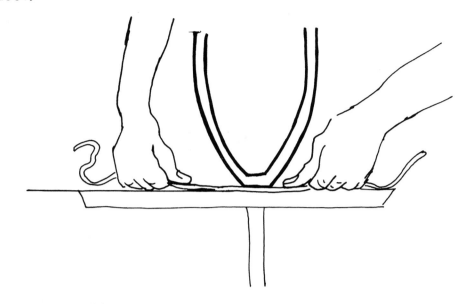

22. removing pot by passing wire under

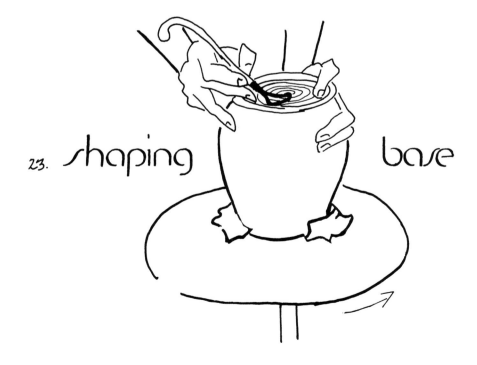

23. shaping base

FOOT RIM: When the pot is firm enough to be turned upside down on the wheelhead, make the pencil test to center it. To secure the pot, support the rim with small globs of clay. Wire loop tools are used to get the rim going. Press the tool down slowly until strings of clay are cut away leaving a raised area. Hands should be supported above the working area on some kind of rest to keep steady (Fig. 23).

SOME MISCELLANEOUS NUMBERS

A thrown pot is symmetrical and it's round. If you want to flatten the sides, press a board against either three or four sides. Paddling the sides with a textured surface of board into a square form is one variation. Corners can be raised by squeezing with fingers or the edge can be smoothed over.

Handles are usually made after the rim. The area on the pot where the handle is to set is dampened with a sponge, and a piece of wet cloth is laid on that part. A pulled handle is one that is drawn or pulled vertically from a lump of clay. Then it is bent over to form a half circle. It stiffens in ten or twenty minutes. The part to be used is pinched off. To attach: score the pot with a fork where it is to be fitted. Then use some slip. Blend it into body with your fingers. If you need more clay around the joints, a small coil can be worked in. When merging clay together, keep one hand braced inside of the pot pressing outward against any pressure on the outside. This prevents distortion. A handle can also be cut from a slab and hand shaped.

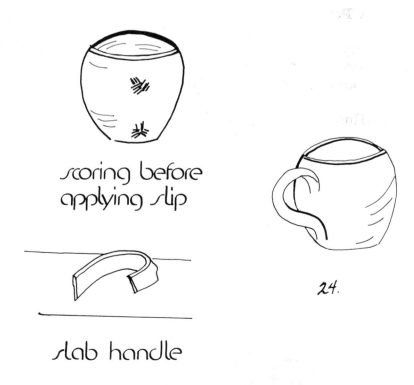

scoring before applying slip

slab handle

24.

A simple pitcher-like spout is made by pressing with both hands on the outside of the pot towards the area for the spout. While one hand is pinching the side together, the other is pulling out the spout at the edge with a finger so that it has a downward curve leading outward.

THE END—BUT ONLY THE BEGINNING

Go to the museums. If you go on weekdays the vibrations you get from items there are strongest. These good vibes are not being absorbed by all the bulk of body weight on the weekends!

Worrying about being influenced is a waste of time if not a vanity. Rather than have a sense of bad design, I think it's best to hit the museums and absorb the best. Roger Fry's Last Lectures is in paperback now and is the best thing I've read on sensitivity and vitality in art works. In the section called Vitality he says, "But the pride of the craftsman as such will always urge the suppression of sensibility in an art-object." That's a heavy thought but also a liberating one if you want to concentrate on developing your sensibility, as much as developing your craft.

BOOKS

J. B. Kenny. The Complete Book of Pottery Making. Chilton House. $7.50. The longest sections are devoted to molds. It gives some glaze and clay formulas.

Bernard Leach. A Potter's Book. Transatlantic Arts. $8.75

Daniel Rhodes. Clay and Glazes for the Potter. Chilton House. $7.50. Included are many formulas for earthenware, stoneware, and porcelain bodies.

Daniel Rhodes. Kilns. Chilton House. $10.

Home Recording
David Shaw

Music recorded at home can now almost rival studio recording in quality. This is due in part to innovations in the field of electronics like the integrated circuit, which allows one device in the form of a single chip to take the place of many parts.

In order to record live music at home, the essential things needed are: space in which to record and a basic understanding of microphones--how they work, where they should be placed, and the combining of these microphones through the use of a mixer. You should also know how to cope with such problems as leakage (which is the sounded intended for one microphone leaking onto another).

BASIC NEEDS

First and foremost you should have a good tape recorder. There are many machines of excellent quality available to the amateur: Sony, Revox, Tandberg, Teac, Concord--all are fine machines. One of the choices you have, depending on how much you are going to spend,[1] is between a one-motor and a three-motor machine. A one-motor machine uses one motor for all functions--playing, fast-forward, and rewind; a three-motor machine uses one motor for the capstan,[2] one motor for rewind, and one motor for fast-forward. Three motors will speed the process of recording, but there are many good machines with one motor. For example, I have found many Sony tape recorders with one motor to be quite satisfactory.

A second consideration is track configuration. Quarter-track stereo machines are versatile in being able to record in stereo[3] in both directions. In other words, you can play the tape through to the end, recording the two

1. Most recorders and other audio equipment can be bought at much lower than list prices through audio discount houses that advertise in audio magazines. On price-fixed equipment, you may also have to buy other pieces of equipment to get a discount on the whole thing.

2. This is the rotating shaft that pulls the tape past the head of a tape recorder, maintaining a constant speed. Some tape recorders have two capstans, which is believed to further stabilize motion.

3. Stereo versus mono: stereo is sound emanating from two sources, each source having different program material; mono is sound coming from one source only.

channels[4] required for stereo, turn the tape over and use the other side of the tape. Now it is obvious that more recording time is feasible with that sort of track configuration. The quarter-track machines enable you to play prerecorded reel-to-reel tapes also.

There are also available to the home user half-track stereo machines (sometimes known as two-track head configuration). These use the entire surface (or width) of the tape, so if you were to record in stereo using two tracks, you could only record in one direction--you could not turn the tape over. Of course, if you record monaurally (mono), using just one of those two tracks, then you could record in one direction, turn the tape over, and record in the other direction monaurally. The two-track or half-track stereo does have the advantage of a better signal-to-noise ratio, which means

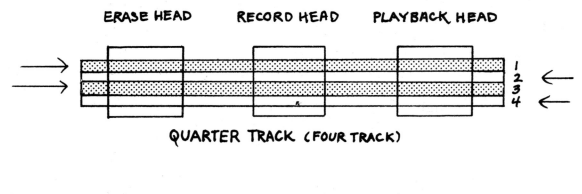

QUARTER TRACK (FOUR TRACK)

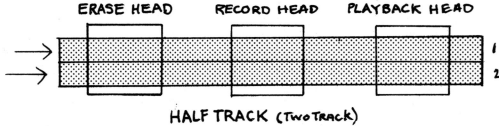

HALF TRACK (TWO TRACK)

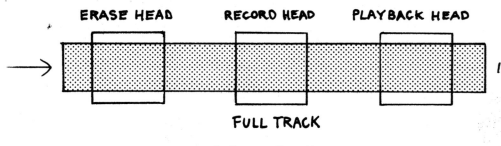

FULL TRACK

1 Tape configuration.

4. A channel is one totally separate signal path of a tape recorder or amplifier.

a quieter tape as an end result and a wider frequency range (one that takes in more lows and more highs, which makes for realistic quality).

The main consideration in making your choice of machines, I would imagine, is how serious you're going to be about recording. To attempt to rival professional quality I would suggest you choose the half-track or two-track head configuration. This head configuration is available through Teac, Sony, and Revox. All three of these makes are fine machines and come close to the specifications of some studio machines costing three or four times as much. I'm mentioning all these things about a tape recorder so you'll have an idea about what you want to get and so you'll be prepared for all the jingle jangle you'll hear in the stores.

TAPE SPEEDS

Tape speeds start at a low of 1-7/8 inches per second (ips), 3-3/4 ips, 7-1/2 ips, and 15 ips. The usual rule-of-thumb is: the faster the recording speed, the better the frequency response and signal-to-noise ratio, which in the end will mean a quieter, more brilliant recording. I would recommend never using less than 7-1/2 ips for recording music. This I believe to be essential, even though some machines may claim to have superior response at 3-3/4 ips. The fact is, if you use 7-1/2 ips or 15 ips, it will be better. Music requires a full frequency range. Again the Teac, Sony, and Revox recorders offer an option of 15 ips and 7-1/2 ips speeds combined and another of 7-1/2 ips and 3-3/4 ips combined. Again, if you are on the serious side, I would recommend the 15—7-1/2 option.

Another option that you will probably encounter is the option of two or three heads. On the two-head machine you have an erase head and a combination record and playback head. The three-head machine has separate erase, record, and playback heads. Now, the two-head machine does have one advantage over the three-head machine, and this is when you overdub (or record sound on sound) with a two-head machine, your final product can be played back in stereo. In other words, both tracks one and two can be played back simultaneously with no delay. On the three-head machine this cannot be done; since there is that space between the record and the play-back head, there will be a delay between the two tracks, so your final pro-duct will be monaural. One of the advantages of the three-head machine is that it enables you to monitor during recording; that is, to listen to the play-back of the recorded sound through the playback head while the record head is proceeding with the taping. This enables you to hear exactly what is going down on tape. With a two-head machine, all you are able to hear during recording is the signal as it comes into the machine--not the signal after it has gone on the tape.

Another advantage to the three-head tape recorder is that it can produce echo. Echo is a delay between the live signal (that is, the original signal on

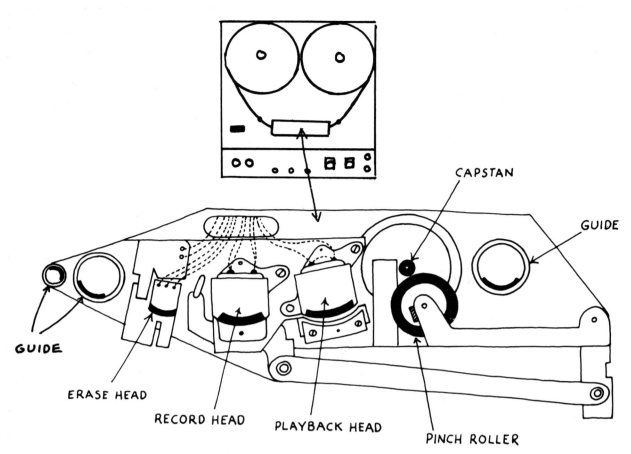

CAPSTAN

GUIDE

GUIDE

ERASE HEAD

RECORD HEAD PLAYBACK HEAD

PINCH ROLLER

2 Tape deck and detail. Black areas should be cleaned and
demagnetized before each recording and during long sessions.

the tape) and the played-back signal. Echo can be used in a variety of ways.
You can add echo to an existing recording, or you can add echo while the re-
cording is taking place. Again, this needs experimentation and playing
around with. Echo has the quality, if used subtly, of making a recording
sound like it was taped in a live room or a concert hall. Applied to a vocal,
it makes it sound very large. But too much echo is just a drag.

I would say, on the whole, that the three-head machine is superior to
the two-head machine, as it offers you the capacity of monitoring and hearing
exactly what your tape sounds like while you're recording. Also since the
functions of each head are individual and specialized, each of those indivi-
dual parts performs superiorly. Again, though, consider the question of
cost, as on the average a three-head machine is more expensive than a two-
head recorder.

Another consideration when choosing a recorder is whether to have a
tape deck[5] or a complete machine with amplifiers and speakers. Now, as

5. A separate tape recorder without amplifier or speakers; in order to use it, you need
speakers and amplifiers.

Following is a list of home reel-to-reel tape recorders that I have used and recommend. The prices are list prices, as of this writing.

Revox Model A-77: This machine is available in the home category. It may be purchased as a quarter-track with 3-3/4—7-1/2 ips tape speeds for approximately $595. It is also available with built-in speakers and amplifiers, giving you a complete self-contained system, for slightly more. Half-track heads and 7-1/2—15 ips tape speeds are available as an option.

Teac Model A-1200: A fine three-head, three-motor tape deck listing for about $300.

Teac Model A-6010: Similar to the above but with better all around specifications and automatic reverse. Lists for about $665.

Sony Model TC-366: A great tape deck. It has three heads, three speeds and uses just one motor. It has good specifications and a switch that enables you to use low-noise / high-output tape.[6] I use this one in my studio to make copies. Costs about $250.

Sony Model 630: A three-head, quarter-track, one-motor recorder similar in specs to the above but featuring built-in playback amp and detachable speakers. For about $400.

Tandberg 6000X: Excellent machine with three heads and one motor. This one features amazing response at 3-3/4 ips. Around $500.

Concord Mark III: Three heads, one-motor deck. It has a nice smooth transport and ferrite heads (could last the life of the machine). This one sells for about $250.

In the way of portable cassette[7] recorders, the Sony Model 110 (listing at the time this is written for about $100) is a fine machine. The Sony Model 120 (listing for about $130) and the Ampex Micro-32 (for about $130 also) are satisfactory, provided you use a low-noise/high-output tape. They offer you portability and ease of operation at a moderate cost, and, by using the low-noise/high-output tape excellent recordings on cassette machines are possible.

6. These tapes have a lower level of tape hiss than standard tapes, as well as the ability to set higher levels without distorting. Scotch 206 is an example.

7. The cassette system uses a miniature enclosure housing a one-eighth-inch wide tape. With this, you don't have to thread the tape. Cassette tapes are slower than reel-to-reel, giving the same playing time on a smaller reel.

far as the actual recording and playback process is concerned, the speakers and amplifiers are of no consequence, as they do not affect the actual recording. The only difference is that if you have a recorder with built-in loudspeakers and amplifiers, you can take that machine out of the house and record live and be able to monitor over the built-in loudspeakers. This is an obvious advantage. Of course, if you have a component stereo system at home, then the deck would probably work out quite well, and save you some bucks, as you can use the amplifier and the speakers that you have available.

A headphone jack[8] on a tape deck can also be useful when taking the machine out and recording live. All that is necessary is to plug your headphones in and listen to the recording while it is going down.

MICROPHONES

Microphones are grouped into classes. There are dynamic, there are ribbon, and there are condensor microphones. The dynamic microphone is very rugged and pretty versatile, yet not too sensitive. Ribbon microphones are extremely sensitive, and care should be taken in the handling of them; particularly, they should be kept away from moisture and dust--and never stuck in front of a loud guitar amplifier or whatever. The ribbons are best suited to acoustic (unelectrified) instruments. The condensor microphones are also very sensitive and, up until now, extremely expensive. This is because they carry their own power supply, as a voltage has to be supplied to the condensor element, and power has to be supplied for a pre-amplifier, which is an integral part of the microphone. Now there is the Electret condensor microphone. This is much simpler, extremely much less expensive and gives you a very sensitive microphone. I recommend these highly for home recordings.

Condensor microphones have been used for years in studios and have proven to be of superior quality. Two of the manufacturers now selling inexpensive condensor microphones are again, Teac and Sony, and also Electrovoice. These microphones are powered by a tiny battery which can last upwards of a thousand hours. They are very sensitive and have a very clean and brilliant quality to them. These Electret microphones can all be purchased for under $100.

Microphones are also distinguished by their patterns. The most common ones are cardiod. The cardiod pattern is a heart-shaped area of sensitivity coming out of the front of the microphone. This type of pattern tends to reject sounds coming from outside of its sensitive area. It is very good to

8. A receptacle for plugging headphones into a tape recorder or amplifier.

have in situations where you are recording musicians in a very small room and want to control the leakage as much as possible.

Another pattern is omnidirectional. An omnidirectional pattern is a large circular pattern and this gives a much larger area of sensitivity to the microphone. They are useful when you are using one or two mikes in front of a group to record the entire group, without individual miking. For instance, they are particularly good when recording a live performance: you take two omnidirectional microphones, placed approximately ten to fifteen feet from the bandstand, and record the entire thing. Also, they are suitable for recording several vocalists on the same microphone, and for miking a piano and other large acoustic instruments. Mainly they are useful in recording large areas.

Then there is the bidirectional mike, which has an area of sensitivity resembling a figure 8. If two vocalists face each other with a bidirectional mike in between them, both will be picked up by the microphone, yet the sounds coming from other directions will be rejected.

On the whole, I would say that most microphones you are apt to deal with will come in two main categories--the cardiod and omnidirectional-- and I would suggest that you more or less try to build up your collection of microphones within these two patterns. I believe that between the two, you will be able to cover almost any situation.

If you are going to record at home in a very small room, I would suggest that you use the cardiod microphone, since it rejects most unwanted signals. If you use this microphone on an instrument it will mainly pick up that instrument and not stray sounds from other instruments.

Another distinction between microphones is whether they are of low impedance or high impedance. (Impedance is the total resistance of an electric circuit or component to the flow of current; it is measured in ohms.) The major difference here is again in the area of noise. High impedance microphones are not able to carry long cables; a maximum of twenty feet is all you're going to be able to put on a high impedance mike--any longer than this and you're going to lose quality and/or gain noise. Try to use low impedance microphones.

Low impedance microphones allow you to use great lengths of cable-- one to two hundred feet--and there will be no degradation in the quality or increase in the noise. I highly recommend their use. The Electret microphones that I mentioned earlier are all of the low impedance type.

Also in this discussion of microphones I'd like to include something about mike stands. I would say the most versatile combination is a standard floor stand plus an Atlas boom attachment. This enables you to place

CARDIOD or UNIDIRECTIONAL

OMNIDIRECTIONAL

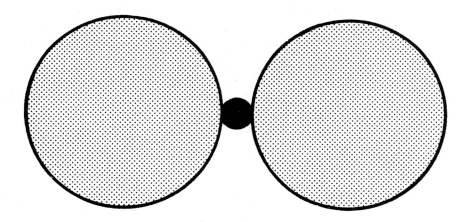

BIDIRECTIONAL

3 Microphone patterns. Shaded area denotes area of sensitivity.
Black circle indicates the microphone in each case.

the microphone in almost any position, whether it's close to the floor--such as in the miking of an amplifier--or around a vocalist, so that it is more or less out of his way, or on an acoustic guitar so that the microphone is out of the way of the player's hands. With this kind of setup you will have the most versatility.

One of the other adapters[9] available is the gooseneck, which I have found to be quite useful, if not as versatile as the boom. The floor stand and boom cost no more than $10 to $18 together.

MIKE TECHNIQUE

One thing I have found in the course of running my own recording studio is that many vocalists--in fact I would venture to say 75 per cent-- have no idea of how to "work" a microphone. Perhaps the most common fault is to go for a loud note and at the same time come in very close to the microphone--sitting in the control room it's like the sirens of Titan.

Basic microphone technique is quite simple and logical and can be conveyed in a matter of minutes to a vocalist. First you must determine how far the mike should be placed from the mouth. This distance will vary according to the sensitivity of the mike but can easily be determined by having the person sing starting from a hand's distance away from the mike (Fig. 4). Then move it away until the smoothest overall sound is heard. Once this distance is found it will become the performer's primary working area. It can be anywhere from four to twelve inches according to vocalist and microphone. If your singer has a lot of dynamic range (singing very softly and then shouting on some passages), he'll have to move slightly forward when he's singing soft, and then pull back when he's going to shout or sing a particularly loud passage. This may be hard to get used to at first but once you get into it, it becomes a highly useful tool.

You will also find that by moving closer to the mike that the bassy quality of the voice is emphasized. This may prove helpful in recording someone with a soft and thin vocal quality. When recording someone with a lot of range (blues, rock, classical) you will find a certain degree of "riding" the gain (slight adjustments in volume) may be necessary. But don't be heavy-handed. Find two points on the volume control to work between--one point for soft or normal passages and the other point for loud passages. You will get the feeling of the voice after a couple of run-throughs.

From time to time in my studio I've run into cats who couldn't be stopped from swallowing the mike; so I let them, by placing a dummy mike

9. There are many different kinds of adapters. They are all used to join one type of connection to another type of connection.

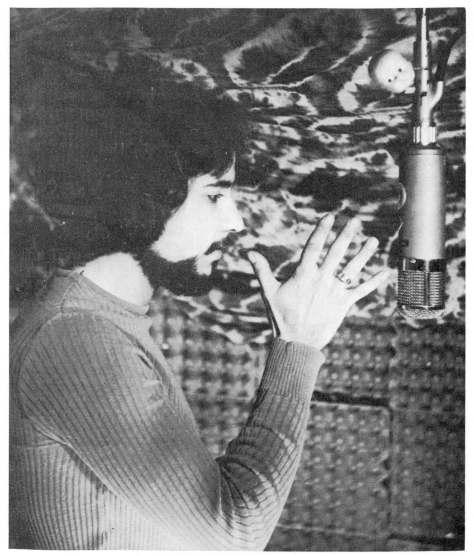

4 Gauging voice distance from mike.

in front of the live mike, right at the primary working area, and they work the dummy mike. It works.

MICROPHONE MIXERS

A microphone mixer enables you to combine the signals from one or more microphones and to set the levels of these microphones individually, combine the sum total of all these microphones, and place them on a single channel of your tape recorder. For any serious recording work, I highly recommend the use of a mixer. There are several inexpensive mixers that are quite suitable for home purposes. They are manufactured by Sony and Shure. The Sony mixer--MX-12--lists for $99. You can mix separately six separate sources on the Sony, and it has a stereo output, which means that you can use three microphones on one channel and three microphones on the

other. This mixer also operates on batteries, so you can take it out in the field, and do live recordings in clubs or whatever. It has slide-type volume controls, which are easily read, and comes with a VU meter[10] built in, so it isn't necessary to look at your recorder's VU meter--you just watch the meters on the mixer.

I would also recommend a combination of two to six Sony Model ECM-21 or ECM-22 Electret condensor microphones and a Sony Model MX-12 stereo portable mixer for excellent results.

The Shure mixer, Model M68, which is also available for under $100, is a very fine mixer. It will accept either high impedance or low impedance microphones, and has a high impedance output which adapts to most home tape recorders. It has a very clean quality, and although it does not enable you to record in stereo, as the Sony does, the purchase of two of these M68 mixers would give you that capability.

OTHER ACCESSORIES

One accessory that should be purchased along with your tape recorder is of the utmost importance. It is a head demagnetizer. The friction of the tape passing across the heads as well as the guides, capstan, and rollers on your machine over a period of time builds up a static charge, the end result being a slight magnetization of those parts. This will cause an increase in noise in the form of hiss on your recordings. The head demagnetizer is an absolute necessity, as magnetization in the parts of the machine will not only produce noisy tape recordings but can actually ruin already good re-corded tapes during playback. If you use your machine a lot, then it is advisable to clean the heads about once a week, and demagnetize everything in the tape path--in other words everything that comes in contact with the tape. At my studio the machines are cleaned and the heads demagnetized before and after each recording session. If a session is long, we clean them when there is a break of sufficient duration.

Cleaning accessories should also be purchased with your tape recorder. If they are not available, then pure alcohol and Q-tips will suffice very nicely. Remember never to use any abrasives on the heads, and always clean them very gently. You should clean them often--after every session that you record. This is a good habit to acquire. A dirty erase head or record head could ruin an otherwise perfect recording.

Another accessory that you should pick up is a tape splicer. As you get more into the recording process you will find this a definite necessity. Of the tape splicers available, I recommend the Edit-All Block. This can be

10. Used so you can see the sound and keep it at a nondistorting level.

147

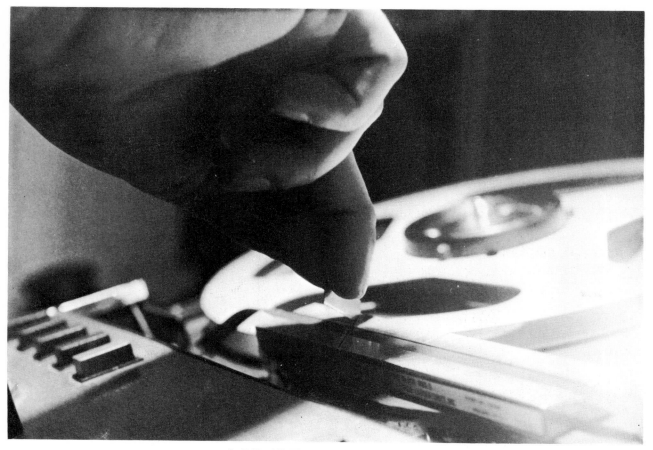

5 Edit-All Block tape splicer

mounted on your tape recorder (Fig. 5), and is available with a variety of mountings--either screw mounting or self-sticking mounting--and this will give you clean splices and excellent results. Cost: $7.50 to $9.

Another useful accessory is earphones. There are many varieties, and the important thing to remember in purchasing them is that the impedance should match that of your tape recorder. They usually fall into two categories: low impedance (4 or 8 ohms) or high impedance (say, 600 ohms). This is one thing you must take into consideration. The other thing is to compare and find which ones you like the best. Go to an audio dealer and listen to the same program material and the same amplifier with every earphone available and then make your choice. Another consideration should be comfort, since you will be wearing them for long periods of time. Choose heavily padded headphones that will block out sounds from the outside.

RECORDING LOCATIONS

Now, if you intend to do a lot of recording in your home, particularly of groups of musicians, there are some things you should know about how to treat the room in which you are recording. If it is a large room with a very

148

high ceiling and windows, there are going to be specific problems you will have to overcome: resonance, vibration, and sound bouncing over everything, back and forth--the end result will have a very noisy, muddy record-sound.

The way to overcome this in a large room is to use very heavy drapery material and cover the windows and any large reflecting surfaces, such as hard walls. The room should have a rug; otherwise vibration and sound will be transmitted through the floors from one microphone to another, also causing muddiness in the recording. If you are going to make it a permanent room for recording, one of the things you can do is to cover the walls with fiberglass insulation, having the fiberglass facing outward. You can also do this to the ceiling. Another, inexpensive way of reducing excess noise is to tack egg crates or separators onto the walls and ceiling (Fig. 6). This will

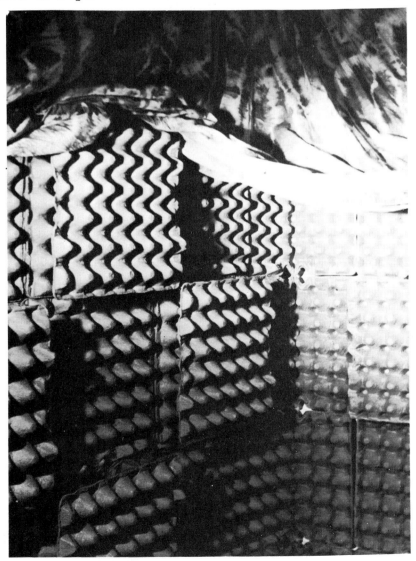

6 Egg-crate baffles on walls, cloth for ceiling absorption.

cut down considerably on the reflection of sound, which will be absorbed. Egg crates are inexpensive, easy to get, and very effective.

Also when you are recording electric instruments, such as guitars, basses, pianos, and so forth, or wherever sound is going to be coming out of a speaker, something must be done to baffle the sound. Otherwise the sound will go right into another microphone that might be placed in front of, say, an acoustic guitar. Then you are apt to get the sound of the electric instruments over the acoustic guitar. Simple baffles can be made, or things like old mattresses, sleeping bags, and rugs can be wrapped around the speaker, covering the microphone and speaker. These will be quite satisfactory. In Figure 7 a typical baffle used in a studio is shown. These are quite easy to assemble and consist mainly of a panel of masonite and fiberglass covered with burlap. You can also use pegboard, with fiberglass on the inside.

7 A studio baffle.

Another thing to keep in mind is to monitor your recording in another room, if possible, away from the room in which the music is being recorded, for obvious reasons. If this is not possible, then a good set of earphones that are well cushioned will reject a lot of the unwanted sound.

Before my present studio was built (Stone Sound Studio, Inc.) I made a studio in the one-car garage in my house. Its description may be useful because it illustrates what can be done with limited funds and scrounged equipment. First, a booth was constructed out from the wall facing the main garage door. It was small--approximately eight feet long by six feet wide. The sides were constructed of two-by-fours covered with siding. Thick fiberglass insulation was tacked to the outside (fiberglass side out) and covered with burlap. The walls and ceiling of the studio were covered with egg crates and the cement floor was covered with old rugs.

The "board" (or recording console) consisted of two high impedance, public-address-type mixers. For a recorder I had a Revox A-77 with half-track heads and 7-1/2—15 ips tape speeds and an assortment of Shure 545 and AKG 1000E microphones. I didn't have any baffles, so I used mattresses to surround loud guitar amplifiers, and rugs and sleeping bags suspended from the ceiling to isolate drums and vocalists. The setup was a bit crude, and perhaps the signal-to-noise ratio was kind of high, but nonetheless, some mighty fine recordings were made there.

WHAT TAPE TO BUY

In the past several years there have been many innovations in tape as well as in electronics. There are available many low-noise/high-output tapes, such as Scotch 206 and 207, Sony SLH, and Advent Crolyn tape. Whereas normally you would record at a level of zero VU on your recording meter, these tapes enable you to record at plus-one VU, and as high as plus-two VU. Since the hotter you record, the quieter the finished product (as far as noise is concerned) I strongly recommend the use of these low-noise/high-output tapes.

VOLUME LEVELS WHILE RECORDING

When you are using a multiple microphone setup with a mixer, the recording levels (that is, the volume as seen on the VU meter) are very important. Levels that are too low will sound very noisy on playback, and there will be an increased amount of tape hiss. On the other hand, recording levels that are too high will cause distortion on playback. So it is within the middle ground of these two that you must work. Again, with the low-noise/high-output tape you can reach levels of plus-one or plus-two VU without distortion.

You may find that on many home tape recorders it is possible to record

well into the red without distortion. This is a safety precaution put in by the manufacturer so that the inexperienced user won't blow a recording because he set levels too high.

The best way to determine the right levels is, prior to recording, to have the instruments play as hard and as loud as they will be playing during recording. This will give you an idea as to what maximum level will be coming in. You should set your recording levels for zero if you are using standard tape, or plus-one or plus-two if you are using low-noise/high-output tape. This will ensure that you do not overload or saturate the tape on a loud passage. Again, there is no definite rule concerning recording levels. You may find that the music is, on the whole, very soft and quiet, but plus-one or plus-two VU during a loud passage. In this case, you should listen and compromise on the best levels. Remember to keep the levels as high as possible without distortion.

MICROPHONE PLACEMENT

Microphone placement differs according to what is being miked. For a vocalist, a good thing to remember is to place the microphone at least six inches away from him (see Fig. 4). Again, it depends to a large extent on the type of microphone you use and the individual's vocal dynamics. If you are using a condensor mike, which is much more sensitive, you can get a foot away from the microphone. The disadvantages of miking a person too close is something known as the "proximity effect"; that is, when a vocalist is too close to the mike, the bass response of the mike is boosted. Of course this quality may be pleasing or you may find it to be a drag. For the flattest response, six to twelve inches away for recording purposes will work out fine.

Again this is using a cardiod microphone. It is good to imagine when dealing with a cardiod microphone, the heart- or mushroom-shaped area of sensitivity coming out of the front of the microphone. In this way determine where proper placement is going to be. In the photos (Figs. 8-10) you will see some common microphone placements for drums, an amplified electric instrument, and for an acoustic guitar.

At this point I'd like to briefly describe to you a typical public-address setup. You may run into this situation if you record a live rock group. The microphones will probably be cardiod, of the close-talk type (ball mikes), as they reject feedback the best. The mike cables are run out to the mixer, which should be located out in front of the group and the speakers. In the drawings (Figs. 11 and 12) you can see where mikes should be placed depending on how many you have for recording a group.

The speakers should be placed to the left and right of the bandstand but in front of the microphones (once the sound from the speakers is picked up

8 Miking drums. Clothes are being used to
absorb some vibrations in the photo
on the right.

9 When recording an amplified electric instrument, a mike should be placed at the speaker.

10 Miking an acoustic guitar.

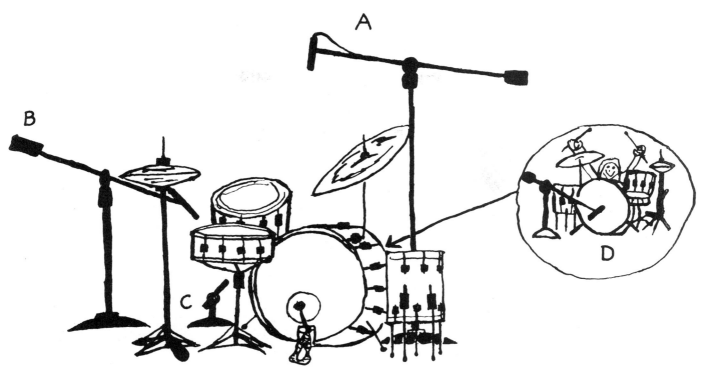

11 Mike priority placement for drums. If one mike is available, use
it in position A; if two are available, use them in positions A and
B; if three are available, use them in A, B, and C; if you have four,
use them in positions A, B, C, and D.

by the mikes, feedback results). A sound test should be made while the
group is singing and playing, and the individual mike levels set. If there
is a master volume-control, its level should be brought up to the feedback
point and then backed off till feedback stops. Using a grease pencil you
should mark this point. The reason for this lies in the fact that when there
is an audience present, the bodies are going to absorb sound, and you may
need more gain than you think. During the sound test, walk out into the
room to see if there is any unpleasing overall quality to the sound, such as
bass heavy or a very shrill quality. If so, and if your mixer or amp has EQ
(bass and treble controls), adjust them accordingly and try to smooth out
the overall response.

Feedback is the main hassle in 99 per cent of public-address situations.
Another way to fight it is to slant the mikes slightly up--not in a straight
line with the amps and drums directly in front of them.

FURTHER POSSIBILITIES AND SPECIAL EFFECTS

For those of you who are more adventurous, there is the possibility of
multi-tracking at home (sound on sound). The first step in multi-tracking
is to record the basic track at the highest level possible without overload.
This will ensure that on later generations of the tape, this basic track will
not have degraded in quality or added any more noise than that added by the

155

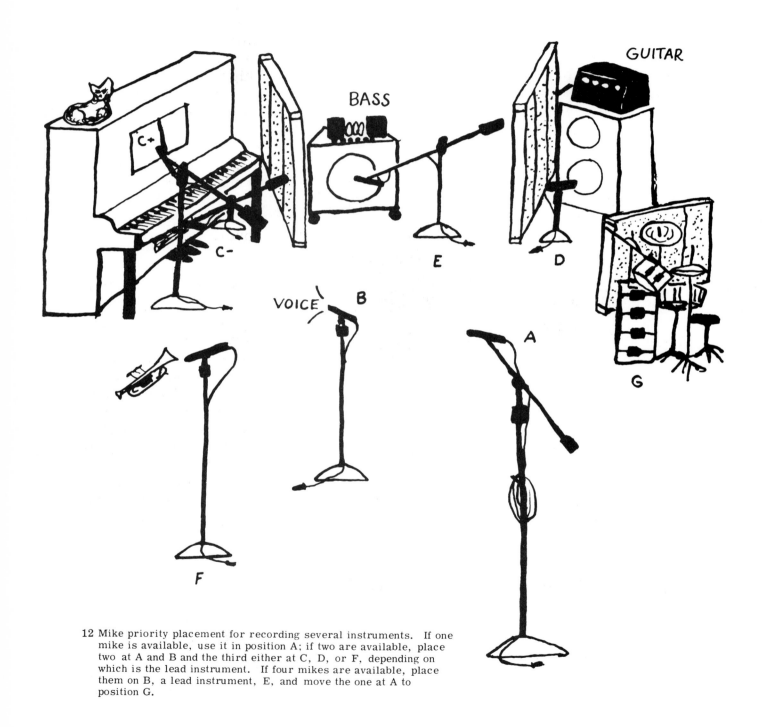

12 Mike priority placement for recording several instruments. If one mike is available, use it in position A; if two are available, place two at A and B and the third either at C, D, or F, depending on which is the lead instrument. If four mikes are available, place them on B, a lead instrument, E, and move the one at A to position G.

generation loss. After you have recorded your basic track with as hot a level as possible, the output of the channel that it was recorded on is then fed into the line input of the channel that you are now going to record on. Along with this, add a microphone through the microphone input of that channel.

In a more sophisticated situation, the output of the channel you've recorded on is then fed into a mixer, where it is combined with live signals from mikes, or other sources such as tape recorders and phonographs. Then the ratio of your basic track can be blended and mixed with your live sources. The output of this mixer is then sent onto the open track of the recorder--track 2, we'll say. Once again, to get the highest recording level without distortion is of great importance. Now your original track is combined with the live mike and exists on channel 2. You are now free to erase and record over channel 1.

This is done as before--you take the line output of channel 2 and go directly into the line input of channel 1, or through the mixer that I have just mentioned. This can be done back and forth for many generations. Of course, noise will be added to each succeeding generation. Again I stress hot recording levels, for this will improve the overall signal-to-noise ratio.

Something that can greatly improve the signal-to-noise ratio on multi-tracking is the B-type dolby unit, such as the Advent Model 100, the Teac AN-180, AN-80 and AN-50 B-dolby units. The dolby system is a two-step process involving recording and playback. In the recording process, it will boost all low-level, high-frequency signals but it does not affect the program material in any of the other frequency ranges. Its compression-expansion action works mainly in the area between 5 and 10 kilocycles (kcs). On the playback, the exact opposite is done with the signals. While recording, these frequencies were boosted when low levels were coming through. On playback, they are attenuated, or brought down a level, so again they are in proportion. What has been accomplished essentially is the reduction of the signal-to-noise ratio by as much as 10 decibels (dbs), which is quite a bit. In using the dolby unit for multi-tracking you must remember the two-step process: dolbyizing is done while recording; de-dolbyizing is done by playing back through the dolby.

FURTHER ADVENTURES FOR THE BRAVE

We will say that the basic track on track 1 was recorded with a dolby unit in the record mode. That track must be de-dolbyized before it goes to track 2. Now the signal from the live mike being recorded on channel 2 must be recorded flat--not through the dolby at all. This may seem like a problem, but it doesn't have to be one. Again, with the use of your mixer

and with the in and out capabilities of the dolby unit, all these functions are possible.

In the next step, program material which now exists on track 2 is going to be sent to track 1 once again. In this phase of the process you will again have to dolbyize the transfer; in other words, the dolby in its record mode. Since you're dolbyizing, the microphone can also go through the dolby circuits as well this time. Now on track 1 you have dolbyized a track and mike, so you're back at step one again. Now, how many times this will work depends on the quality of the equipment that you're using and what the program material is. Experimentation may yield some exciting results.

The possibilities in the use of two machines will expand your capabilities by 100 per cent. If you have a second machine and a stereo amp or preamp you can place it between the two machines and make a copy of an existing tape while rebalancing and perhaps changing the bass and treble settings before they reach the second machine. In so doing, you may be able to improve a deficient recording.

While making a recording you may use a second machine for echo--if the second machine is a three-head model. While you're recording in stereo on the first machine, either track or both tracks may be sent out via their line outputs to the line inputs of the second machine. Then this machine is placed into the record mode while the tape is monitored. The outputs of the second machine are sent back to the record inputs of the first machine, either through a mike mixer or through the line inputs, while using the microphone inputs with the microphones you're using for the recording. By controlling the strength of the signal coming back from the second machine you can add echo to this recording. Using a very slight amount will add spaciousness and make it seem as though you had recorded in a large room. By bringing up the level of this second machine you will hear the actual repeats--this may also be used as an effect.

Another possibility for two machines is that of overdub, but instead of an inter-machine overdub--using two machines--your basic track can be recorded on both channels of the original machine, which will give you a stereo basic track. After this has been completed, the line outputs of your machine are sent again--either directly or, preferably, via a mixer--into the line inputs of the second machine. The first machine is played back; the second machine is placed in record mode, and the basic tracks plus the microphone have been transferred to the second machine. Once again, you may take those tracks and go back to the first machine with them through the line outputs of the second machine into the line inputs of the first machine. Again, through the use of a dolby unit in between the two machines, the possibility of innumerable machine transfers exists. Again, it is a matter of experimentation.

CONCLUSION

You should by now have a basic understanding of recording equipment and how to use it. If you need further information, a good source is manufacturers' literature, which you can write for on reader-reply cards from audio magazines. One person I know asks help from people already using equipment, and once, when really at a loss, he called a local recording studio, and their engineer solved the problem.

Beads
Betsy Sife

Six months ago--once upon a time--I fell in love, so strangely that nights were never seen, and days were sunny and fine from one to the next.

This young man was a fine young man, and so much did I love this child of fate, that all hours were devoted to self-discipline, which I based my responsibilities and work upon.

Every thought of joyous and caring moments put this light heart through such incredible changes, that to create something out of my emotional gratification seemed quite momentously important.

One summer afternoon, I sat outside as evening fell and thought in my penniless state of affairs about the possibilities on which my concept of this feeling would be created.

Anyway, as luck would have it, that night was the beginning of a new creation. . . . a structural breakthrough, glorious, glittering, very far out, and quite inexpensive.

And, oh yes! If a glittering, slightly very far out structural breakthrough is attached to the person or thing you happen to create it for, that breakthrough might just break through if you don't get into using strong thread or dental floss. Be it a mad head playing lead guitar, or some bean-bag that just feels lonely--don't be a fool, start out by having the right material (and plenty of time!). Anyway, my instructions to you are tried and true. His first necklace, through the process of youthful energetic activities and vast appreciation, was completely destroyed.

The next step was another similarly constructed frame for dear Porfiro, lending a slightly flighty mind a sort of starrily surrounded sunburst. Which after completion was also totally destroyed. You see, he practically begged me to make him a new one, but being not quite as strong as it should have, the same old disaster led up to the same old hassle.

Anyhow, now I've got it down! Peace be with me! (Even if Viet Nam is in a state of transitional disaster.)

And so in the past few days and months, friends and things of many shapes, colors, and sizes have received from Betsy's little color-factory

structural creative breakthroughs. . . . such as solid one-color things and many quite absurd combinations, such as only green and red. If you happen to be a Christmas-tree fanatic, why not? Or maybe red, white, and blue if you get off on patriotic (in one way or the other) fads.

So dig it, and, by the way, begin with some sort of symmetrical design from which strings and patterns can flow.

Another little insanity to take note of, is that it's really a stronger image if the overall design is not <u>completely</u> symmetrical (don't be a perfectionist and what you do will have a lot more vitality)!

So, anyway, that's pretty much all I can tell you and the rest is up to your own built-in good old imagination, and by the way honey,

Good luck,

love,

Betsy

Otherwise known as

<u>**WHAT TO USE**</u> & where to get it.

◀ BEADS ▶

When purchasing beads (at least the smaller ones) keep in mind that it's a real drag if the holes are not large enough to pass the needle through. You see many beads have such tiny holes that it is made impossible to string them.

SO! Look at the holes before you buy them. Also - shiney beads are really the best with a few exceptions.

The best place to buy them (in general) would be your local head-shoppe, but realizing that you may be fairly limited, try sewing & dime stores.

TYPES OF BEADS TO USE

a - Bugle Beads · · · · · · · ⬭—⬭ } I drew these to show you approximately the exact size.
b - small round beads · · · ⊙ ●
c - intersecting beads · · · ⊙ ▣
 (with large holes)

NEEDLES & THREAD

sizes 5 - 7½ beading needles
& dental floss say it.
 * dental floss can flatten
 easily, (to slide through needle)
 by pulling it through your teeth
 or finger nails

KNOTS, ENDS, & SAFETY KNOTS

(A) - When you begin with a knot, the
major thing to watch for is that it
won't slide through the first bead.
(B) - When you begin (if you do so) with
a large bead (type c) the easiest way to
make sure it will remain on the thread
is to tie a small round bead (of the
same color as type c) then put the larger
bead on. - this way the small bead won't show.

(C.) - If you have any doubts about the knot holding, try putting a small blob of modelling glue on the knot, - (& set it down to dry.

♡ Making of the necklace ♡

When you sit down, (or at least when I do,) to make a necklace, I usually start out by making a central design, & then working around it, or should I say build onto the primary design (the center) -

Most of the time a necklace will be made up of the star pattern or variation on the star pattern (which I will show you) from which I extend symmetrically (on both sides) strands of beads which all connect at certain points. -

Intersecting Beads

they are - Beads used to join more than one strand or structure of beads. used in or at - the tip beads on the points of star figures - so that when or if you want to attach another strand or star figure to it, you can.

also - used to attach strands to each other.

Strands

they are - long single lengths of beads which attach sections together, also they go around the neck & help to develop width at the sides.

Different types of strands

★ good for just about anything, especially if you want to add width & height to the center of the bib. (subpatterns)

NOTE these are only ideas which you should vary to make yourself happy.

★ good for the main neck strand because it has many larger beads from which the center, & other strands may be attached.

★ very desirable because the bugle beads shine; a lot!

STARS

① <u>KNOT</u>. Knot a peice of dental floss aprox. 16" long.

② thread needle

③ place 5 bugle beads & 5 sm. round beads on floss in this order.

④ bring needle through first (NEEDLE) sm round bead, from knot side.

⑤ A start points of the star by placing a bugle bead, then a fairly small bead (but large enough to be passed through twice) then another bugle bead. —

B then bring it through the next round bead on the center.

C continue all of the way around.

A —

B —

C —

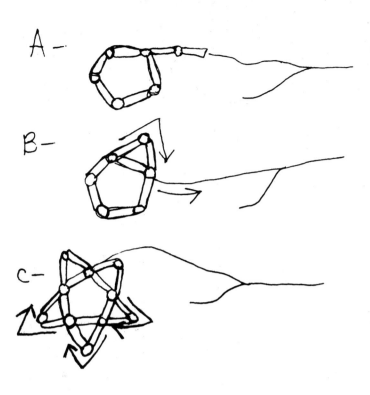

Variations on the Star

NOTE
These are only examples; use them if you like, but also use your own.

a — change number of points —

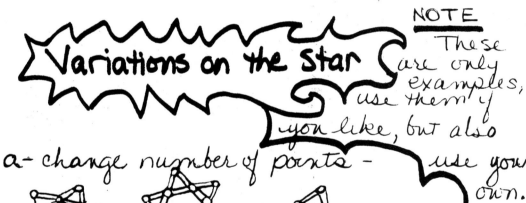

OR

b — six sided center, with 3 doubled (in # of beads) points
same # only continuing outward

c — six sided center, with doubled points.

more beads.

167

Setting up to make a necklace

have on hand — beading needles
dental floss,
all three types of beads,
at least 2 colors of each &
enough of each color to fill
½ of the bottom of an egg
space in an egg carton.
also — a light & fairly
large work space

Getting it together
/ or at least
1 way 2.

a. make a center pattern

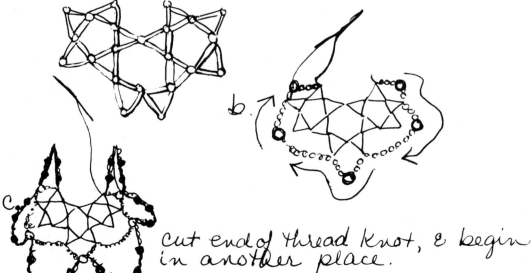

cut end of thread knot, & begin
in another place.

D.

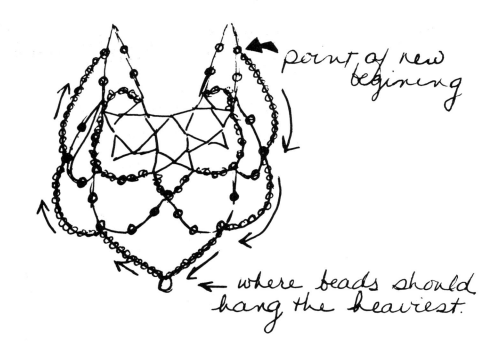

point of new begining

where beads should hang the heaviest.

E

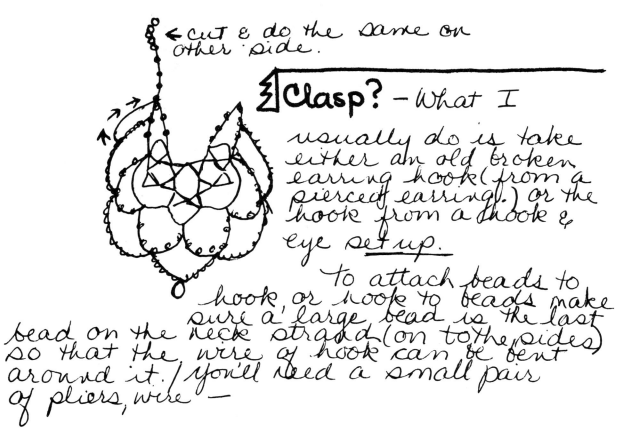

← cut & do the same on other side.

§ **Clasp?** – What I usually do is take either an old broken earring hook (from a pierced earring.) or the hook from a hook & eye set up.

To attach beads to hook, or hook to beads make sure a large bead is the last bead on the neck strand (on to the sides) so that the wire of hook can be bent around it. / You'll need a small pair of pliers, wire —

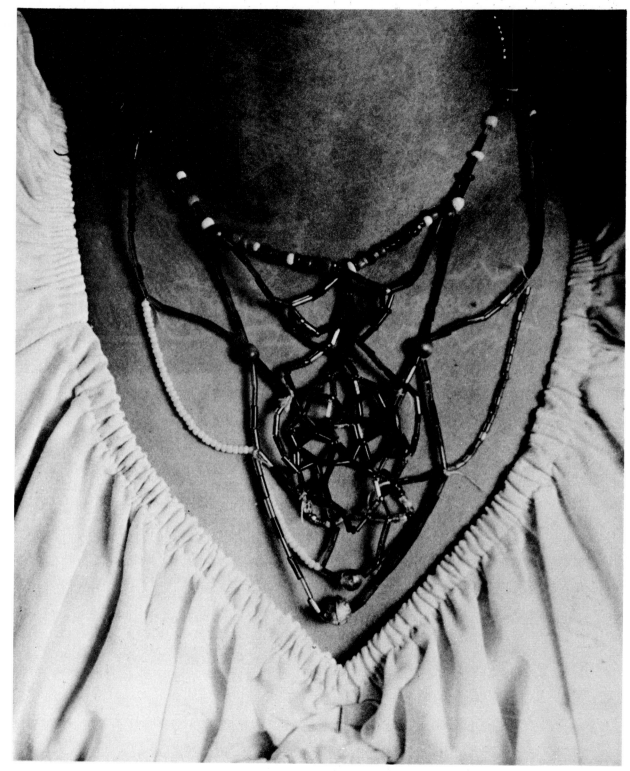

if you're wondering how the beads hang spread out, don't — because, they will!

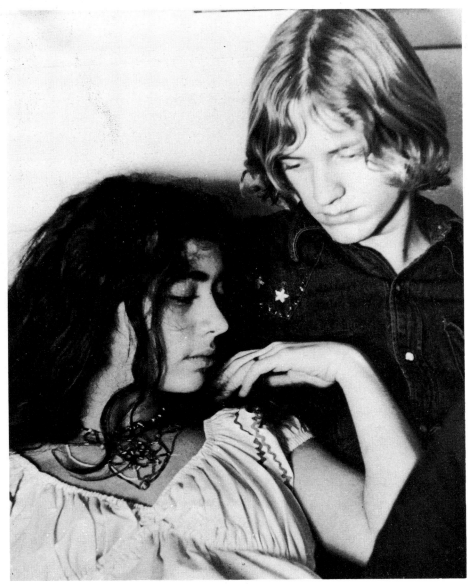

Neil likes stars too

Weaving

Sandy Sprinkling

Weaving is a groove if you love color and texture. And if you love allegory it's even better. History and mythology are full of weaving metaphor: "the warp and weft of life," "the tapestry of history," . . . You dip into a very old and deep stream of human experience when you get into weaving, not to mention the fact that you will make beautiful things to use and look at.

This chapter is an introduction to very simple kinds of weaving. If you really get "hooked" you can look into more complex weaving processes such as are done on floor and table looms. You will find plenty of good literature available on those subjects.

I got into weaving the hard way: first I learned how to use a floor loom, then a table loom. After I bought my own floor loom I had to wait several months for delivery and, at that point, I looked into what could be done with simpler materials. I found that essentially the same activity goes on with all looms: yarn is strung back and forth in parallels across a space or board as "warp," and yarn is picked over and under the warp threads as "weft" or "woof" (Fig. 1). Different combinations of warp

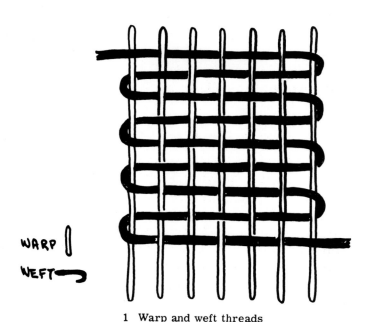

WARP
WEFT

1 Warp and weft threads

threads can be picked up to make patterns and textures in great variety. Several looms are described here: cardboard, frames, board, and frozen warp. A few basic weaves are introduced to start you on your way.

I've used the looms introduced here mainly to make small tapestries or wall hangings. You can try these out, making "samplers" to get the feel of weaving. Consider that each method you explore opens the way to hundreds of variations. Besides being a craft with which to make useful and durable items, weaving is a plastic art and needs loving attention to line, texture, form, color, filled and open space, and materials.

As for rules, well, anything you love and find works out, goes; you will find that if it doesn't work it will probably fall apart. Experiment. If you don't like what you're doing, tear it apart and start over. Be a perfectionist and you sharpen your tools and your perception, and your experience as well as your product will be of high quality.

CARDBOARD LOOM / BASIC WEAVES / USE OF EQUIPMENT

The first piece of equipment that you need is a piece of cardboard-- shirt cardboard, illustration board, or chipboard. Chipboard is a special cardboard that is flexible and strong. It comes in different weights, so you have a choice, but I recommend the medium. Art-supply stores usually sell it. You also need yarn, a large tapestry or stole needle, scissors, ruler, pencil, a wide-toothed comb and a long, narrow, flat stick or bamboo skewer.

A cardboard loom is a small project, and a small investment. You can use leftover yarn you haven't finished off in knitting, crocheting, or rug hooking projects. And cardboard is readily available in the form of shirt boxes, cereal boxes, cardboard boxes, etc. Cut a piece from any cardboard box you have around. It shouldn't be too much larger than 8 by 10 inches, or 10 by 12 inches; anything bigger gets unwieldy. The finished project will be about one inch smaller all around than the dimensions of the board.

If you want a symmetrical piece of weaving, measure off half-inch or quarter-inch intervals along the top and bottom of the cardboard. These will be the points at which the warp will be wound; the space between intervals that you have chosen will determine the density (closeness of weave) of your piece. Warp threads that are very close together will produce a closely woven piece, and those farther apart will produce an open weave. Warp intervals of one inch or wider will result in weaving that may be too loose to hold together; quarter-inch to half-inch spaces are best for this size piece. If you want to cover the warp with the weft, use larger spaces between warps. If you want the warp to be part of the overall design, use close warps.

Cut notches (V's) about a quarter-inch deep at each point you've marked. Slit the first and last notch on all four corners of the cardboard so that the ends of the warp yarn will not slip out easily.

The best yarns to use for this and most of the projects following are any of the softer wools and knitting worsteds. I don't recommend tapestry wool because it isn't very resilient, and elasticity is an important quality of weaving yarn. Also, weaving uses up quite a lot of yarn, and tapestry wool comes in very small quantities.

The cardboard is prepared and you have the wools with which to begin warping the loom. Make a knot on the end of the yarn and slide the knot into the upper lefthand notch, pulling the yarn down into the slit. The knot should be flush with the back of the cardboard, where it should remain secure. Wind your yarn around the cardboard from the top to the bottom notch, around the back to the next top notch and down again, wedging the yarn firmly into the notches. On the front of the cardboard you should be forming parallel vertical lines of yarn. Don't pull the yarn tight; it should be firm but not stretched, as it will then bend the cardboard and "kill" the yarn. The weaving process tightens the warp as you go. A general rule to bear in mind throughout your weaving is to keep everything looser than you think it should be. This seems to be one of the most difficult operations in weaving to remember. In teaching I found I had to remind students over and over again to "keep loose." So if I keep mentioning it, it's because you'll probably keep forgetting it. Tuck the end of the warping yarn into the last slitted notch and it should remain secure.

Thread a long or short tapestry or stole needle with a foot or two of yarn--you must use a blunt-tipped needle so that you don't split or pierce the warp threads. You can find these needles at a good notions counter or in shops that deal in needlecraft supplies. If you don't want to bother with a needle use your fingers.

With your threaded needle go over the first warp thread, under the second, over the third, under the fourth, and so on. Don't pull the yarn tight! Leave at least three inches of yarn before the first warps, and, if you've used yarn only a bit longer than the warp is wide, leave at least three inches after the last warps at the end also. These ends will be woven into the back of the fabric when the piece is complete and will strengthen the edges (selvages).

The next row of weaving is alternate to the first, the weft going under the warp thread previously gone over (Fig. 2). The third row should repeat the first row, the fourth row repeats the second, and so on. This "over one, under one" is called Tabby, or Plain weave. Once you get into the rhythm of the weave, experiment with different weight yarns, adding beads or whatever turns you on. Most important of all, enjoy, and let your

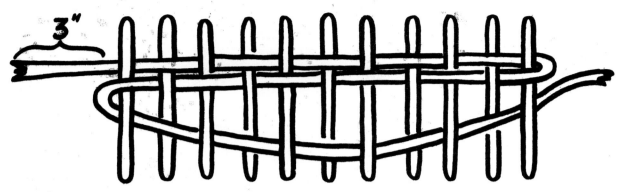

2 Tabby or Plain weave

mind run loose (like the yarn!).

I repeat, don't pull the yarn tight across the warp, as natural as it may seem. This can only lead to distortion of the selvages (side edges) and pinched, tight weaves whose textures and subtle patterns are lost. Stay loose and the resultant piece will be plush and the patterns will lie together naturally, softly. To help achieve this, what is called "bubbling" is done with the weft yarn: arch the weft yarn across each row so it is longer than the row is wide and push it with a wide-toothed comb or your fingers against the preceding row. This action is called beating in, and the comb, or whatever you use, is the reed or beater. An Afro comb is an excellent beater, though any wide-toothed comb can be used. A kitchen fork works, too, and so do your fingers. Both beating in and bubbling the weft are universally

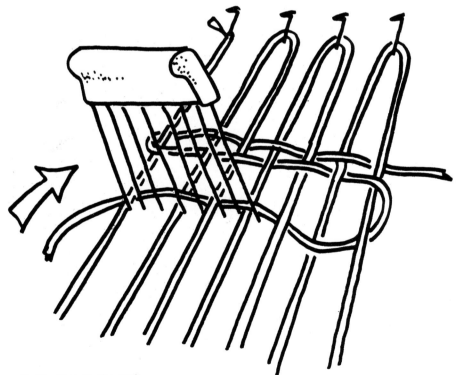

3 Beating in the weft

done in weaving whatever the size or complexity of the loom. If you want the warp to show through--that is, to be part of the design--beat loosely. If the warp is to be completely covered, beat harder. Try both ways to see which suits the yarn weight and your requirements best. As mentioned earlier, you must suit the warp intervals to the weave--that is, for a covered warp, greater intervals between warp threads; for warp as part of the overall design, lesser intervals.

While weaving, you must pull up the warp yarn that you have passed the weft under to avoid splitting or piercing the warp (which can lead to all sorts of problems, such as inability to beat the weft down, weakening the warp yarn, and so forth). To insure the safety of the warp yarn, and, incidentally, to make life easier for you, you can do this with a narrow flat stick, a narrow ruler, tongue depressor, one of those flat sticks that you find in some clothespin packages holding them together, or a bamboo skewer. Whatever you decide to use, it should be longer than the warp is wide. I've tried them all and, depending on the yarn and what I'm doing, each has proved to be useful. The bamboo skewers are handly for a lot of things. I buy them in markets that carry Oriental foods. Next time you buy sesame oil, pick up a bundle of skewers. They're also good for staking up philodendrons or as spare knitting needles. I understand they're even good for skewering.

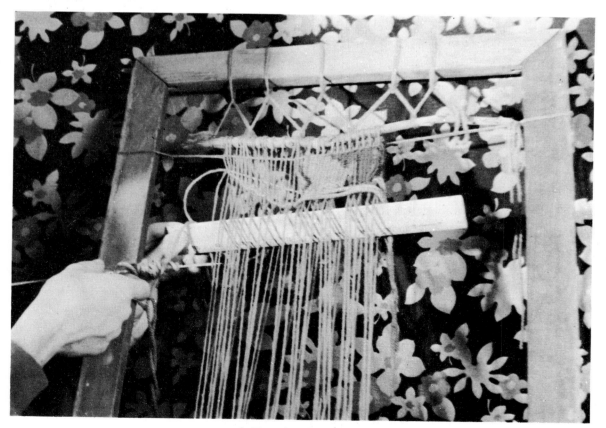

4 Use of a shed stick

Using the skewer (or stick) as if it were the weft, pass it under and over the warp, sliding it straight across the width of the warp. (If you like the way it looks, leave it there as part of the weaving!) Pull the skewer up and away from the cardboard to form an opening through which you can easily pass the weft without damaging the warp yarn with the needle. The space or opening that is formed this way is referred to as the shed. Any stick that is used to make this opening is called the shed stick. A flat stick, when used as a shed stick, may be turned on its side, leaving both hands free to pass the weft through. You must remove and replace the shed stick for each row of weaving, since the weft goes over and under different warps each time; however, you can leave one stick in for one shed permanently, and that will save having to go over and under for one of the two openings. Just flatten it. Then insert another shed stick to make the second opening. Bubble the weft after the stick is in place, remove, if necessary, and beat the yarn into place. Such is the weaving process.

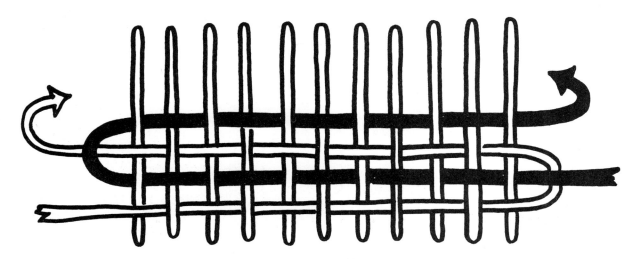

5 Vertical stripe Tabby weave

There are many variations of the Tabby weave. One is the weaving of horizontal stripes. You simply change colors of the weft yarn every few rows of weaving. A vertical stripe in tabby is possible also. Thread two tapestry needles with two colors, weave "over one, under one" (Tabby) all the way across the warp with one of the colors, leaving a three-inch excess as usual. With the second color, weave Tabby beginning at the side of the warp where the preceding weft ended (Fig. 5). Repeat, weaving every other row with the same color. The same color weft will always cover the same warp threads in alternate rows and, if you do enough of them, you will discover you have vertical stripes. Follow the diagram carefully, being especially aware of how the ends of the wefts loop over or under the next. This alternate color tabby is a technique used in native weaving all over the world.

Tabby is by no means the only weave available to a prospective weaver. Barely introduced here are basket-weave, twill, knotting, and wrapping. Each will lead you to fantastic discoveries, I'm sure. By passing the weft over two warp threads and under two, and so on, reversing each second row by going under the two that have been gone over previously, you will produce a basket-weave.

Twill is a strong, attractive weave commonly used in the production of yardage for clothing and upholstery. There are hundreds of variations possible and, when used for small pieces on the looms described here, they can add good surface excitement: diagonals, herringbones, arrows, zigzags. If you follow the diagram for the basic twill technique very carefully (Fig. 6), you should be able to get the knack of it with a little practice. The diagram does not show the weft that passes under the warp; the weft drawn is just that which passes <u>over</u> the warp (the spaces being the weft <u>under</u> the warp). Every two warps are passed over and under until the width of the warp is covered. The second row is shifted over one warp, then two warps are covered over, the next two under, and so on, until four rows, each shifted over one more than the last, complete the pattern. The lower design in Figure 6 can be made by weaving four rows and then reversing the pattern for the next four. Try twill with contrasting colors for background and pattern. Background would be Tabby. A great many of the variations in woven material are achieved by taking up different combinations of warp threads.

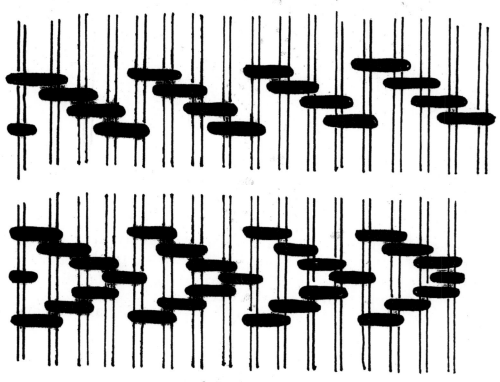

6 Twill weave

Soumak weave is one of the wrapped-warp techniques and provides an interesting contrast to the preceding weaves. Tie the weft yarn onto the first warp thread on the left side of the loom. You don't need a shed stick for this weave, as each warp is covered in each row. Pass the weft over the second warp, turn under the same warp and over to the next warp and repeat. Soumak can also be made by going over four warp threads and back under two of them. You are actually encircling the warp with the weft, and this weave is similar to the stem stitch in embroidery. If you wish to have the Soumak weave's diagonal texture run in the same direction in succes-

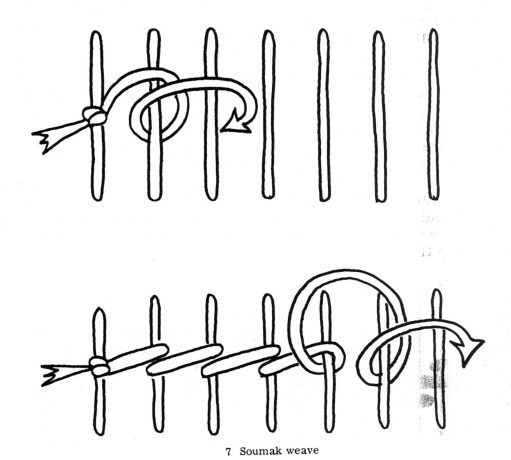

7 Soumak weave

sive rows, weave alternate rows of Soumak and Tabby (first row Tabby, second row Soumak, third Tabby, and so forth). Soumak is a very sturdy weave and is used extensively for rugs. It can also take on many faces without any variation in technique. By using soft, elastic wool you will develop a flat and linear weave; if a springier, stiffer yarn is used it will produce a raised coil-like weave.

The Rya knot or Giordes knot is another way of wrapping the warp. It is used in a type of Scandinavian rug weaving where a strong plush pile

with graduations and soft blendings of color are characteristic. It can be used as pile, long or short, or loops if you don't cut between the knots. There <u>must</u> be several (two or more) rows of Tabby between each row of knots or they will not hold. These knots are best done on closely spaced warp threads. Upon completion of the areas you want to cover, clip the crest of each loop for a pile or fringe texture, or leave loops. Very, very long fringe as a part of the design, with beads or even macrame decoration, can be quite beautiful when combined with plain flat weaves and different heights of knots.

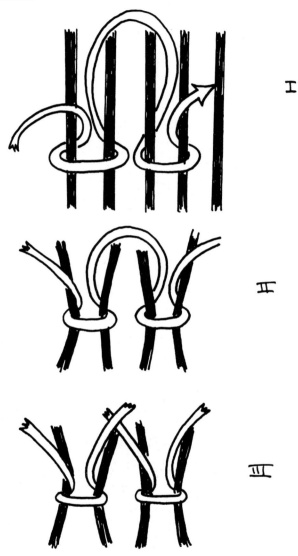

I

II

III

8 Rya or Giordes knot

So far we've covered weaving with wefts from one side to the other, and there are many possibilities for further exploration. Making forms with color, adding color, developing different shapes within the piece, all add to the surface excitement of the basic weaves.

To weave wide vertical stripes, of the same or different widths (vertical being the direction of the warps, horizontal being the direction of the wefts), follow Figure 9. Pass each weft yarn over the other as in the diagram and weave in opposite directions beneath the row where the joint was made. This is called Interlocking. Repeat this each time you wish the colors to join. This can also be done for shapes that aren't geometrical, by joining the colors at the edge of the shape to be filled. You need to work with two needles--or bobbins (a half skewer with yarn wound round) if your piece is big enough to warrant carrying more yarn than you can put in a needle. Actually, if you have three or four colors going across one row, you need a needle or bobbin for each color. In Figure 4, I am using a bobbin.

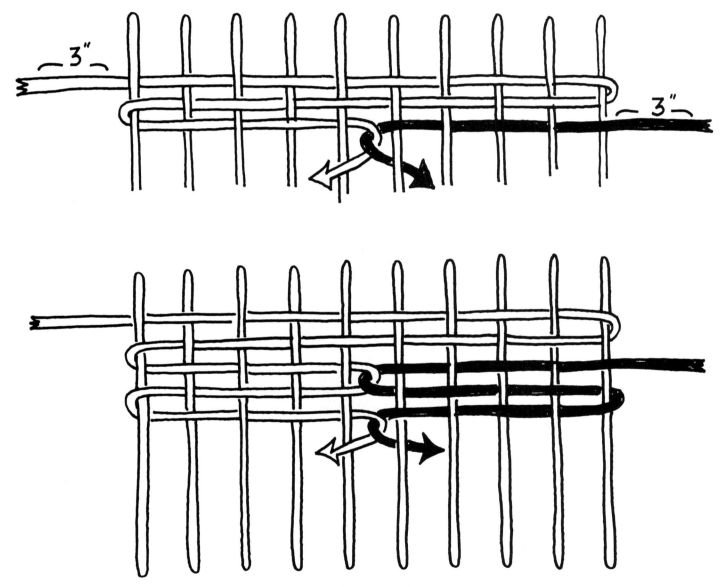

9 Interlocking

Another way of working with separate color areas is the Slit-tapestry technique. This is a very ancient method used for rugs and textiles as well as tapestries. The two color areas fall adjacent to each other but do not join. This technique also works as a part of a design within areas of a single color. Follow Figure 10 carefully, being certain that the two colors meet on the same weft row. Each must continue in pattern as the same weft. Note how the second color (left) maintains the "under, over" pattern of the first color as if it were the same weft. Slits can be opened for a different effect by pulling the weft tighter on each side of the slit (an exception to the general "keep loose" rule!). Holes and open patterns can be achieved with this technique. If you want to use slits within the same color area, you will still need two or more needles or bobbins for each area.

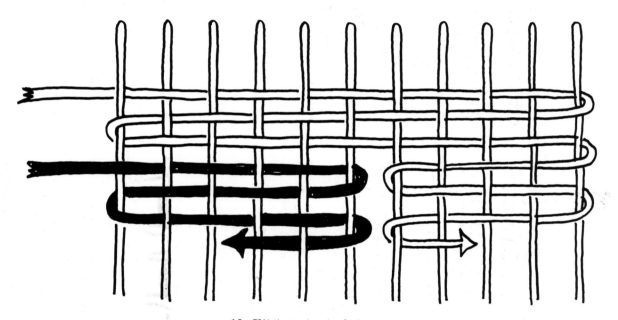

10 Slit-tapestry technique

For the looms described here you can easily fill in one shape or area at a time by using the Dovetail technique shown in Figure 11. (When using a floor loom you won't have the luxury of being able to fill in one shape at a time, as the woven section is rolled up as you weave, and each row must be completed before going on to the next.) A gradual diagonal can be achieved with this method of joining colors, as shown in Figure 11B; a more extreme one appears in Figure 11A.

All of the techniques and weaves covered so far should be experimented with freely, and you should cater to your whims. If it doesn't work, you won't like it, or it will fall apart, or both. That shouldn't be considered a loss--you've learned something.

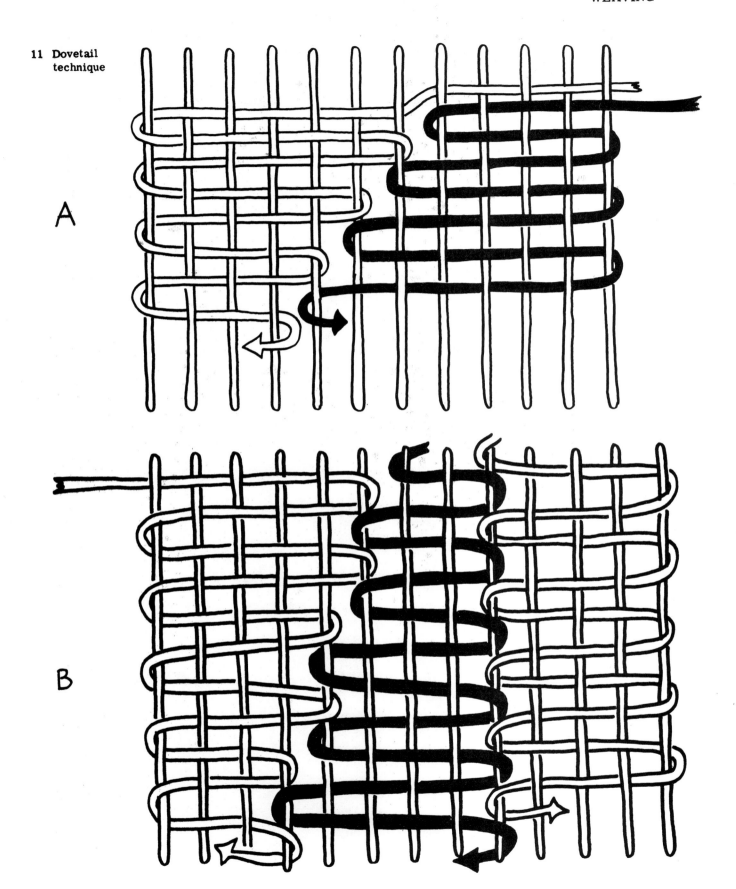

11 Dovetail
technique

A

B

To remove the piece you've finished from the cardboard, turn it over and cut the warps in the middle for fringe that will be of equal length on both top and bottom, or cut shorter on top or bottom as you prefer. See Finishing and Hanging below for special touches. Turn the piece over and with a tapestry needle or crochet hook tuck and weave in the ends. If you like them hanging out--leave them!

BOARD LOOM

The method of warping is the only real difference between the various looms covered here. The cardboard loom has its warp wrapped around it, front to back. The board loom has the warp wound around nails or T-pins

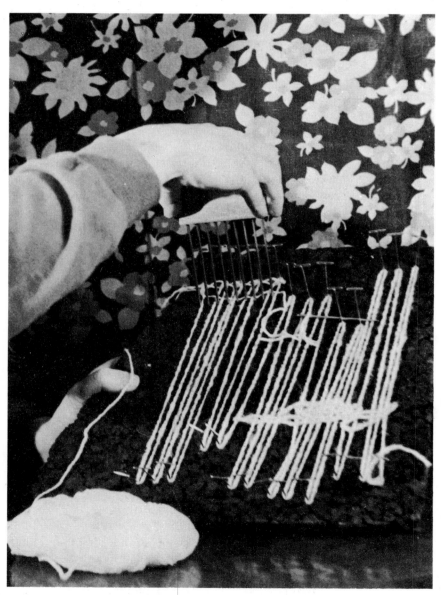

12 Beating in on a board loom

on one side of the board. For this loom you'll need a piece of cork, celatex (a thick, light fiberboard found in lumberyards), or plywood. The size of whatever you decide to use should be an easy size for you to handle. Anything larger than 18 by 24 inches will probably be too clumsy to work with. Have on hand finishing nails (if you are using plywood) or T-pins (for cork and celatex) and all the rest of the equipment listed for the cardboard loom.

You can make irregular woven shapes on a board loom, as you are free to place the pins or nails in various positions around the board (Fig. 12). T-pins can be found in macrame and art-supply stores. The pins should be pushed into the cork or celatex at a slight angle--the top of each pin pointing toward the outer edge of the board (Fig. 13). This will prevent the pins from pulling out when the warp is wound around them. Remember to place the pins close enough so that the piece will hold together when woven.

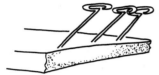

13 Angle of T-pins on a board loom

At the end of the yarn for the warp, tie a slip loop (Fig. 14) onto the first pin in the upper lefthand corner and proceed to lead the warp down to the first pin on the lower edge. Bring the warp up and around the second top pin and down, repeating and forming somewhat parallel lines, until the last pin is reached. Be sure to keep tension even and firm, not taut. Tie a thumb knot (Fig. 15) around the last pin, and it should keep the warp secure. To change or adjust the warp threads, pull the pins out and place them elsewhere. Do it now, it'll be difficult later. Weave on!

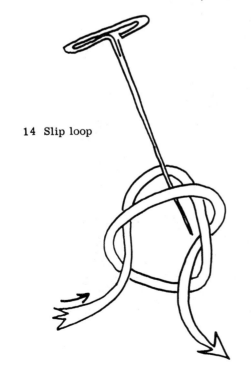

14 Slip loop

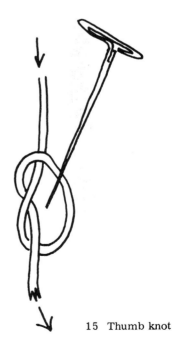

15 Thumb knot

Remove the finished piece from the board loom by pulling the pins, or sliding over the nails if you're using a plywood board. Weave all excess ends into the back with a tapestry needle and finish the top and bottom as you like (see Finishing and Hanging).

FRAME LOOM

To warp a frame loom you must first have a frame--either one you've nailed together from lumber scraps (1 by 2 inch board is good), an old picture frame, or canvas stretcher bars that come in different lengths and are sold in art-supply stores. The last are quite easy to put together but are not rigid, so you might need some kind of reinforcing at the corners to keep the rectangle from going askew. Finishing nails (nails with small heads), a hammer, yarn, beater, shed stick, scissors, needle, and whatever else you'll be using for the actual weaving complete the list of supplies.

Hammer nails in a row along the top and bottom of the frame, as close together or far apart as you want, remembering you want the piece to hold together; it's probably best at a quarter-to a half-inch apart. The warp is wrapped over the opening in the frame, so there should be at least two inches of space between the two side warps and the inner edges of the loom (frame) so you'll have room to work in, begin nails at that point. Hammer nails at a slight angle away from the center opening so the warp won't slide off the frame when wrapped around them.

Tie a slip loop on the first upper lefthand nail (as done on the T-pin on a board loom) and wrap the warp carefully, following Figure 16. Keep the tension even and firm. End the warp with a thumb knot (Fig. 15) around the last nail reached. You are now ready to weave, and the weaving process is the same, though the loom is slightly different. On this loom you will be more aware of the open space you cover or weave around, and the loom itself is lighter in weight.

Remove the piece from the frame loom by sliding it off the nails. Do not cut, as there will be no way of holding in the end rows of weaving if you have woven right to the nails top and bottom. If you want fringe top and/or bottom, keep the weaving in the center of the frame, slip the warp off the nails, and then cut the loops. Knot to hold as described in the finishing and hanging section below. Weave in excess weft ends.

A frame loom with a laced-in beam is a device for weaving a hanging bar right in as a part of the design. To do this you'll need a frame (stretchers, lumber scraps) about three inches wider all around than the size of the piece you wish to complete. (Actually, I usually match the size of the piece I'm weaving with available frames, or boards, or whatever.) Other supplies are yarn, a dowel or twig, or whatever you want to weave in as your hanging bar (which must be shorter than the width of the frame),

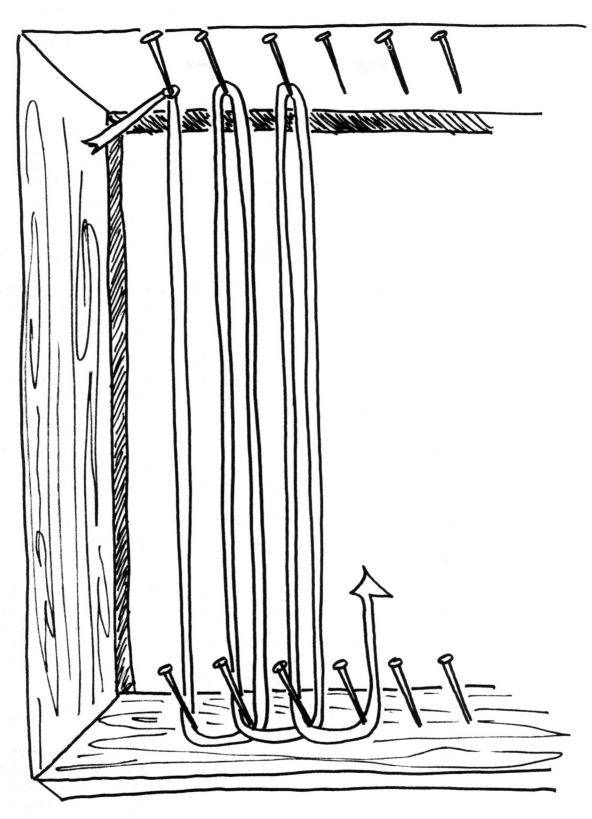

16 Warping a frame loom

and beater, shed stick, needles, as for the other looms. In addition, you will need a chair or two to wind the warp around.

Measure the height of your frame. Then look for a chair, or two chairs, doorknobs, two C-clamps (hardware store items), around which the yarn can be wound the same length as the frame height, and slipped off easily. Begin wrapping the yarn for warp around the back of the chair, circling it half the times the number of warp threads you'll need (each complete circle around the chair back will make two warp threads). The way to determine how many warp threads you want is the width of your piece--that is, if you should want it 10 inches wide, with warps a quarter-inch apart, you will have 4 warps per inch, or 40 warp threads or ends. Wind carefully-- even, firm tension is more difficult to achieve when winding a warp in this way. When finished, slide the yarn off the chair and slip the dowel or twig (referred to as the beam) into the loops of uncut yarn at one end, allowing the yarn to hang from it.

Another piece of yarn three or four times as long as the length of the beam will be used for attaching or lacing the beam to the frame. Tie a slip loop (Fig. 14) onto the lefthand end of the beam--the warp still hanging from it. Distribute the warp yarn over the beam evenly. It's probably a good idea to do this with the frame lying flat on a table so you won't lose the warp by having it slide off the beam. Gravity is a basic problem here. Lace the length of yarn over the frame and under the beam carefully, following the diagram (Fig. 17), suspending the beam two or three inches beneath the frame. Separate the warp threads at fairly even intervals between lacing points. This procedure is done so the beam will be stable and suspended between the frame sides for weaving and the finished piece will hang without distorting or slipping to one side. The space between the beam and the top of the frame can be adjusted for tension. As you weave, the warp gets tighter, so you may want to loosen it; or, if it is very stretchy yarn, you may want to tighten it. Make another slip loop at the end of the lacing on the beam.

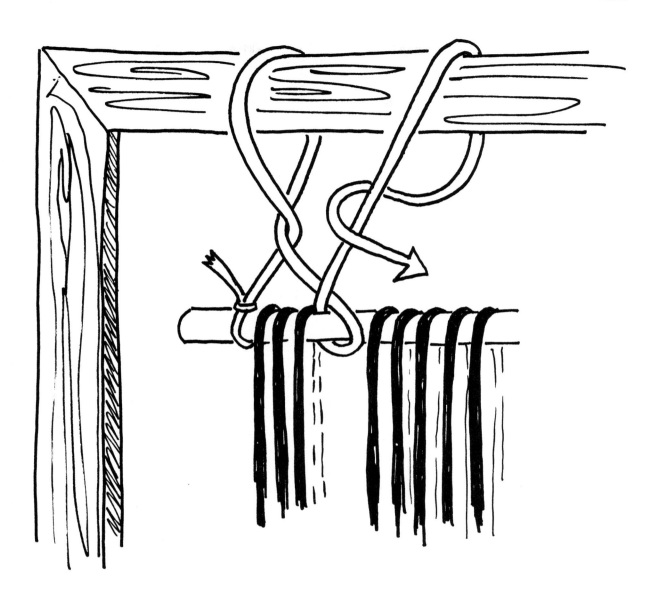

17 Lacing a beam to a frame loom

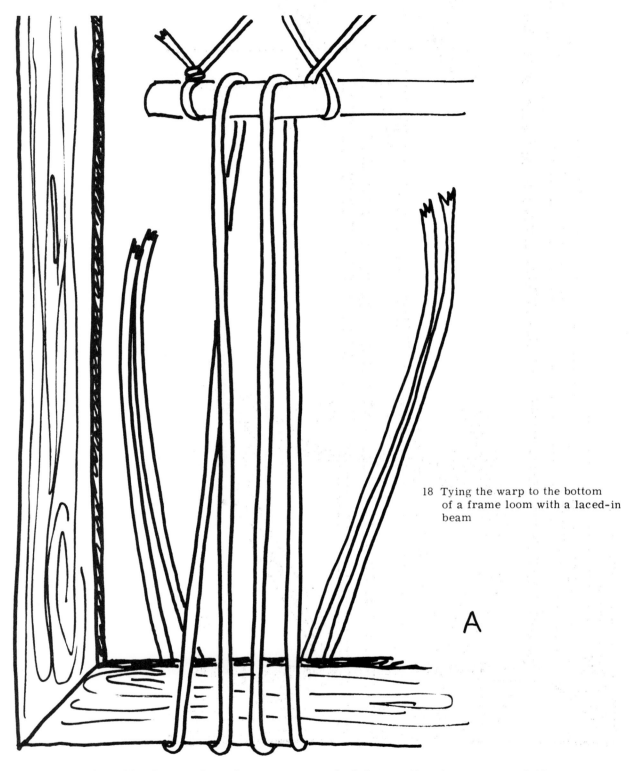

18 Tying the warp to the bottom
of a frame loom with a laced-in
beam

A

Now that the beam has been suspended from the frame, and the warp threads have been distributed over the beam at even intervals, clip the bottom loops of the warp. Bring all the warp threads (ends) forward over the front of the frame. Separate them into bundles so that they will be evenly

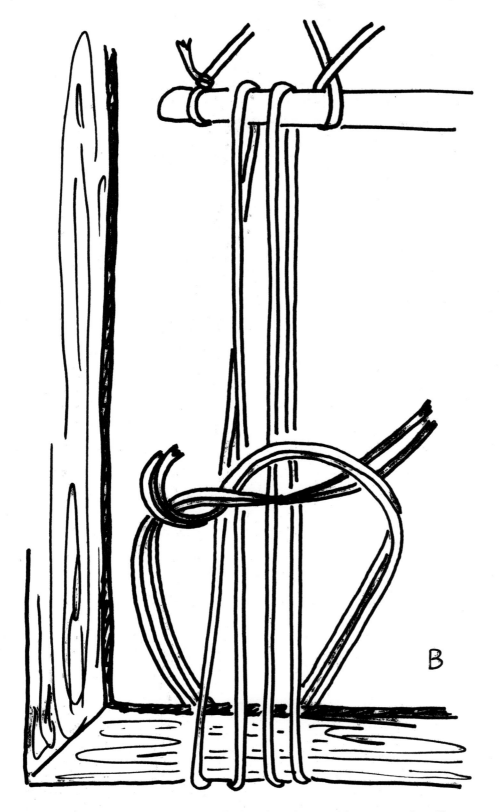

B

placed over the bottom of the frame. They can be the same bunches separated by the lacing on the beam. Take each bunch and wrap it around the bottom to the back of the frame, dividing the bunch in two at the back. Following the steps in Figure 18 <u>A</u> through <u>D</u>, tie knots, as described, close to

191

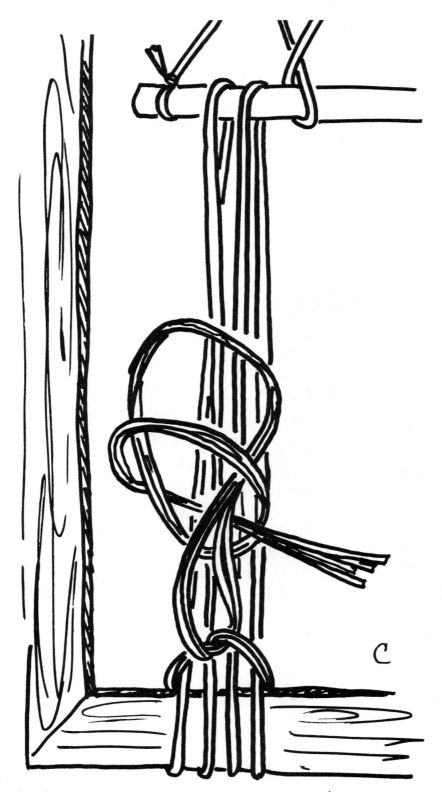

C

the frame at the bottom. These knots (slip knots, or half-bows) are used so that when the piece is finished they are easily loosened. The overall tension can be adjusted by loosening or tightening the lacing on the beam; the tension on individual threads can be adjusted by retying these knots.

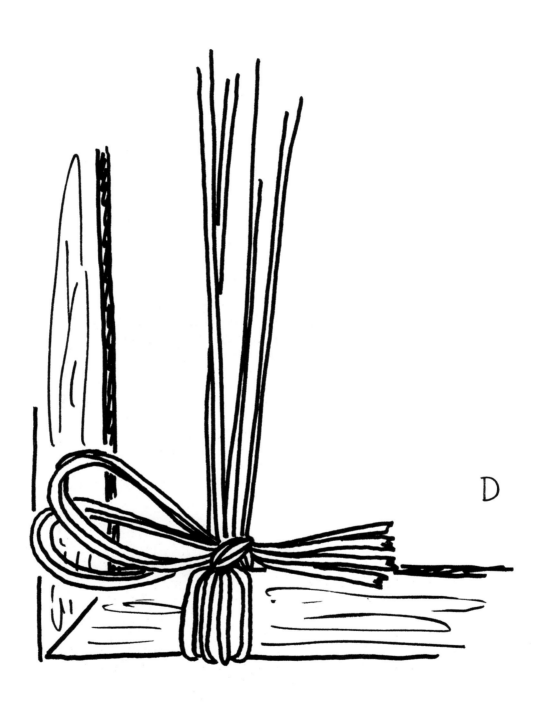

D

19 Warped frame loom with a laced-in beam. Notice the space
between warps; these will be brought together by twining
first weft

When each bunch has been securely tied to the bottom of the frame, the
warp threads are spread evenly over the beam and evenly across the bottom.
You will notice that the beam has divided (spread) the warps forming spaces
(Fig. 19). Closing these gaps by pulling the warps till they are more nearly

194

20 Doubling a length of yard across a frame loom with laced-in
 beam in preparation for twining

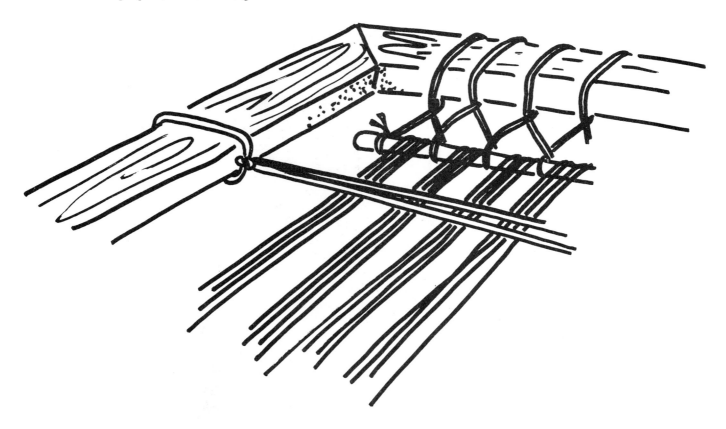

parallel will make the weaving neater. Twining (another wrapped-warp
weave) will bring the warp threads that are behind the beam forward and
place them all on the same level or plane. Take a piece of yarn at least
twice the width of the frame. This will be woven into the top of the piece,
so plan it as a part of the design. Double the yarn around the lefthand side
of the frame and tie both ends into a square knot very close to the inner
edge of the frame (Fig. 20). Pull both ends over the warp so they lie
straight across it, and determine where you want to start your weaving
(right up close to the beam or with a space between the weaving and the
beam). Slide the yarn up to the point where you will start, and proceed to

twine the yarn around the warp threads. Follow Figure 21 and work the weave straight across the warp, tying the two ends to the frame on the other side. Pull the weft threads tight every six or seven warps and be sure they are evenly spaced, or spaced as you want them. Once you've tightened them it's very difficult to realign the warp, as I've found out, without redoing the whole row.

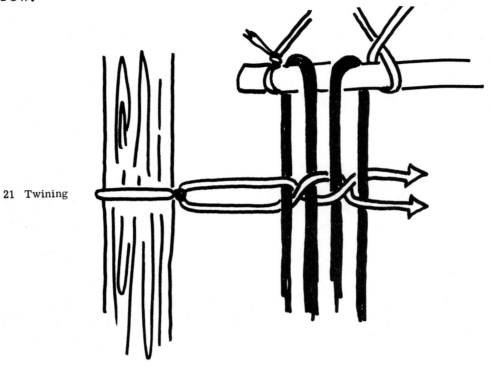

21 Twining

If you will be using a lot of one kind of yarn try using a bobbin (as mentioned before, a half-skewer, pencil, orangewood stick--with yarn wound round it). Use it as you would a tapestry needle by unwinding enough yarn to go across the warp, and pass the bobbin through the shed. This is also a good way to keep the yarns you're using in order.

Untie the slip knots along the bottom of the frame and finish however you'd like. Unlace the top lacing, attach a cord for hanging, and hang the piece up.

FROZEN WARP METHOD

The frozen warp method is a way of weaving without a loom. This technique eliminates the loom by incorporating the tension that a loom would produce into the warp itself. This is done by stiffening the warp with a white glue solution before weaving. The possibilities this technique offers are virtually unlimited and tremendously exciting. The weaver can produce unique shapes, even work in three dimensions or on freestanding pieces, without the use of outside support.

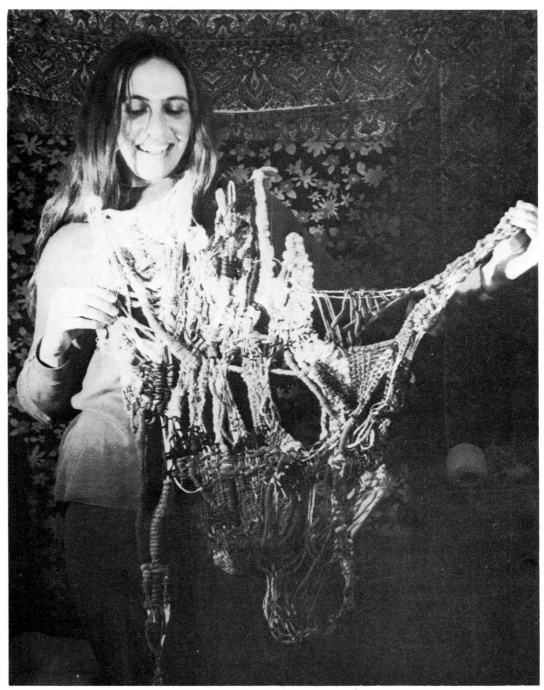

22 Sandy with a frozen warp piece

Relatively little equipment is needed for working a frozen warp. A bottle of white glue, which can be bought in almost any hardware, houseware, department, or art-supply store. Groceries sometimes carry it, too. Along with this--yarn, string, scissors, push pins, needles, a big pan or bowl, and a piece of strong cardboard (heavy clipboard's the best) or plywood, half again as big as your piece—are all that's necessary.

Mix approximately ten parts glue with one part water in a bowl or pan. Wrap the warp (string, cord, yarn) around the back of a chair or chairs (see the earlier section on frame looms with wrapped warps for more detailed instructions). Slide it off the back of the chair and dip it into the glue solution, mushing it around until it is completely soaked. I usually do frozen warps outside or in a studio, so I don't mind the mess, but you can cover your floor with newspaper, or a painter's dropcloth for protection. Remove the warp from the glue solution and spread it out on the cardboard or hang it on the wall (which you have previously protected with newspapers, I hope). Arrange the wet warp in any shape you want, leaving spaces and areas to weave in. Try to maintain some parallel warp threads for strength and diversity from the open spaces. Allow the warp to dry.

When the warp is dry, it will be stiff and you can weave all over it. Throw yourself into it. Use colors that you love, try some textured yarns. The finished piece can be very expressionistic and exciting. When you are finished weaving, hang it up.

The choice of a loom is mostly a matter of individual preference. However, the board loom and frozen warp are freer, more expressive methods, while the frame and cardboard looms are more suitable for traditional weaves, patterns, and shapes.

FINISHING AND HANGING

After your weaving is completed remove the piece from the loom-- whichever loom you've chosen. Cut the warp at the back of the cardboard, if you've used a cardboard loom. Pull the T-pins or slip the piece off the nails, if you've used a board or frame loom. Untie knots and undo the lacing of the frame loom with wrapped warp.

Fringes are most usual on woven pieces. If you want fringes on pieces woven on the board or frame looms, you'll need to attach them after you remove the piece. Use the macrame mounting knot (Fig. 23) for attaching fringe. Otherwise, of course, the fringe is just the unwoven warp. Some way of keeping the weft from sliding off the warp must be devised. Beads can be slid up to the weft and knotted in place, macrame knots can be used and are very beautiful as part of woven pieces. A common knot (Fig. 24) is a simple, effective way to finish the piece. What is most important is that the finishing should be an integral part of the design of the weaving as well as hold the weft in place. Try different methods.

The wrapped-warp method of weaving has a built-in hanging rod, and you can also add a hanging rod (or rods, to top and bottom) to pieces made in other ways. One method is to take the warps hanging from the top of the piece and tie the ends around a rod (dowel, stick, branch, or whatever).

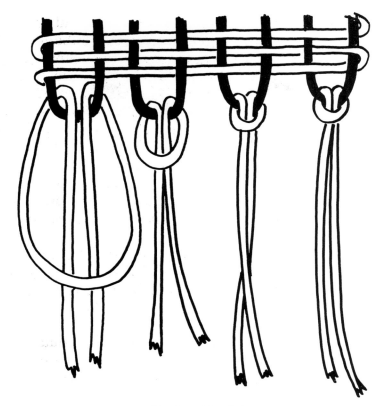

23 Attaching fringe

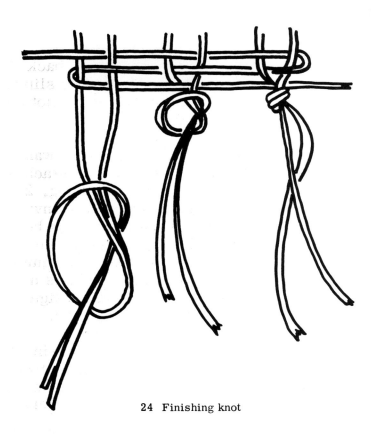

24 Finishing knot

It's a bit tricky to get all the knots even, so the stick hangs in properly, but keep at it and you will get good at it.

To apply a hanging rod to a piece woven on a board loom or frame loom, don't clip the warp loops at the top (after slipping them off the frame). Lay a dowel, or whatever, along the top of the loops and, one at a time, tie the loops to the bar with another cord (Fig. 25). Don't clip these loops if you have woven right up to them--the loops hold in the weaving.

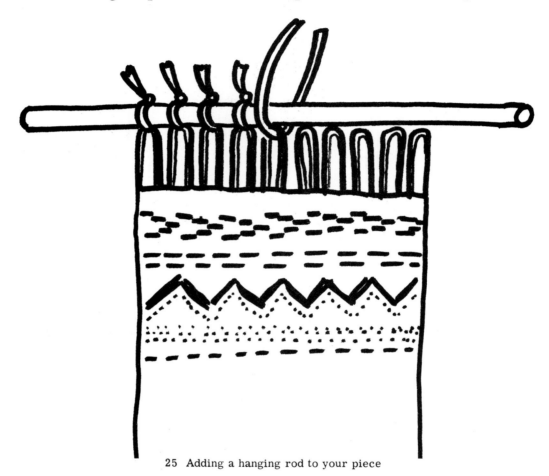

25 Adding a hanging rod to your piece

Most of all, you must use your imagination and sense of design to determine how your piece will best be displayed; there are no rules--if it works, use it.

PROBLEMS

If your weaving exhibits any of the following characteristics then you might consider tearing it apart and starting again. These are all typical mistakes, but if the mistake works as design you might want to keep it. The fabric strength will be diminished by most mistakes, so don't fall into sloppy habits and pass off their effects as "art."

SHRINKING SELVAGES (edges or sides). This comes from pulling the weft too tight. The yarn should be bubbled loosely and beaten into place more carefully.

BULGING SELVAGES. The weft is too loose. It should be wrapped against and around the end warp threads, leaning comfortably. Each row should maintain the same tension if even edges are desired.

WOBBLY WEAVING. This comes from uneven tension over the loom to begin with.

As you may have noticed, I have mentioned tension quite a few times. From this you may deduce that, while tension in daily life is not so desirable, it is a cardinal facet of weaving. So respect and use it with care.

CONCLUSION

Finally, it's your time, your materials, your aesthetic investment--make something you love making. I haven't mentioned any "useful" projects here--most books on weaving do that. Even so, on these simple looms you can make such things as purses, pillow covers, headbands, belts, ponchos, curtains, afghans, and many other things. Pieces can be made separately and sewn together to make larger items. My own predilection is for tapestries and wall hangings. One of the reasons for my preference is that you are much freer to experiment with different yarns and materials such as dried grasses, weeds, leaves, bark, seaweed, metals, whatever turns you on. It's amazing how you start noticing your environment in a new way when you are looking for weft materials. Warp is less flexible, but try different kinds.

Don't be intimidated by what's been done, or being done. Just take it on, one step at a time, getting as big or complex as you choose. There is always further to go, more to learn, more to do. But you can stop anywhere (if you can, that is, once you get into it). Don't worry about being good. If you love doing it, that's the reason to do it.

Tie Dye and Batik
Shelagh Young

Tie dye and batik are related in principle. They are both methods of resist-dyeing, which means that parts of the fabric are protected from absorbing any dye during the dyeing process by the application of wax (batik), or by tying the cloth tightly in a pattern (tie dye). The design is made by the resistance of these parts to the colors, and, with the use of more than one color, by the overlaps and color contrasts.

These are probably the oldest and most primitive methods of printing designs on fabrics. Their origin is probably central Asia, the period of their invention as remote as the art of dyeing itself. In old Japan there was a technique called Kyochi Zome: silk was clamped between two boards with a pierced design through which the dye was applied--a tedious process, but the results were magnificent.

The most popular patterns in tie dye now are done by folding the fabric and binding it with elastic bands to make diamonds, and sunbursts, and freeform splashes of color.

WHAT YOU'LL NEED

FOR TIE DYE:

A good pair of heavy rubber gloves.

A large metal cooking spoon, for lifting and stirring during dyeing.

A box of Ivory Snow detergent. A little added to the dye solution will help the colors seep in.

A turkey baster, one of those long pointed glass, or metal, or plastic tubes with a squeeze bulb at the end.

A large box of thin, medium-sized rubber bands, for tying.

Some bleach.

An endless quantity of newspapers, and an old sheet.

These things, if not around the house already, can all be found on the shelves of any department store or hardware store, and can be had used from most thrift stores.

Good dye is essential. After all the time and effort invested in doing a piece, the result should be worth it.

Cheap dye is a horror. The kind you can buy in drugstores and super-markets--without mentioning brand names for fear of lawsuits--is terrible. The colors fade quickly, wash out, and actually end up being terribly expensive, if you're considering doing more than one piece, since you're paying around 35 cents for about a tablespoon of dye.

One brand of packaged dye is very good but, again, it would be expensive to use in volume. These dyes are made by W. Cushing & Co. They aren't available everywhere, but are worth looking for, if you want to experiment with some things before sinking a lot of money into bulk dye. The address of the company on the package is: W. Cushing & Co., Dover-Foxcroft, Maine, U.S.A.

Bachmeir and Company, in New York, sell the best bulk dyes I've found. They seem a fairly large investment, running from about $8 to $14 a pound, but they really go a long way, and the results are beautiful. You might be able to find some friends interested in dyeing, and the group could split the cost. Bachmeir makes a different dye for each fibre, the colors are fast and dependable and mix well. Their address is: 154 Chambers Street, New York, New York, 10007. They will send price lists, and each color must be ordered by name and number, and can be sent c.o.d.

Other companies make cold-water dyes. These are necessary if you are going to use any wax (batik) in combination with the tie dye (wax will melt away in hot water).

And finally, you can explore the possibility of using natural vegetable dyes. There are many pamphlets on the subject, most libraries have some information. You can get beautiful, subtle, earthy colors by foraging for dye-producing plants and roots, like chickory, indigo, sumac, and even onions. (Vegetable dyes are only viable if you have much more time than money, since the process of dyeing becomes more involved; as a matter of fact, it becomes a major procedure.)

You will also need several large, deep washbasins, preferably enamel. They are durable and easiest to clean. The size of the basins depends on the size of the pieces you will be doing. There should be enough room for the fabric not to be crowded, but not so huge that a lot of dye would be wasted each time.

Dyes are poisonous and messy. Bear this in mind when you are setting up your work area. The kitchen should be a last resort. The gas company will hook up a small gas burner that sits on a table, with a tank of gas (you use very little) for around $14. If you have a basement with washtubs for rinsing, so much the better. The gas burner can be installed there. If this is all impossible in your particular circumstance, cover everything with newspaper. Bleach will remove dye from almost everything, including you.

FOR BATIK:

A double boiler, for melting the wax. Wax is inflammable, and should never be heated directly over a flame. If you can't get a double boiler, a small pan resting in a larger pan of boiling water will do.

For dye-pots, you'll need washbasins or plastic pails, since the dye doesn't have to be heated.

And rubber gloves, cooking spoons, mountains of newspapers, lots of paraffin wax, some cheesecloth, an iron.

Some thumbtacks, a piece of smooth plywood, and a scraper of some kind to take the wax off the board.

An assortment of brushes. Watercolor brushes are best, sable if you can afford them. (Good brushes generally last longer than cheap ones.)

There is a tool which is good to have, although certainly not an absolute essential. It looks rather like a metal pipe with a wooden handle and has a fine tube extending out of the bottom end. You might be able to get one at a batik studio in a large city, or at a hobby or craft store; otherwise one can be made quite easily with a stick or piece of bamboo, and two pieces of copper tubing. On the next page is an illustration, showing how one can be made and used. The advantage of having one of these tools is this: the wax must be kept very hot for batik, so that it will penetrate the cloth completely and not form a crust on the surface of the fabric that the dye can seep beneath, where you didn't intend it to go. Wax cools very quickly on a brush. You have to keep dipping the brush into the wax to keep it hot enough. This tool,

being metal, stays hot longer. You dip the pipe into the wax; it fills; the copper heats up, and you can draw on the fabric with more ease. It makes a finer, clearer, and more precise line than does the brush.

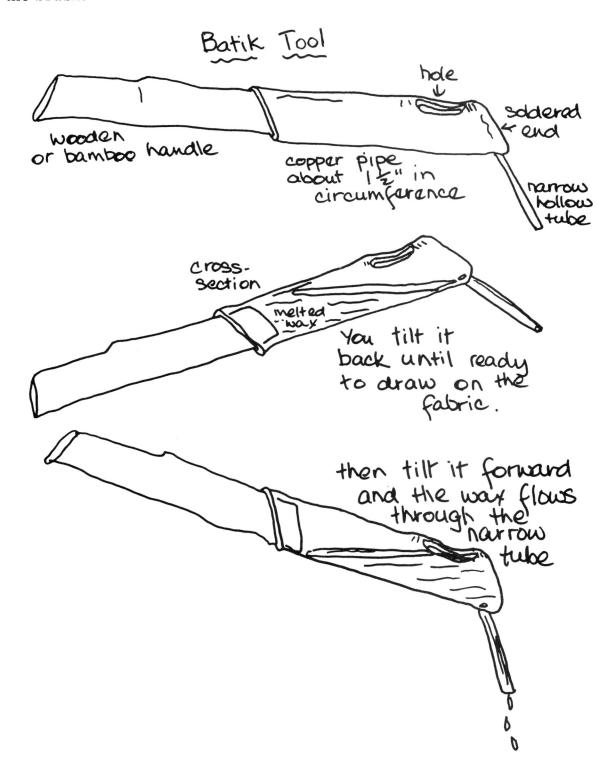

Batik Tool

hole

soldered end

wooden or bamboo handle

copper pipe about 1½" in circumference

narrow hollow tube

cross-section

melted wax

You tilt it back until ready to draw on the fabric.

then tilt it forward and the wax flows through the narrow tube

Cold water dyes are hard to find. Batik studios are good sources, if you can find one. I really can't recommend any as reliable sources, since they seem to fold up and slip off into the night so quickly and so often. Try hobby and craft stores, too.

There is, of course, the selection of fabrics. For tie dye, I like working best with velvet (especially old velvet), silk, silk chiffon and satin. The lustre and light-reflection of satins and velvets give a whole beautiful new dimension to the colors. Unmercerized cottons fade. So does nylon. I'd say they aren't worth your time and energies. White acetate satin would be a good starting place. It is inexpensive enough for experimentation, and looks fantastic when done. And it can be used for millions of things--satin sheets, curtains, pillows, clothing, and wall hangings, to name a few.

I like to use different textures in materials, like velvet and satin, in patchwork. And combinations of batik and tie dye are endless. If you do any sewing at all, you can cut out a shirt or a dress, sew together the shoulder seams, sew on the sleeves, leaving the underarm seam and the sleeve seam open so that the material lies almost flat, and then batik and tie dye a pattern to follow the shape of the garment--maybe a pattern that swirls a-round the neck and drips down the sleeves. Beautiful.

Each fabric reacts differently to the dye. There will be subtle changes in every piece you do. I have never tried to batik on velvet. The wax would interfere with the nap, or the nap with the wax. It would probably be very difficult to get the wax out of the fabric without destroying it. But then, I've never tried. What are good are fairly heavyweight lining silk and medium silk shantung, linen, and mercerized cotton. Very lightweight materials don't hold the wax well; very heavy ones are much harder to penetrate with wax.

THE DYEING PROCESS

BATIK:

Batik is a process of painting with wax on fabric, then dyeing the exposed parts to make a design. You melt the wax in a double boiler or similar con-traption (never over direct heat, to avoid fires). It must be kept hot. Re-member to keep adding a little water to the bottom pan; it boils away.

Thumbtack the fabric to a board. You can draw your design very faint-ly on the cloth with a light pencil, then start applying the wax, with a brush or with the batik tool already described.

If you are using brushes, the wax should be applied hot enough so that it will penetrate the cloth fairly evenly, and not just spread out over the surface of the fabric in a crust or the dye will seep through it. This is

very important. And remember that every part of the piece not protected by the wax will absorb color. You have to think almost in terms of negatives: you cover one area, but the areas all around it take on the color. Design possibilities are as infinite as your imagination. You can begin with free-form "action" batik, Jackson Pollock-style, loading the brush with wax and letting it drip onto the cloth in streams of droplets and lines. This looks fantastic when combined with tie-dyed crunches--like ocean waves with bubbles. And you can do very precise designs, even realistic paintings. Since the colors are protected from each other by wax during the addition of further colors, the number of colors on one piece of work can be limitless.

The fabric is dyed in cold-water dye, the instructions for which vary, according to the source. Sometimes you have to add your own mordants, or substances to "fix" the color. Sometimes these are pre-mixed.

The fabric is dyed and hung to dry with newspaper under it to catch drips.

Cover the ironing board with newspaper and, while the piece is still slightly damp, lay it on the newspaper on the ironing board, put a layer of newspaper over it, and begin to iron very carefully. The iron should be fairly hot, so that the wax melts and is absorbed by the newspaper. Keep changing the newspaper, discarding the wax-saturated sheets. Keep ironing until no more wax appears to be coming out on the newspaper and the fabric is only very slightly stiff. Now, sink the fabric into enough boiling water to cover it well, and hold it well beneath the surface. The last remaining little bit of wax will float to the surface, and can be skimmed off with cheesecloth.

Now the fabric is hung to dry again, and is ready for the second waxing, then the second color. This seems to be an appropriate place to mention color. In batik you have more control over colored areas than in tie dye. If the wax is applied carefully, you can plan exactly what colors will develop and exactly where they will be and where they will overlap to make new colors.

TIE DYE:

In tie dye there is always a certain element of surprise, a certain amount of the unexpected. Basically, though:

Where red and blue overlap will be purple.

Where red and yellow overlap will be orange.

Where yellow and blue overlap will be green.

AN EXAMPLE OF OVERLAP

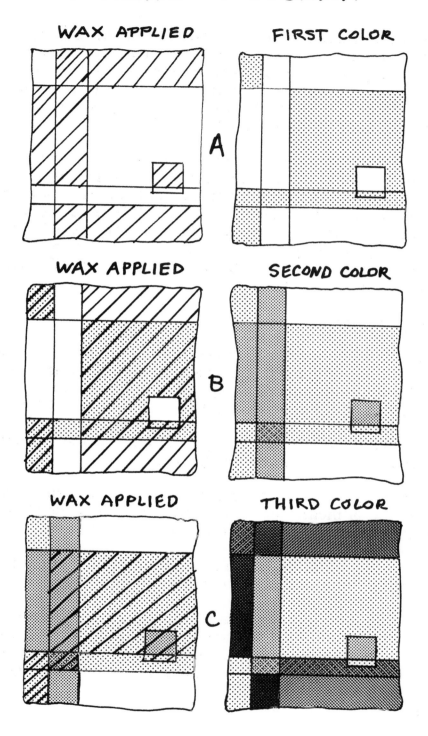

WAX APPLIED FIRST COLOR

A

WAX APPLIED SECOND COLOR

B

WAX APPLIED THIRD COLOR

C

Where red and green, or green and orange overlap will be brownish . . .

Different shades make different tones of colors, of course. Turquoise and yellow most often make lime. Pink and turquoise make a shade of fuchsia. Depending on the brands and shades of dyes that you will be using, you will arrive at your own favorite and most successful combinations. There aren't any rigid rules in tie dye, everything is very loose and approximate. Don't be afraid to experiment.

Three colors per project are usually plenty. More than that and they begin to get a little muddy. Again, remember that depending on how the fabric is tied the colors will meet and mix and overlap to make new colors. The dyeing itself depends on the tied pattern: The fabric can be totally immersed in the first color, rinsed, retied, and placed in the second--and so on, for a complete overlap of color over the whole piece. The fabric can also be dyed in sections in different colors, then put in an overall color. Once again, be willing to experiment.

THE DYEING PROCESS

Wear rubber gloves. Fill the basin about halfway up with water. There should be enough to allow the fabric easy movement. Heat the water to a light boil and keep it approximately at that heat. To every gallon of water add two heaping tablespoons of dye and two tablespoons of Ivory Snow.

Wet the fabric. Sink it into the dye and leave it there from thirty to forty-five minutes, lifting and stirring often.

Take it out and squeeze out the excess dye. Put it on a newspaper, and squirt a few drops of bleach on each elastic with the turkey baster. Wait ten seconds and drop the whole piece in a basin of cold water.

Take off all the rubber bands and rinse until the water runs clear. It is now colorfast, even in the washing machine.

Wring it out, and iron it while still damp. An old sheet over the ironing board will help in the ironing by absorbing a little water. If the iron sticks at all, it's too hot. And now for the folds. After you have mastered these basic folds and patterns you will, no doubt, go on to invent ones of your own.

Have fun.

The fabric can be
simply
tied in knots

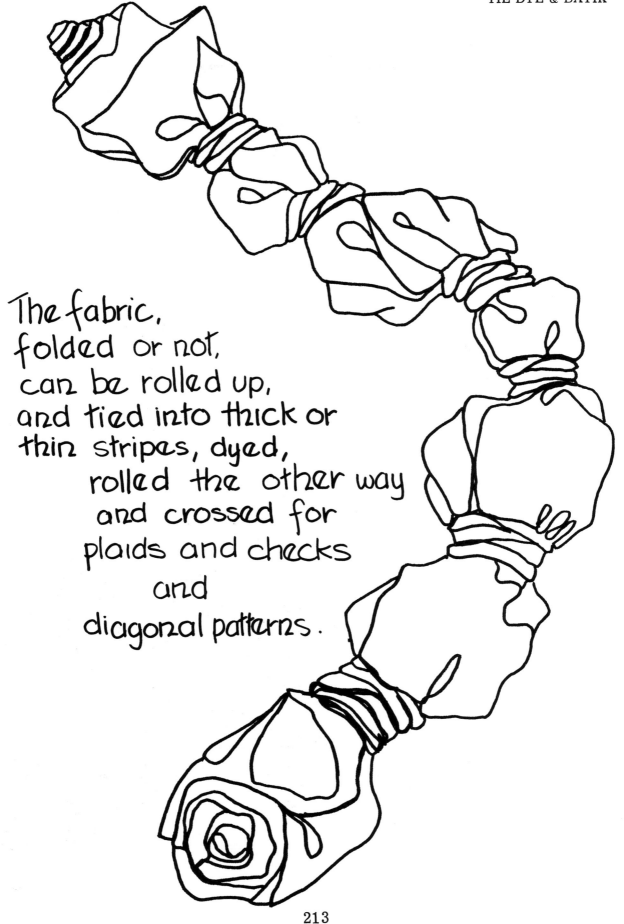

The fabric,
folded or not,
can be rolled up,
and tied into thick or
thin stripes, dyed,
	rolled the other way
	and crossed for
	plaids and checks
	and
diagonal patterns.

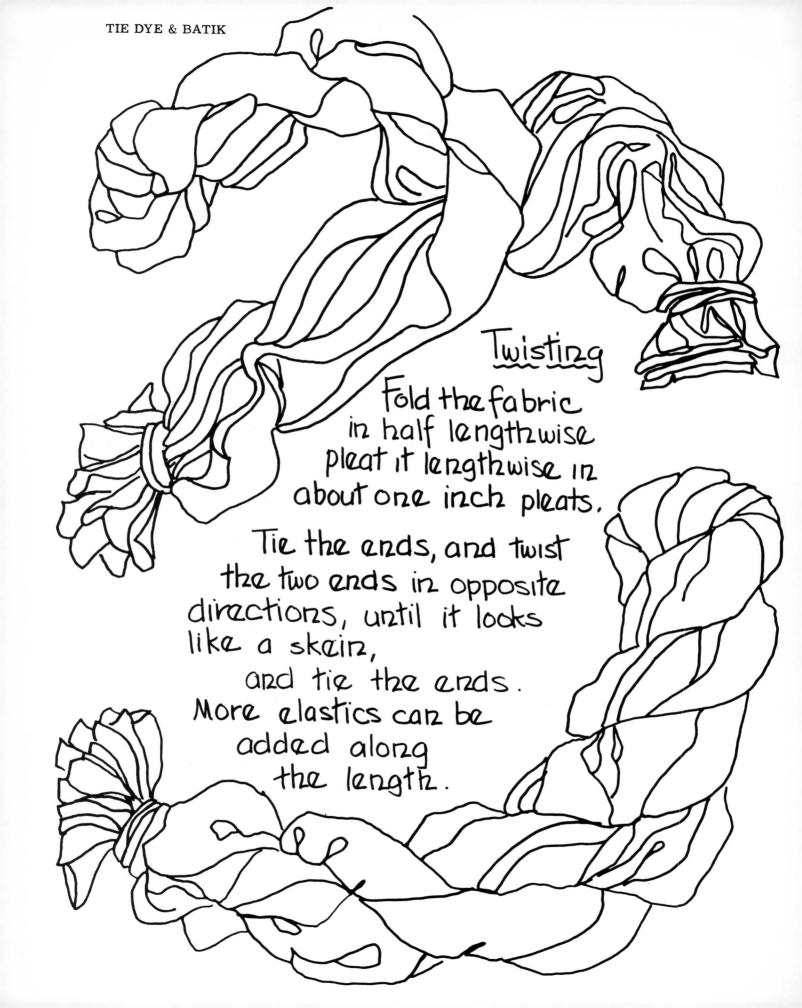

Twisting

Fold the fabric
in half lengthwise
pleat it lengthwise in
about one inch pleats.

Tie the ends, and twist
the two ends in opposite
directions, until it looks
like a skein,
and tie the ends.
More elastics can be
added along
the length.

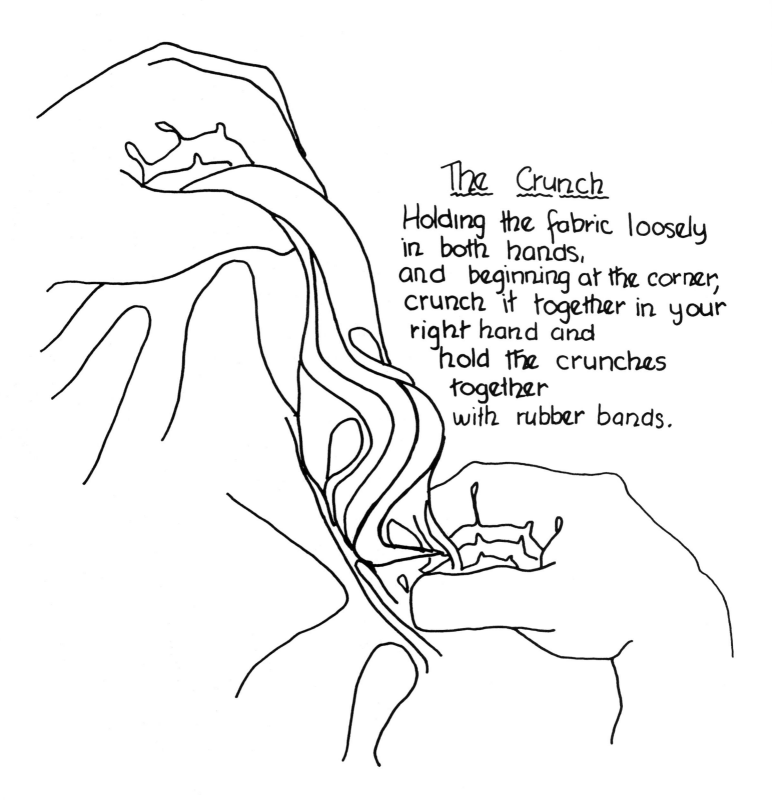

The Crunch

Holding the fabric loosely
in both hands,
and beginning at the corner,
crunch it together in your
right hand and
hold the crunches
together
with rubber bands.

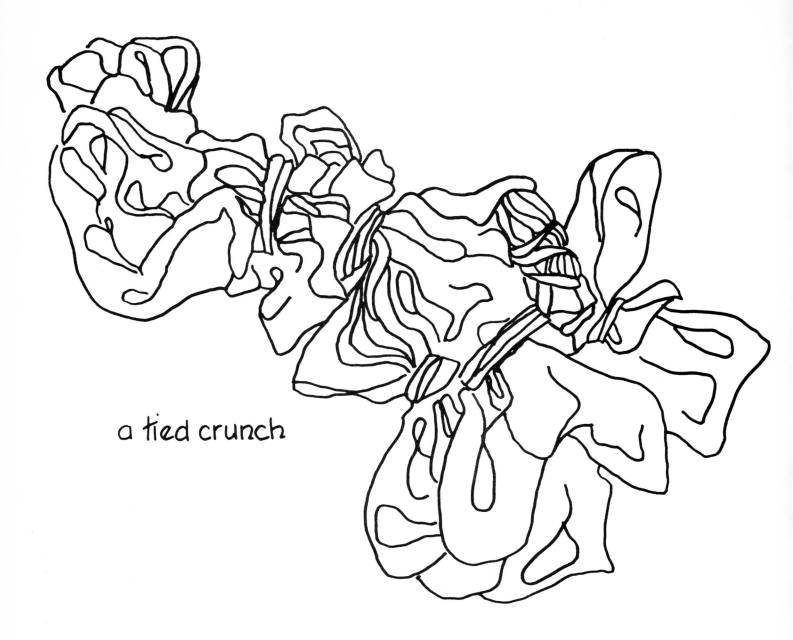

a tied crunch

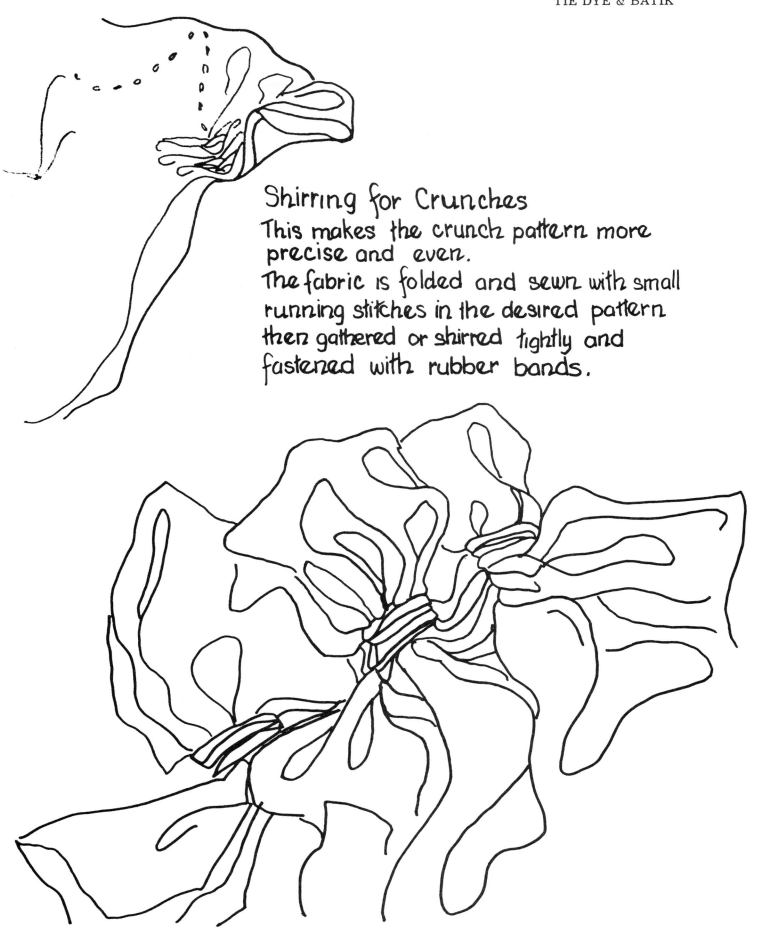

Shirring for Crunches

This makes the crunch pattern more precise and even.

The fabric is folded and sewn with small running stitches in the desired pattern then gathered or shirred tightly and fastened with rubber bands.

<u>Nail-head Patterns</u>.

Finishing nails are driven into a board,
in a pattern or shape or outline.
Knots are sewn and tied around the nail tops,
then the fabric is pulled off the nails and
dyed.

(It looks like smocking.)

This method is best in combination with
batik, with a little melted wax painted
around the ties for better color
delineation.

With the use of wax, use cold dyes.

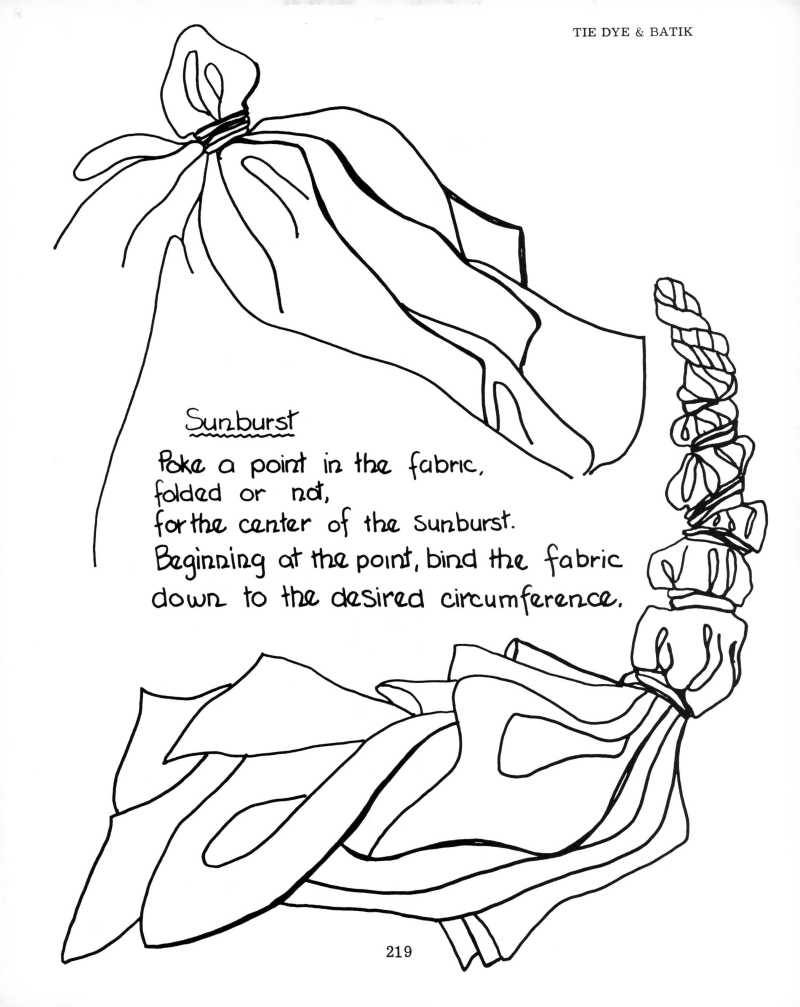

Sunburst

Poke a point in the fabric,
folded or not,
for the center of the sunburst.
Beginning at the point, bind the fabric
down to the desired circumference.

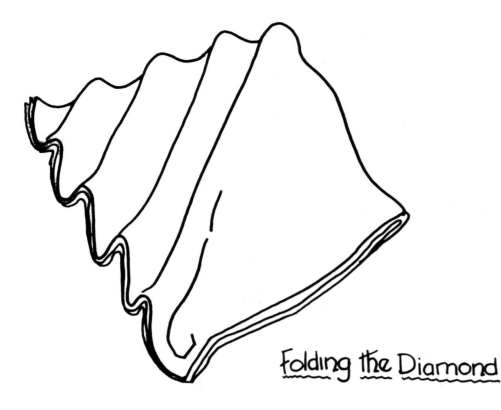

Folding the Diamond

Fold the fabric with the selvages together, with the right side up.

Fold again in quarters.

Pleat diagonally, corner to corner, binding the pleats with rubber bands about an inch apart.

Double Diamond

Fold the fabric in half
lengthwise, and in half
again lengthwise.
Do the flag fold,
bringing the right top corner
diagonally across to the fold,
then folding that triangle over and down,
and so on, until the whole piece is folded into
a triangle, the points of which are
tied with rubber bands.

Silkscreen
Roger Sessions

Silkscreen is probably one of the most versatile of all art forms. The fact that anything that lies flat and doesn't move or talk back can be printed on by this method is attested to by its successful use everywhere from the designs on Kellogg's cereal boxes to giant replicas of tomato-soup cans. The silkscreen has a subtle influence on all of our lives, and even perhaps on history--where would we all be if some bright boy at Harvard had not had a silkscreen to print the fist symbol with? It may not even be an exaggeration to say that behind every successful revolution, there are two people down in some basement pushing squeegees. As one can see, silkscreeners come in all shapes, sizes, and colors.

For this reason, I dedicate this chapter to everyone who at some time in his life will have a love affair with a squeegee, whether he be revolutionary, artist, or boy scout.

Silkscreen is based on the following simple principles. Silk is placed over the surface to be printed. A stencil is placed on the silk. Ink is forced through the silk and is blocked at certain spots by the stencil. Where the ink is blocked, a blank appears on the printing surface. Where there is no stencil blocking, the ink goes through and prints. The squee-

gee, a rubber blade with a wooden handle, forces the ink through the silk.

In setting up shop, I've found the following items essential. Almost all of them can be found at a good art-supply store. The few exceptions are either hardware store specialties or easily found in obvious places.

BASIC PRINTING UNIT: a sturdy frame of wood with tightly stretched silk securely stapled and taped on. The frame is attached with removable hinges onto a wood base or backboard. Paper is then fed on top of the base, the frame is let down, and ink is forced through the silk.

SQUEEGEE: As described before, the squeegee is run across the surface of the silk, forcing ink of all colors through the silk and onto the printing surface. The squeegee is the last link between you and your finished product. A word of warning: squeegees have personality and can produce slightly unpredictable effects.

INKS: You need the three basic colors (red, yellow, and blue), plus black and white. From these, using your imagination, you can mix just about anything else. Try to visualize colors you can get by mixing yellow with red (oranges), red with blue (purples), blue with yellow (greens). Any addition of white with pure color gives you tones going towards soft pastel, and any black gives you your color in darkish form. A mixture of black and white with any pure color "grays" that color. Interesting things can happen in mixing; you find them by mixing samples: for instance, a bit of black with yellow will mix to a yellow-green or avocado color. More about applying color later.

Also under this heading comes what is known to silkscreeners as "base," a mystic substance that smells horrible and is used to thin down the inks that are bought much more concentrated than even you real fanatics could hope to use.

GALLON OF WINE: This lubricant to your creativity may be cheap but make sure it's drinkable. An inexpensive chablis can serve the purpose handsomely. True, there are those who feel silkscreen is a "fine art," best done without the intoxicating friendship of wine, but these purists are rather scarce and unlikely in any case to effect any lasting social changes.

CLOTHESLINE AND PINS: or any other suitable drying arrangement you can think of. Paper clips can be strung on a wire hanging device. Drying time may range from five minutes to five hours.

DECENT-SIZE PLATE OF GLASS: This is the best palette you can have (and the cheapest) for mixing inks. A lot of other things can be used in an emergency, such as plates, pans, wood surfaces, and so forth.

A LOT OF CLEANING FLUID: such as white gas, turpentine, paint thinner. Used for all the obvious reasons.

SHARP CUTTING KNIVES: used for cutting stencils. They must be very sharp. Exactos and similar brands are fine.

<u>STENCIL PAPERS</u>: I'll go into this later.

<u>SILKSCREEN TAPE</u>: special tape that is resistant to water, ink, and cleaning fluid. This is used for taping the silk to the frame.

<u>MANY GLASS JARS</u>: for storing ink that you mixed and then didn't need. Whatever you do, don't use plastic because ink eats right through it.

<u>CLEANING SETUP</u>: a good sized washtub will give you years of satisfaction for this purpose.

<u>MASKING TAPE</u>: you'll use it for everything.

<u>PRINTING PAPER</u>: Almost any paper prints. Choose a type that suits your purpose.

<u>SILK</u>: Most art-supply houses carry silkscreen silk. Start with a relatively inexpensive (but not the cheapest) type, and as you continue you can try different qualities.

MAKING YOUR OWN PRINTING UNIT

Your first major project must be making your printing unit. They can be bought ready-made at many art-supply stores, but then again, so can TV dinners, which are about equal in personality, content, and uniqueness. Prices for these units vary according to the size. Assuming that you would like to "roll your own," follow these steps:

Determine how large a printing area you need and how large you may want your prints to be. Remember that small prints can be made on a large screen, but large prints cannot be made on a small screen. Let's say, in a hypothetical way, that we want a printing area of 12 by 18 inches. The frame must be large enough to give this much area for a stencil, plus enough room to put the stencil on, plus enough room to tape the silk to the frame (the silk is both stapled and taped to the frame for additional support). Stencils are taken off the silk and new ones put on, but the silk is only changed in extreme circumstances).

We have determined that it is necessary to be able to place a 12-by-18-inch stencil on the screen. An additional 2-inch border is necessary on all sides of the stencil to allow for proper positioning and a little maneuverability. This brings the area necessary up to 16 by 22 inches (adding 2 inches on all sides).

You will need an additional 2-inch area on all sides for taping the

screen to the frame (by the way, "screen" refers to the silk, not to the stencil). Now the total area is 20 by 26 inches (adding another 2 inches on all sides).

This, then, is the total amount of empty space you must allow within the frame to accommodate a 12 by 18 inch printing area. Note that the <u>necessary additional space</u> is not proportional, and is the same for a small frame as it is for a large frame.

Now that we have an idea how large an area we are working with, the actual building can begin. Keep in mind that the finished frame must be very rigid to support the great tension put on it by the stretched silk and also that it must be very level (in other words, it cannot rock when put on a flat surface). Test the wood for bendability at the length you are planning on using. Wood that is quite suitable for a 20-by-26-inch screen won't support a 35-by-45-inch screen. Standard 1-by-2-inch board should work fine for our hypothetical frame.

Cut two pieces 30 inches long (the length of the inside plus 2 inches on either side for the wood) and two pieces 24 inches (ditto).

Cut the ends so that they fit together.

Fit them together, and fasten with corner braces securely, checking for levelness and snugness.

Cut a piece of silk about 3 inches larger all around than the frame.

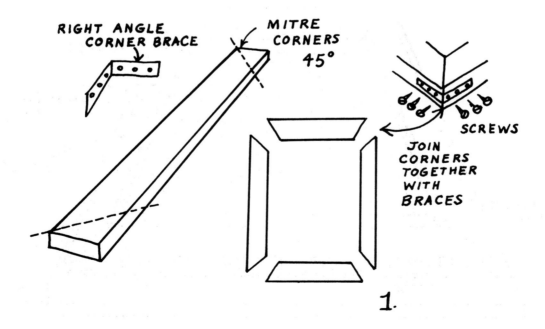

RIGHT ANGLE CORNER BRACE

MITRE CORNERS 45°

SCREWS

JOIN CORNERS TOGETHER WITH BRACES

1.

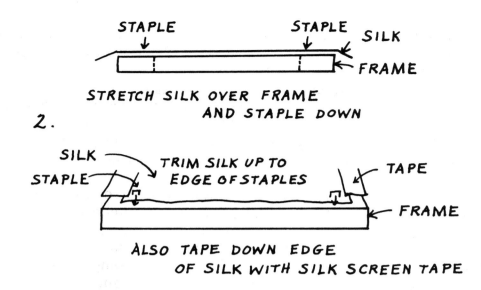

STRETCH SILK OVER FRAME
AND STAPLE DOWN

2.

ALSO TAPE DOWN EDGE
OF SILK WITH SILK SCREEN TAPE

Begin stapling the silk onto the frame with a staple gun. Start at the corner of one edge and put staples in at an interval of about 1 inch. Before stapling at each point, pull the silk tautly away from all other staples. Try to achieve a uniform tautness, like the top of a drum. Staple opposite sides, first starting from the center and working outwards. When finished, the silk should be just tight enough to give about a half inch.

When the stapling is done, trim the silk almost up to the staples. Then tape each edge with your silkscreen tape.

Turn the frame over, with the <u>silk side down,</u> and tape the inside edges.

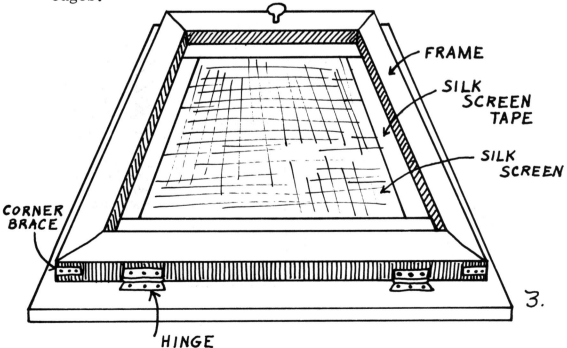

3.

Hinge the frame onto the straight backboard (three-quarter inch plywood is best for this). It shouldn't be warped, and pick a size 6 inches or so bigger all around than the frame (Fig. 3). Figure 4 shows a good way to keep the screen propped up.

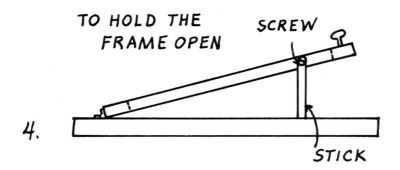

OK. The groundwork has been laid. If you have gotten this far, you can sit back and take it easy. If (much more likely) you got hung up on some point, then now is the time to bring out the wine. Relax. Have a glass, then try again. It usually goes a lot easier this time.

STENCILS

Once you have gotten your printing unit finished, you can start making stencils. This is the most creative part of your venture, and therefore, to many people, the most fun. There are three important types of stencils which I'll discuss in turn. In general, each stencil represents one color, and a finished print may involve any number of stencils and printings, depending on the number of colors used. There are, however, some short cuts. A two-color, blue-yellow print is going to need one stencil for each of the two colors, but a three-color, blue-yellow-green print may be done with two stencils also. (Yellow and blue mixed or printed together make green.) In the latter case, one stencil would be cut for blue and green, and another for yellow and green. The two stencils would overlap on the green site only. Both yellow and blue would be printed separately but they would combine on the "green" sites to create that color. This overlap technique can be carried quite far, giving up to seven different colors from three printings of the basic colors (red, blue, yellow).

GLUE STENCILS: Water-soluble glue is used for glue stencils. The glue is applied with a paintbrush directly on the silk in every place where you do not want color going through. When the glue dries, it forms a hard film which the ink cannot penetrate. The ink is spirit-soluble, and, as such, will not dissolve the glue (nor will cleaning fluids). Basic law of chemistry: two things that are not soluble in any of the same substances will not dissolve each other. A glue stencil can literally be soaked over-

night in turpentine with no ill effects; however, a few drops of water can destroy the stencil in a matter of seconds. If you add a few drops of food coloring to the glue just before applying, it will be much easier to see the work, since the glue is normally almost invisible.

After the stencil is dry (usually from one to three hours, depending on humidity and other factors) it must be held up to a light and searched carefully for "pinholes"--that is, any place where there was not a sufficient amount of glue to form a solid film. Ink will come through any of these places. A few more dabs of glue will prevent spotty prints.

Glue stencils can also be made by applying spirit-soluble touche with a paintbrush every place on the screen that you do want the ink to go through. After the touche dries, the entire screen is coated with glue. When this dries too, the screen is washed vigorously with spirits. Since only the touche is spirit-soluble, only the touche (and whatever glue is on top of it) is washed away in the spirit bath. This has the advantage of not requiring negative thinking when painting the stencil.

Glue stencils give more of a painted look to the finished print, with less definite lines than other methods. Clouded effects can be achieved with light glue painting. Since it is difficult to get well-defined lines, this type of stencil lends itself with difficulty to the overlapping techniques discussed before, which require very precise coordination. However, far be it from me to say it can't be done.

"STENCIL" STENCILS: The "stencil" stencil is the more traditional approach to stencil making, especially in overlapping, and, like most traditional approaches, it is one of the less rewarding ones. It involves the use of specially prepared stencil paper (again, your friendly neighborhood dealer will be happy to supply you). The "paper" has two layers. One is heavy plastic and serves as a backing for the extremely thin layer of film which is the actual stencil. The film is made to adhere to the backing just enough to allow it to be peeled away when you are ready, but not so much that the two parts would become separated under accidental conditions. The stencil is prepared by cutting away the outlines of the open sections (open, is of course, where the ink is to go through) and then peeling these sections off the backing. In cutting, only enough pressure is applied to cut through the thin film, and the backing is left intact. The screen is then placed, silk side down, directly on the film so that they are touching. The film is dabbed with acetone through the silk and begins the process of dissolving. Film is soluble only in acetone. Too much acetone would completely eat the film up, and it must be carefully applied so that only enough to make it adhere to the silk is used. When the film has completely adhered to the silk and the acetone is dry (a matter of one or two seconds), the backing is very carefully peeled off, leaving a ready-to-print stencil.

The advantage of "stencil" stencils is that fine, well-defined lines can be made and put exactly where you want them, which is necessary for fine color-coordination. The disadvantage is that this is extremely difficult to perform, since there are about six places where you might easily destroy the stencil. This method also requires the use of large amounts of acetone, which is more inflammable than turpentine and a potentially serious health hazard if not used in a properly ventilated area. It is probably one of the commonest types of stencils now in use. For me, I find it much more of a drag than it's worth.

<u>PAPER STENCILS</u>: Although paper stencils have an almost nonexistent use right now in the silkscreen world, I think that they hold by far the greatest potential, especially for the amateur who is not interested in runs of several thousand prints. The paper stencil is extremely simple to make. Cut a piece of paper a little larger than the outside edges of the frame. The paper that you use for this stencil should ideally be about the thickness of newsprint, but of a consistency that will not as readily allow ink to soak through. Even newsprint will work for a run of less than twenty. Cut your design out of the paper (Fig. 5). A very sharp knife will make your

5.

burden incomparably lighter here and is guaranteed to reduce your ruined stencils by half. When your stencil is completely cut, ignore it. Get everything else ready for printing. When you are all ready, lay a sheet of newspaper (instead of printing paper) on the backboard, and the stencil on top of that. Let the screen down (Fig. 6). Center the stencil so that it overlaps a little on all sides. Then put some ink on the screen, and squeegee it through (see section on printing). The ink will provide enough cohesion to bind the stencil to the screen, and the stencil will remain in place until it is purposely peeled off or until the ink is washed off.

6.

The disadvantage of this technique is that the stencil is only good for one run (a run being as long as you continue printing consecutively). The advantage is the ease and maneuverability of working with these stencils. You can even peel one off and put another one on without washing the screen, as long as both printings are of the same color.

The alert opportunist may see great possibilities in this method. For example, the same cohesive force that holds the stencil to the silk will hold leaves and god only knows what else to the silk, allowing for interesting and original effects. Yet this technique is all but ignored by the silkscreen textbooks. It is rarely mentioned, and its possibilities are only superficially explored.

COLOR MIXING

In technical jargon, there are three types of silkscreen colors; transparent, translucent, and opaque. These terms refer to the different degrees of transparency that each gives when printed. For example, transparent blue printed on transparent yellow gives green, as mentioned before. Transparent colors are prepared by diluting the raw color (from the tube or can) several times with base. (Proportions of ten base to one color are not at all unreasonable.) Opaque color completely blots out anything printed underneath it. It is made by mixing raw white with raw color. Translucent color is prepared by adding both base and raw white to raw color. A translucent blue printed on transparent yellow gives a very bluish green.

Exactly what proportions you want must be determined by your own experimentation, keeping in mind that base is a lot cheaper than color and that a little color can be made to go a long way.

In time you may find yourself building up a collection of particularly appealing colors in the same way that other people collect vintage wines. There are literally hundreds of different silkscreen colors on the market for you to choose from. Never, of course, buy a color that you can mix yourself; you will, however, occasionally find some wonderfully pure, high tone that you could never duplicate. There is one particularly beautiful fuchsia that I regularly stock up on after endless failures at mixing it myself.

PRINTING

Your frame is built, your stencil cut, your color mixed and your wine is poured, so you are now all ready to print. This is a very joyous occasion, and your dress, manner, and mood should reflect this fact.

7.

You have by this time already devised a way of drying your prints. Close at hand you should also have cleaning stuff (rags, etc.), printing paper, scrap paper the same size as your printing paper; the printing set-up; squeegee; the colors; and any other unmentionables that you find necessary to do your best. Realize that any clothes you are wearing will never look the same, so plan your attire accordingly.

Lay some color on the screen as shown in Figure 8 in a column perhaps an inch or two thick, and center the dummy printing paper underneath the frame as best you can by eye. Hold the squeegee at the angle shown in Figure 9 and firmly run the squeegee the length of the printing unit, stopping two or three inches short of the opposite side; then turn the squeegee around and do it again in the opposite direction (Fig. 10). Lift up the printing unit and remove the printed dummy. Notice whether you have centered it well or not. Position another dummy and print that one. Keep going through this trial-and-error procedure until you decide that you have found just the right spot to place the paper to get the proper margins. Border that spot with some very lightweight cardboard and masking tape so that you can easily feed paper into the unit without fumbling.

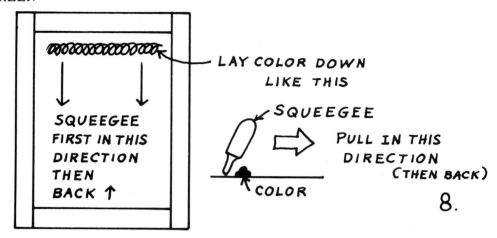

LAY COLOR DOWN
LIKE THIS

SQUEEGEE
FIRST IN THIS
DIRECTION
THEN
BACK ↑

SQUEEGEE

PULL IN THIS
DIRECTION
(THEN BACK)

COLOR

8.

9.

10.

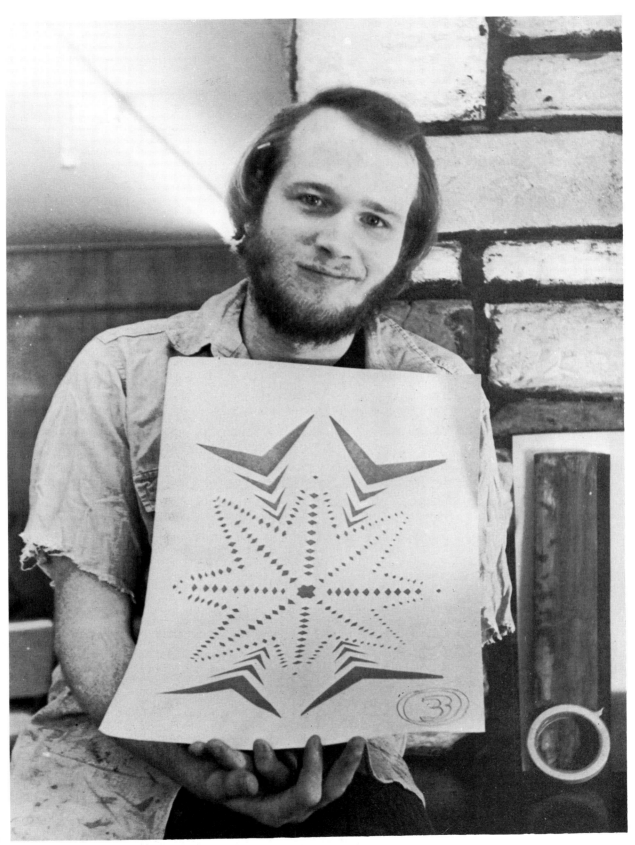

11.

Just go though exactly the same procedure with your _real_ printing paper and you have your first print (Fig. 11). If you are planning on doing a job using more than one color, you'll find centering much easier on subsequent prints, now that you have a printed reference on the paper to look at. Make sure that you print enough extras to allow for messups later on. After that, what can I say?

When you're done for the day, cleaning up is a drag, but it must be done. If any ink at all is left on the screen, it will dry and permanently block out parts. On the other hand, be careful that in your enthusiasm you don't rip the fragile silk.

Use for cleaning fluid whatever the particular solvent is for your ink--white gasoline, turpentine, paint thinner are the standards. Keep in mind how flammable these substances are when you dispose of rags. It would take very little to turn a pile of turpentine- or gasoline-soaked rags into a major disaster area.

SPECIAL EFFECTS

As you continue silkscreening, you will undoubtedly discover new techniques for creating your own special effects. I'll describe two of my favorites to help get you started. The first is open-screen technique. The stencil, if used at all here, is simple, and may serve no other purpose than to create a border. The effect is created by placing the ink before you print as shown in Figure 12 and causes the illusion of one color fading into another. The other technique that you might be interested in is printing on wet objects. Just before you print, get the object good and wet in whatever solvent you use for that particular kind of ink (water for water-soluble inks, turpentine for oils, etc.) and then just print normally. You can get some nice blurred effects that you can learn to control with varying

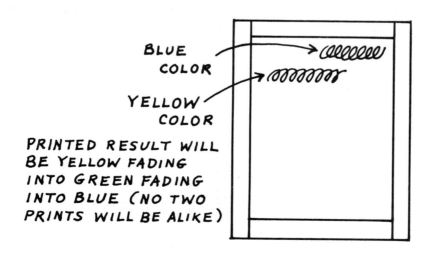

BLUE COLOR

YELLOW COLOR

PRINTED RESULT WILL BE YELLOW FADING INTO GREEN FADING INTO BLUE (NO TWO PRINTS WILL BE ALIKE)

12.

amounts of wetness. Don't limit yourself to one or two techniques but experiment with them as much as you want. If all of this brings visions of sugarplums dancing in your head, fine. Think creatively and feel free. Your silkscreen studio is your castle.

PRINTING ON CLOTH

Before I leave you to your printing, I'll add a brief note on printing on cloth, which is slightly different than paper printing.

First of all, you will need special cloth inks, which may take some tracking down. The printing itself is basically the same, except that when you're all done, you must fix the ink to the cloth. Ideally, this is done with a large oven contraption that costs about $5000, plus $200 for shipping; if this is beyond your means, an iron will do. Heat does the fixing, so the more you iron the finished fabric, the better the end product will be.

You will be better off using a variation of the basic printing unit rather than the same one. I use a table made of a full 48-by-72-inch sheet of three-quarter-inch plywood with a full 48-by-72-inch sheet of soft board on top. Some sort of padding on top of that will probably be worth the effort. For the printing unit I just use an unhinged and unattached frame and silk. The fabric is pinned to the table, and the printing frame is placed freehand on top of the fabric. Using this method, you sacrifice the ability to do any print requiring a fine color coordination, but you gain in ease, cost, and maneuverability. If you are going to go seriously into cloth, it will be well worth your while to learn something about batik, since batik and silk-screen can be combined most profitably.

Silkscreen, then, is at the least an experience, and at its best an art. Its limitations are many, though these same limitations can be manipulated until they seem far less formidable than they first appeared. Use both your mind and your body. Your equipment is just an extension of your self, so consider it as such. Most of all, of course,

Love your squeegee,

Roger

Let's Knot: Macrame
Paul Schwartz

Macrame is decorative knotwork that first appeared in the Middle East as fringe on shawls and towels. It was developed in Spain, France, and Italy through sailors' and fishermen's knots until, by the sixteenth century, European lacemakers were creating designs of great complexity.

As a craft it's great fun and can be learned by mastering a few simple knots that have a great variety of applications. Some of the things that can be macramed for the home are wall hangings, curtains, hammocks, hanging planters, free-form sculptures, screens, and room dividers. Wearing apparel, such as vests, chokers, shawls, bracelets, headbands, borders for clothing, pendants, and even bathing suits can be macramed.

Its emphasis on rhythmic control has a stabilizing effect that has led some of the world's foremost statesmen like Churchill and De Gaulle to find soothing relaxation in both knitting and knotting. It can be satisfying therapy for those who see their larger problems in terms of confused strands and loose, fraying ends.

TOOLS

Most tools in macrame are simply designed to give you a third or fourth hand to hold the stationary cords; therefore, these easily rigged gadgets are essentially a wide selection of clamping and pinning devices.

STOMACH CLAMP: The stomach clamp is a small rectangular piece of wood with two grooves to hold the strands of the material being knotted. To prevent the material from slipping, rubber bands are stretched around the sides of the grooves. Drill a hole in one end so that it can be snugly attached to your waist by a cord. It may feel awkward at first, but after a while its value becomes evident.

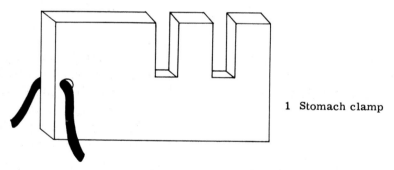

1 Stomach clamp

C-CLAMP AND FLAT BOARD: These are devices to hold the material to a table or to another board so that tension can be applied to the lines as you knot. (The strands you work on are clamped

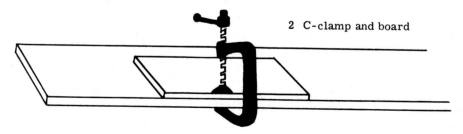

2 C-clamp and board

3 Nails and wood block

under the board). <u>Or</u>: Instead of clamping, you can also take a heavy block of wood and drive a row of nails into it as shown in Figure 3. (If it's heavy, it won't slip off that table in front of you.) The nail method works best when you are using thin cords or only a few strands (as when you are making a belt or straps) because you can't wrap bulky cords around a nail.

<u>ROD OR STICK</u>: A knitting needle or long glass stirring rod fastened to a cork or polyurethane board by U-pins (which you can get in a sewing-goods store) does somewhat the same job as the clamps. Since the moored-down knots are able to slide across the rod, adjustments in the beginning are easier.

In addition, you'll need a scissors and ruler for cutting and measuring. You also need hands, eyes, and other sensibilities. These tools are an abstraction but only until they become extensions of the hands. With that, the manipulator vanishes and the creative process flows. The true experience of craftwork is the abandonment of the Great Manipulator and the acceptance of the Great Body.

MATERIALS

The basic materials are anything that can be knotted--cord, twine, rope, and yarns of various weights. The material must be flexible enough to tie, but not so elastic that it leaves misshapen knots. For example, most leather lacings don't knot well because it is hard to maintain tension and control the strands. Certain kinds of yarn tend to curl up and disappear. But don't give up on yarns, for some relatively smooth yarns can show off knots very nicely. The best materials are those closest to the ones that the sailors originally used, such as butcher's twine, jute (an unusually coarse cord that works in well with butcher's twine), rayon cords, rattail (a rich-looking satin cord that seems to offer the widest variety of colors), tubular (a rayon and cotton cord), and chalklines. Most of these materials can be obtained at any hardware store. For others you may have to canvass the nearest urban garment district. You can find other usable materials by trying them out. Some may give more resistance than others. Some may fray more than others. It's your choice. Often different materials combined in a piece add diversity and interest; this technique, however, can present problems. Some materials will not knot securely with others. You become aware of this when knots work loose without too much difficulty.

4 What you'll use

If it takes a great amount of tugging to get a secure knot, it generally won't remain tight for long--especially if you are making an item of apparel like a belt. Oftentimes you may have to double material to get a proper knot. Linen seems to combine well with other materials. Rattail and tubular do not work well together. It is best to experiement with many types to develop the faculty of determining how best to execute the macrame piece.

ACCOUTREMENTS

Once you have beads on your mind, you will see them everywhere from the five-and-dime store to your mother's closet. The list is long--antique beads, beads from old jewelry, macaroni, and feather-quill; in short, any-thing with a hole in it large enough to accept the thickness of the material

you want to wiggle through. Rattail is best for beading projects due to its slick surface. Yarns and threads of less density can be pinched together at the ends and made to go through beads with ease. An especially good thing to know is that a bit of Elmer's glue or Sobo glue on tips will dry and make these ends stiff like a needle. The glue also helps condense the pinched ends even more to narrow a point for beading.

In most cities there is a bead district in or near the garment districts. For instance, there are entire warehouses in New York City that sell nothing but billions of beads. Clear or opaque glass beads run about 90 cents per hundred--so that gives you an idea of what to anticipate if you want quantities. Some dealers try to force large purchases if you seem the least bit unsure of yourself. Make sure you tell them what you need.

PLANNING AND PREPARING

Bow to the East. Select your materials with a careful eye for the weight, color, and texture that are called for by the nature of your project.

As a general rule, the cord should be from two to four times longer than the anticipated finished length of your project. The amount of the material varies with the length and breadth of the piece, the type of material being used and the complexity of the knots. A twelve-inch piece of macrame work with a glorious network of half-hitches in chains or half-knot sinnets (a sinnet is a long cluster of knots) could require more material than a twenty-four-inch piece with evenly placed square knots. Narrow and flexible material will knot tighter, leaving more to work with than heavier cord. Some ropes or line will not draw tight no matter how hard you pull, so you need to allow for such situations ahead of time. These combined factors must be considered before starting unless you want to let it all hang out by clustering knots very spontaneously for a free-form type of approach. It is best to overestimate than to run out and have to tie in cords nine-tenths of the way through a project. If you find that you need more cord, an easy splice is made by applying glue to the unraveled ends of each cord and twisting them together. Be sure to allow for proper drying time or they may pull loose.

When mounting strands on rings or dowels or other strands, the cords are halved in such a way as to create a reversed double half-hitch. Don't worry if this sounds like a sophisticated football play, for the procedure will be explained in the next section on knots. It's important to note here, though, that if the cords are mounted in this manner, a double length of material will be required for each strand, and only half the number of long strands will be necessary. For example, should you want to make a rather simple two-foot wall hanging of twenty-four strands, you cut twelve eight-foot strands, measuring them with a yardstick or using a device called "two nails to a measure," which is simply two nails struck into the wall four feet apart. You tie the material to one nail and wrap it around the other and

back twelve times to give you a dozen eight-foot lengths. Cut the material where you originally tied in. When a lot of material has to be cut, you may find strands popping off the nail, in which case a friendly hand may be necessary.

MOUNTING THE STRANDS

It is easiest to clamp the strands under a board with a C-clamp or tie them on a nail (refer to Figures 2 and 3). These are the methods used by professionals who must produce a volume of specific work, a belt for example, in a short time (it is hoped that the reader's thoughts are directed towards aesthetic creation through craft rather than knotted with exploitative intentions).

5 (A) Reversed double half-hitch

(B) Mounting on a buckle

A more sophisticated mounting method is halving the strands and tying them to a dowel, rod, or buckle with a reversed double half-hitch (Figs. 5A, 5B). The horseshoe loop of the first step should be in the middle of the strand held in your hand. This is the "hand strand." The horizontal line in Figure 5C represents a dowel or holding strand, which is either fixed

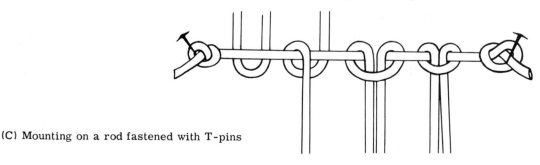

(C) Mounting on a rod fastened with T-pins

244

tightly between two nails or knotted and T-pinned to a board. (A T-pin is shaped like the letter <u>T</u> and can be purchased in art-supply stores and sewing-goods shops.) Bend the horseshoe over and slip the two hanging strands through the loop as shown in the picture. Using this knot, you can mount almost anything.

USES OF THE STOMACH CLAMP

Either by using the reversed double half-hitches or the nail or C-clamp method, anchor the ends of four strands and sit down in a straight chair with the stomach clamp tied around your waist. The middle strands are held together and brought through the left side of the groove in the clamp, then down. Lock them in place by wrapping them tightly around the clamp once. There should be no slack between you and the mounted end. If there is, re-groove a little higher and tighten up or move the chair back a bit. You have to wrap some of the more satiny materials through the groove a second time.

THE HALF-KNOT

With the two middle strands clamped taut, take the two outside strands and make a half-knot: take the left strand and pass it over the two grooved strands, making a small figure 4. The right strand is then passed under the grooved strands and through the center of the 4. When tightened, this is the completed half-knot. If this is repeated four or five times, you have a sinnet of half-knots.

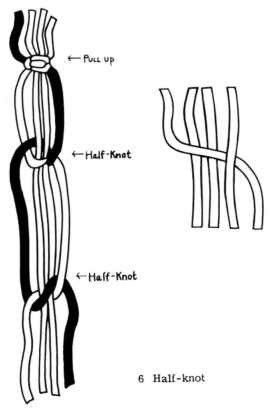

← Pull up

← Half-Knot

← Half-Knot

6 Half-knot

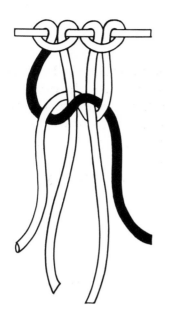
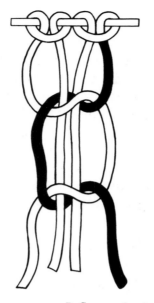
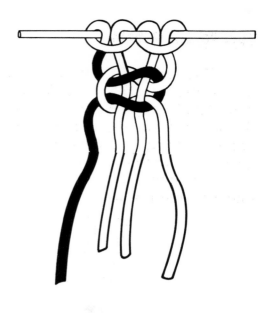

7 Square-knot

THE SQUARE-KNOT

A square knot is simply two half-knots. This second half-knot is added to the first by bringing strand number one back across the grooved strands, strand number two over it, under the grooved strands, and up through the loop. By tightening each one of the knots separately from both the top and the bottom, the knot is completed. Practice a sinnet of square knots (Fig. 8).

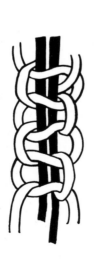
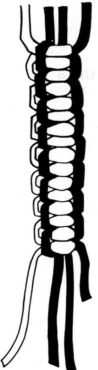

8 Sinnet of square-knots

THE HALF-HITCH

This knot with its many variations can create an almost unlimited variety of effects. The two middle strands are clamped, and the outside cord on your left is looped over the two grooved strands; then back around again and through the resulting gap. Since the knot is only used along with other knots, don't worry if it seems loose by itself. Just loop the right strand over the grooved strands and make a half-hitch under the first one. By continuing these hitches with two strands, first on the left and then on the right, you make a chain of alternating half-hitches.

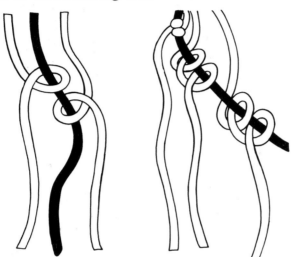

9 Half-hitch (left) and double half-hitch (right). (Only one grooved strand is being used here)

DOUBLE HALF-HITCHES

As you may have guessed, this is a series of two half-hitches made one after the other about the same strand or strands. By interworking these knots some of the most interesting macrame is made. Changing the angle of the knot-bearing strand can lead to a vast variety of designs. Try a vertical line of double half-hitches. With four strands you can make two vertical rows with each middle strand as knot-bearer for the outside strands on either side, or you can have one knot-bearer for two strands. Another possibility is a double knot-bearer in the middle. For horizontal and diagonal rows use more than four strands. Let's say there are twelve strands hanging loose. The one on the extreme left will be the knot-bearer. The bearing strand is stretched across the others at a right angle. Then, using each strand in succession, a series of half-hitches is made. They are brought under the knot-bearer and over to the left, so make sure there is a little slack still in each knot before it is in its final place. Then you can fix it with a tug. For a diagonal effect let the knot-bearer angle downward and tie in without changing the angle. Pay attention to the proper degree of tension and adjustment of the knot-bearer. As you work with diagonals, you will accidentally discover ellipses. Make them work for you at a later time.

Elements of Design

1. Pattern - Total; specific

2. Shape - of piece; within the piece

3. Texture - materials, knotting

4. Color - strands, beads, bones, shells, etc.

5. Line - amount, directions

6. Contrast - color, types of materials

7. Variety - knots, patterns

8. Density - of knots

9. Space - openness; between knots

10. Repetition - knots; pattern; lines; color

Repetitive square-knot patterns can be made by immediately tying the loose strands of one square knot into another knot. When a square-knot is to be made over two strands, the two working strands come through the middle and the two component strands hang on either side of the knot. One of these hanging strands can be used with the hanging strands of an adjacent knot to form another square. This can go on as long as you wish to continue the design. (Another approach is to use the square knot over a single strand.) Through the use of double half-hitches, knot-bearers can be made to converge and diverge, creating diamond patterns (Fig. 10). By varying the spacing and alternating the knots and grooved strands, other patterns can be brought about. For example, with four strands a conventional square knot is made by tying the two outside strands about the two inner ones. Fix these outside strands to a stomach clamp and start a square knot about an inch away from the original one and a new alignment begins to appear.

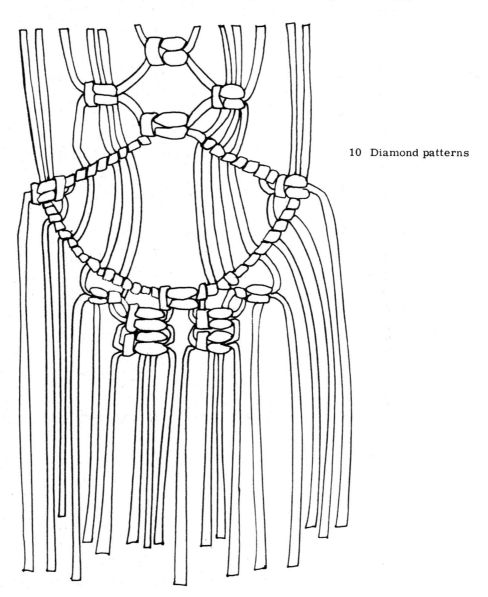

10 Diamond patterns

When two diagonal double half-hitches converge, a double half-hitch is made by one knot-bearer over the other. Vertical or horizontal rows of double half-hitches placed beside or below each other can angle off in different directions by alternating the strands being used as knot-bearers. For example, a twelve-strand row of eleven horizontal double half-hitches can be made by using the first left strand as knot bearer. Under that, a row of ten double half-hitches can be made using the second strand as bearer, and so on until the system is played out.

I don't want to give you blueprints for working in macrame, because most of the gratification of any craft comes from working it out on your own, but some of the concepts below are pretty basic and good to know when you start working out a design. They are technical considerations that can be picked up with little or no effort.

Series of knots can be worked into patterns that are either anticipated or arrived at spontaneously. Often while working one pattern, others will emerge. One day's error will be another day's plan.

An example of a pattern is the alternating square-knot triad, which can be made once the square knot is understood. As you know, a square-knot consists of two parts: the middle strands held by the stomach clamp, and the two outside strands, which, as the components of the knot, are tied around the middle ones. An alternating pattern is formed by using the component strands from the knot already tied as the middle strands for the next knot. Practice this with eight strands first, by working with two groups of four strands (Fig. 11). Make two square-knots beside each other, taking care to keep them as horizontally true as possible. Now use the right com-

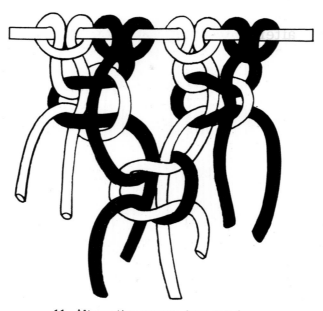

11 Alternating square-knot triad

ponent strand from the left knot and the left component strand of the right knot as the middle strands of a new knot: what was the right middle strand of the left knot becomes a component in the third square knot when it is worked in with the left middle strand of the right knot. This third knot forms a sort of inverted triangle familiar to all you junior achievers as the symbol of the Great Earth Mother. The triangle can be expanded as you become used to working with more and more strands. Make three rows of alternating square knots and you have engendered that little diamond shape within a circle that is the subconscious key to alchemy. Through silent contemplation of the horizontal, vertical, and diagonal members of the pattern, the essential energy of the universe is manifest.

Variations appear everywhere. For example, two knots (or a double square-knot) can be tied side by side with two more placed directly beneath them as if to make sinnets. When a third element such as two square knots is tied in below, the point of a triangle is made. No jive, this is how the molecules gather. Another pattern of square knots can be made with six strands using two groups of threes. One strand is used as the middle strand and the square-knot is tied around it; the second elements are made in the same side-by-side fashion. The third and final element is made by using the right component of the left knot as the middle strand. The components of this knot are the middle strand of the left element and the left component of the right element. Expand, experiment, and change this as you will. Patterns of infinite variety will come to mind. You've only to close your eyes.

Double half-hitch patterns are determined by the position of the knot-bearer. Since the double half-hitch can be drawn tightly on the knot-bearer, repeating rows of close knots can be made, to create a mat effect. A diamond pattern can be made with half-hitches by using two middle strands as knot-bearers. They diverge in opposite directions up to the last hitches at the widest point, after which they converge until the diamond is completed (see Fig. 10). Rows of double half-hitches can be placed beside and below each other for a warm, bulky effect. They also can be used to separate patterns within a whole design. Different colors can be introduced to the design with contrasting and bold effects. Materials of different color and gauge can be mixed together to create a variety of textures.

FINISHING

Loose ends can be left as fringe or tied off with a gathering-knot. (Fig. 12). On pieces like a belt, the long ends can be left for braiding and then secured by a noose-knot (Fig. 13). Ends can be further secured by placing a small knot at the tip of each strand to prevent fraying. If you're neat conscious, these knotted ends can then be cut to a uniform length. Loose ends can also be finished off by knotting sinnets (Fig. 14).

12 Gathering-knot

13 Noose-knot

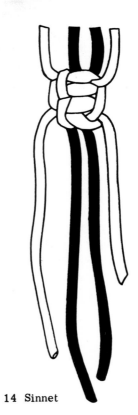

14 Sinnet

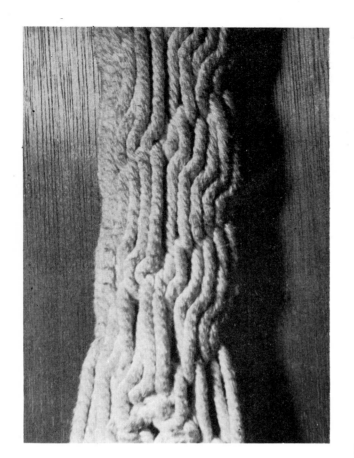

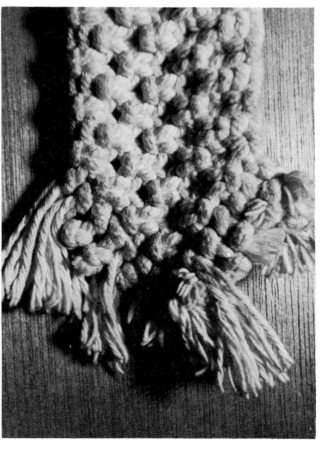

Design and layout by Bertie Hoover